Follies

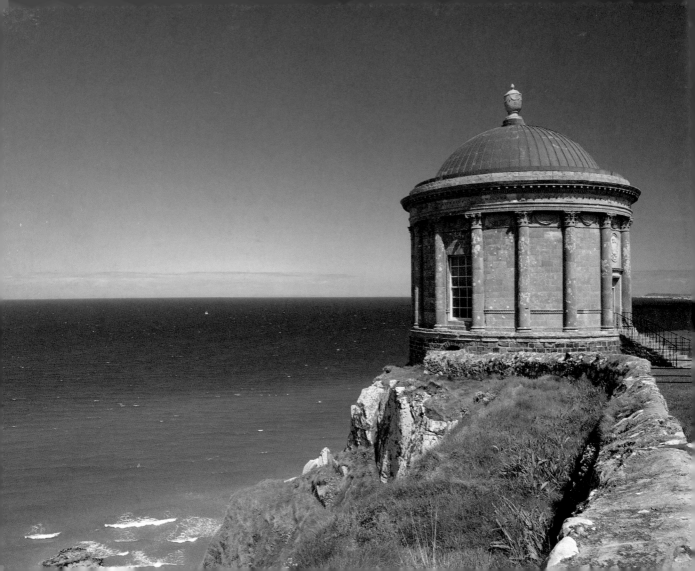

Follies

Fabulous, fanciful and
frivolous buildings

Gwyn Headley

National Trust

For Wim Meulenkamp
who knows and loves folly

First published in the United Kingdom in 2012 by
National Trust Books
10 Southcombe Street
London
W14 0RA

An imprint of Anova Books Company Ltd
Copyright © National Trust Books 2012
Text copyright © Gwyn Headley 2012

ISBN 9781907892301

A CIP catalogue record for this book is available
from the British Library.

21 20 19 18 17 16 15 14 13 12
10 9 8 7 6 5 4 3 2 1

Reproduction by Rival Colour Ltd, UK
Printed and bound by 1010 Printing International, China

This book can be ordered direct from the publisher at the
website www.anovabooks.com, or try your local bookshop.
Also available at National Trust shops and
www.nationaltrust.org.uk/shop

Page 2: Mussenden Temple,
County Londonderry

Contents

Introduction 6

The follies 10

Visitor information 90

Picture credits 96

Introduction

Follies are misunderstood buildings.

In almost every case, the buildings in this collection were erected by men (and a couple of women) who believed that what they were erecting was logical and necessary. And a few centuries down the line in we waddle, pointing our fingers and calling them foolish. Nobody likes to be laughed at, but if there is one quality that sets the British apart from other nations, it is the ability to laugh at ourselves. Our follies are no exception. Other countries have their follies, some perhaps even wilder and more deranged than their sometimes decorous British cousins, but they're not seen as foolishness. Their builders are admired and respected.

The primary function of a building is shelter. Everything else is secondary. When buildings cease to become necessities they become pleasures, and when that pleasure becomes too gross, others call it folly. For one of the many quirks of the folly is that you cannot actually build one yourself. You can build a house, a church, a factory, but you cannot build a folly. It is for others to grant the honorific. I can't call myself Sir Gwyn Headley, more's the pity, because the title has to be awarded. It's like an ordination.

For many years follies were largely ignored by architectural historians because many were deliberately built to deceive, to look older than they actually were, which was not playing the game. Nevertheless, follies have been disproportionately influential in the stylistic development of English architecture. The first Gothic Revival building – a deliberate harking back to an obsolete architectural style – was a folly. Nineteenth-century London (which means most of it) is almost entirely Gothic Revival, inspired by one folly in Cirencester, Gloucestershire. Alfred's Hall dictated the look of the world's greatest city. It was a simple deception, and the pleasure was widely shared. The folly had been built in 1732 to replace a wooden hut where Jonathan Swift had stayed. Mrs Pendarves wrote to Swift the

The Temple of
Ancient Virtue,
Stowe

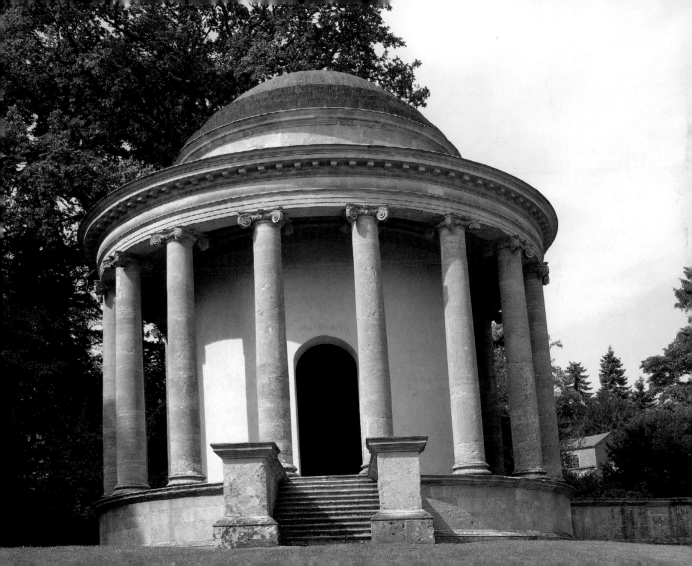

following year: '[Alfred's Hall] is now a venerable castle, and has been taken by an antiquarian for one of King Arthur's, "with thicket overgrown, grotesque and wild." ' To fool an antiquarian so quickly! What merriment that must have caused!

When looking at the Temple of Theseus at Hagley Hall in Worcestershire (not in the care of the National Trust), even people with no knowledge of architecture could say 'That's a Greek temple.' It is. It's also a folly, a garden ornament, built for pleasure before purpose. And it's the first Greek temple in Britain. The first Gothic Revival and the first Greek Revival buildings in England were both follies.

Perhaps the purest folly, the ultimate conceit, is to build a ruin. What greater disregard of the need for shelter can there be than to erect a structure that can offer no shelter at all?

Hitler's architect Albert Speer had a theory of 'Ruin Value', figuring that as the Third Reich was going to last a thousand years, the buildings he constructed should be designed to decay impressively, leaving monumental ruins in the style of Rome. He wanted to use only natural materials like marble and stone, because reinforced concrete would make such a disagreeable ruin. In that respect he was right, for once. He must have realised that creating a ruin from scratch was a task beyond anything the deformed Nazi mind could conceive, just as 250 years ago the travel writer William Gilpin commented on the sham ruin at the National Trust's Shugborough:

'It is not every man, who can build a house, that can execute a ruin. To give the stone its mouldering appearance – to make the widening chink run naturally through all the joints … are great efforts of art; much too delicate for the hand of a common workman and what we very rarely see performed.'

Sham ruins are to us the most follylike of follies. The National Trust has an abundance of them, and they are faced with an amusing dichotomy; while they fight to keep the stately

homes of England from falling into ruin, they have to battle just as hard to keep their sham ruins standing. From Wimpole in Cambridgeshire to Mow Cop in Staffordshire; from Belton in Lincolnshire to Shugborough in Staffordshire; from Slindon in West Sussex to Croome Park in Worcestershire, the sham ruin captures the pure spirit of folly.

Do follies stand for foolishness around the world? Other languages don't share the word. In France 'la folie' is at most a garden pavilion; Americans going to see follies expect dancing girls. The nearest and merest hint of frivolity comes in the Italian and Spanish words 'capriccio', 'capricho'. But the leaden skies of England, Wales and Northern Ireland lend such foolishness a heavy, doom-laden air. A massive structure such as the Lyme Cage in Cheshire could never have been seen as a caprice. Gaunt and minatory, it looks more like a private-sector prison than a pavilion of pleasure.

Form follows function was the diktat of 20th-century Modernist architects, and the brave new rationality of that war-torn century militated against frivolity in architecture. A century ago Peter Behrens had three assistants in his architectural practice in Berlin: Walter Gropius, Le Corbusier and Mies van der Rohe. It is difficult to imagine gales of laughter sweeping the büro. Nothing that was deemed decorative was allowed out of the drawing office. Follies went backstage. But more recently, in this century with stratospheric wealth being accumulated by the very few, the gulf between 'Us' and 'Them' has widened and the folly is making a tentative return to the footlights. We may not be able to live like 'They' do. But we can still laugh at 'Them'.

Follies have been astonishingly influential as well as misunderstood buildings. The misunderstanding allows us all to define a folly. If you think it's a folly, you can say so. And who will gainsay you?

No one – except perhaps me.

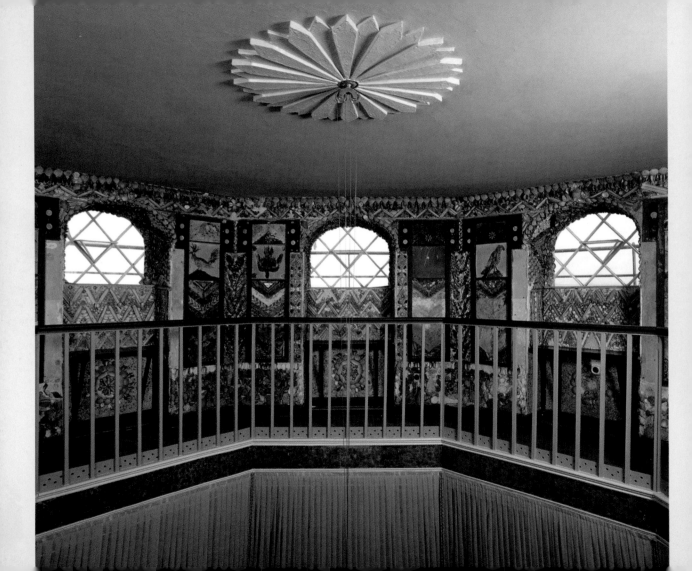

A La
Ronde

Devon

A La Ronde, 1798;
Point-In-View, 1811

The Shell
Gallery

Built by women for women

A La Ronde is said to have been inspired by the church of San Vitale in Ravenna, which Jane and Mary Parminter, cousins twice removed, had visited on their Grand Tour. The near-circular design of the house, which has sixteen walls, allowed them to move round in sunlight all day, from breakfast in the eastern quadrant to the westering sun in the oval room; the fenestration is bizarre, with diamond- and lozenge-shaped windows.

Mary Parminter's will stipulated that only unmarried women could inherit the property, but in 1896 the Greek scholar Reverend Oswald Reichel, another relation, inherited and made substantial changes, replacing the thatched roof with tiles and adding the dormer windows and the ladder climbing up to the catwalk running round the top of the house. However, A La Ronde's most remarkable feature is the interior, where the central room is 10.7m (35ft) high and crowned with a circular gallery of feather- and shellwork, too narrow and dangerous to allow public access. It was never intended for men to see, anyhow. Perhaps this is why the Reverend Reichel built the external catwalk; we have no record of his waist measurement.

The Parminters' most heartfelt desire was to see the conversion of the Jews to Christianity. They built a chapel with more curious windows, naming it Point-in-View, and endowed a school. Provision was made for a schoolmistress, and preference was to be given to a converted Jewess, should one apply. As well as serving as the cousins' mausoleum, Point-in-View still thrives as a United Reform Church. With such indefatigable passion, it is easy to see how they also found time to encrust the interior of A La Ronde with the finest display of coquillage in these islands.

Alderley Edge

Cheshire

Druid's Circle,
19th century

Opposite:
Druid's Circle

Shamhenge

In the eighteenth century the Stanley family of Alderley appropriated common land and enclosed it, as many wealthy families did during the period. Today this act would be unimaginable, but to allow them credit, the Stanleys always permitted public access to the woods along the sandstone escarpment. This 180m (590ft) hill has been a favoured location for 10,000 years; a Neolithic settlement was discovered here. As with most archaeological sites, the visible evidence is disappointing to the untrained eye, so in the late eighteenth century the Stanleys were thought to have enhanced the scene by the addition of a low stone circle.

Buried deep in the woods between the open views at Stormy Point and the Beacon (a stone plinth now overwhelmed by trees), the circle was described in 1810 by William Marriott in his book *A History of the Antiquities of Lyme*. He believed it to be a genuine Neolithic artefact, though the author Alan Garner claims it was actually laid out by his great-great-grandfather Robert Garner, 'because he wanted to get rid of some old stones'. In 1843 Lady Stanley commented that the circle was evidently a sham, which argues that perhaps the Stanleys may not have erected it.

The National Trust was gifted Alderley Edge in 1938. One reason for visiting the place – apart from its obvious natural beauty – is to rediscover Garner's magical children's novels, many of which were set in the area, including *The Weirdstone of Brisingamen*. Above a well on the Edge is a carving of a bearded face with the words 'Drink of this and take thy fill/For the water falls by the wizard's will'. The date and origin of the carving are unknown, although the hand of Robert Garner is again suspected.

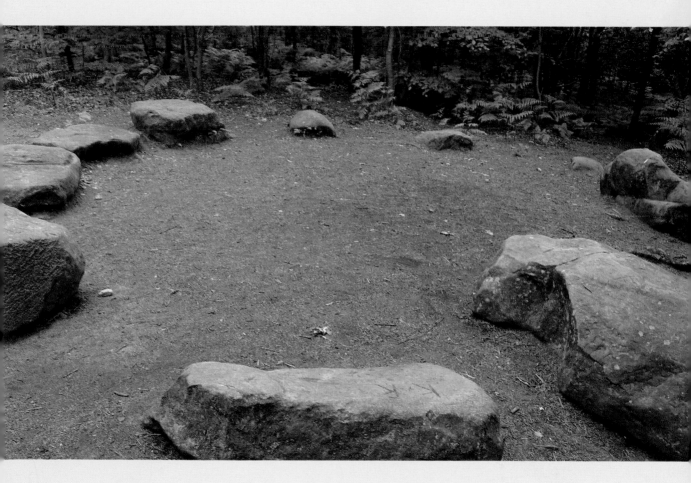

Belton House

Lincolnshire

Bellmount Tower, 1749;
sham ruin, c. 1750

Opposite:
Bellmount Tower

Lord Brownlow's Britches

Belton is a large, exceptionally beautiful Wren-like house built in 1685–88, probably by William Winde, for Sir John Brownlow. The house is full of paintings, many depicting Belton Park's various manifestations; one shows a lime avenue leading to an elegantly proportioned prospect tower. No such elegance exists today, for the spindly arch called Bellmount Tower was shorn of its balancing side arches as a result of a scathing comment by the first Baron Brownlow's brother-in-law, Philip Yorke of Erddig, who thought they should be demolished. Brownlow took him at his word, and the resulting atrocity, looking like a great pair of pants, was nicknamed 'Lord Brownlow's Britches'.

Why such a large building remains so little known is a mystery; there are few mentions of it, yet it appears to have dominated Belton Park for over 250 years. We know it was built between 1749 and 1754 and we can conjecture that it was built as an eye-catcher and prospect tower – beyond that, it must be a folly. After it was damaged by fire in 1841 it went into a steady decline for years, until it was restored by the National Trust in 1989. It is a tall, beastly thin arch surmounted by a Venetian window with two small round windows above, and appears to be purposeless.

Belton has other treasures in the park; there is an orangery designed in 1811 by Sir Jeffry Wyatville, with a surprising cast-iron interior, while in the Wilderness is a splendid eighteenth-century Gothick sham ruin, with a cascade and a footbridge. On Canal Pond there is a temple with an ice-house behind, while on Villa Pond (not accessible) are the remains of a hermitage. Food enough for the folly fancier.

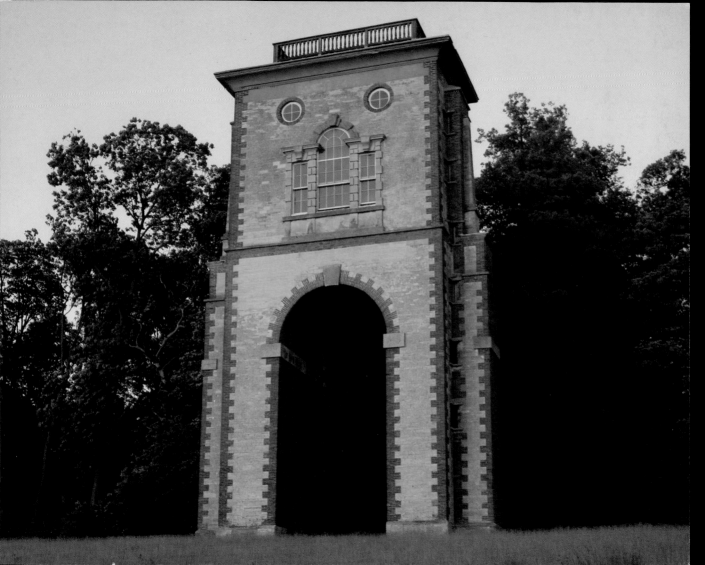

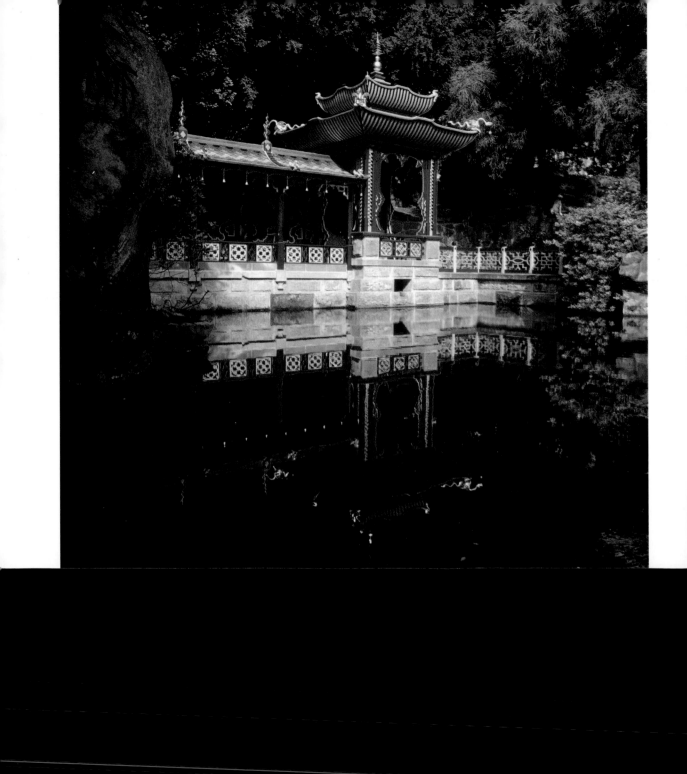

Biddulph Grange Garden

Staffordshire

Garden buildings, 1842

The Chinese
Temple

Past parks and bygone gardens

When places are new and fresh they possess a natural beauty which catches the eye and heart. Given proper care, that beauty does not diminish with time; it simply evolves. Neglect, not years, leads to condemnation, but there is a poignant moment when a bygone garden can still summon all its youthful charm to shine through the mass of rotting undergrowth. The moment is evanescent, and once it is passed the descent into dereliction is steep and rapid.

The two greatest dangers to building conservation are too little or too much money. If the former state prevails, a building will sink into disrepair through lack of maintenance and gradually crumble into ruin; in the latter, improvements are bound to be inflicted on the structure, in some cases obliterating the youthful beauty and exuberance of the original. Nothing preserves a building better than regular low-level maintenance. Binge repairs and sudden makeovers are best avoided.

The dream of James Bateman, Biddulph was created in one sustained burst of energy between 1842 and 1869, and began to decay from the moment Bateman had to sell up. The hospital that owned it was aware it possessed a masterpiece, but did not have the capital for its rebirth. Some desultory maintenance took place, but this remarkable early Victorian garden was slowly, inexorably settling back into the Staffordshire countryside. Its importance was nationally recognised, and when the National Trust took it over in 1988 the conservation world heaved a collective sigh of relief.

But still the nostalgia for the decaying ghost of a half-forgotten garden lingers…

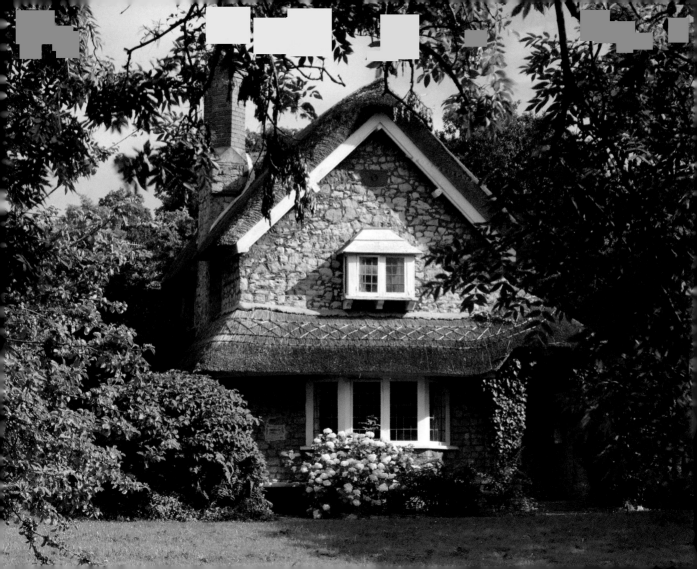

Blaise Hamlet

Bristol

Blaise Hamlet, 1811;
Blaise Castle, 1766;
rustic lodge, c.1830s

A Blaise Hamlet
cottage

Chocolate-box Britain

If you've ever been given a box of chocolates, a Merrie England jigsaw or a calendar of Beautiful Britain you'll recognise Blaise Hamlet. It is the most preposterously picturesque assemblage of cottages in the country; you either love it or hate it.

Blaise Castle was a folly tower bought in 1789 by John S. Harford of Miles & Harford's Bank. In 1796 he had local architect William Paty construct Blaise Castle House, allegedly with the assistance of John Nash. Later in 1810 Harford commissioned Nash, shortly to become the Prince Regent's favourite architect, to build a bank in Bristol's Corn Street and also to create a model village for his retired estate workers. Given that Harford was a Quaker and an abolitionist, his motives for creating Blaise Hamlet were probably as altruistic as they were sentimental.

There are nine houses, endowed with prodigious chimneys, clearly for ornamental effect, set round a pump-cum-sundial on a typically English village green, lacking only a pub and church. Roofs of thatch, stone, slate and pantile cohabit with a promiscuous array of styles and angles to deliver an overall artificiality that is helplessly pleasing. Even the cottage names are quaint: Circular, Diamond, Dial, Double, Dutch, Oak, Vine, Sweetbriar and Rose. None of the front doors face each other – as a deterrent to gossip, it is said.

Blaise Castle House and its folly are owned by Bristol City Council; the National Trust was given the hamlet in 1943. This is not so much a folly, rather an oasis in architectural history. Some say that it anticipates the Garden City concept by 90 years, but in reality it is a fresh interpretation of the almshouse.

Blickling Estate

Norfolk

Pyramid, 1794

Buckingham's razor

The sharpest blade in Britain beheaded Henry VIII's second wife, Anne Boleyn, who still rides down the avenue of her ancestral home at Blickling in Norfolk one night a year, carrying her bleeding head in her lap, in a hearse drawn by headless horsemen. And the sharpest building in Britain is the Pyramid at Blickling – after more than two centuries the cut stone is still keen as a razor, and surely here will be proof of the myth that razor blades are sharpened by placing them inside a pyramid. But we are not permitted inside; that privilege was reserved for John Hobart, 2nd Earl of Buckinghamshire, and his two wives.

The mausoleum was commissioned by Buckinghamshire's daughter Lady Caroline Suffield in 1796–7, and built by Joseph Bonomi, an architect so fashionable that he got a namecheck in a Jane Austen novel. This elegant pyramid pre-dates the Egyptian Revival in Britain by a dozen or more years. On the east side is a doorway with an entablature surmounted by a coat of arms and the family motto *Auctor pretiosa facet*, 'The Giver makes it valuable'. A tablet records that the mausoleum was erected to the memory of John Hobart, Earl of Buckingham (d.1793). The Pyramid was Bonomi's only work at Blickling; the Buckinghamshires seemed to have used local architect Thomas Ivory for other buildings in the grounds.

You might be lucky enough to come across Anne Boleyn at Blickling; you would be less fortunate to encounter her father Sir Thomas Boleyn, doomed to ride for a thousand years with his head tucked underneath his arm, flames spitting from his mouth, over twelve local bridges. See him and die, they say, which poses the question of who lived to tell the tale. Why do we see so few headless horsemen nowadays?

Opposite:
The Earl of
Buckingham's
mausoleum

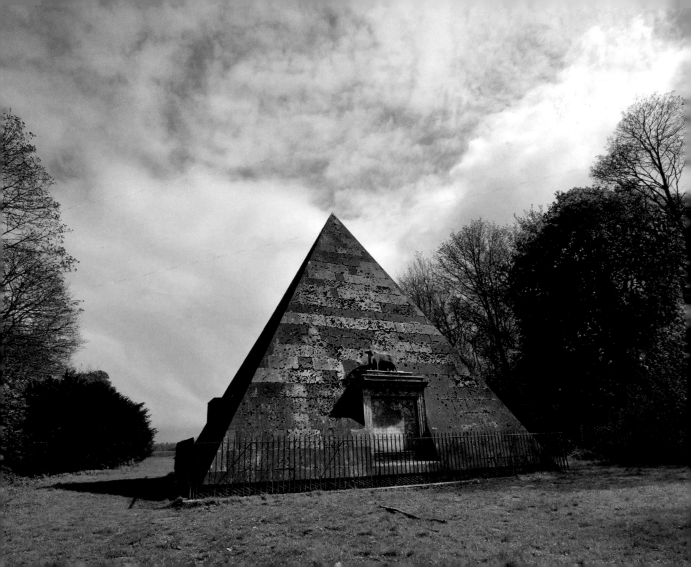

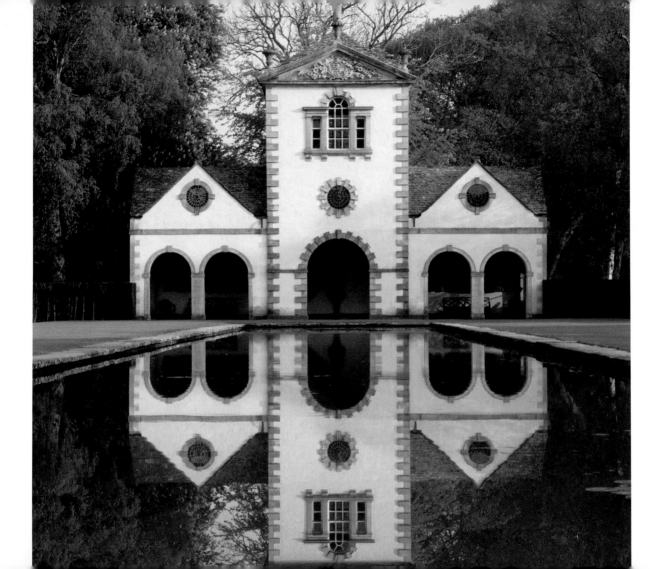

**Bodnant
Garden**

Conwy, Wales

Pin Mill, 1720 / 1938

The Pin Mill

Pins and needles

Bodnant ('buzzard valley' in Welsh) is the home of Wales's most upmarket garden centre, luxuriating in the fame of the surrounding gardens. To the surprise of some, the gardens pre-dated the garden centre; they were created by Sir Charles McLaren, a Scottish barrister who became the first Baron Aberconway, in the first half of the twentieth century.

One of the chief glories of the garden is the Laburnum Arch, a cascade of pendant sunlight and the finest laburnum in captivity, forming a dense tunnel 55m (180ft) long. The other glory captured here in this serene enclave is an elderly retired factory building said to be a pin mill – but a pin mill of such exceptional beauty that one has to question its authenticity. Pin mills were workshops for the making of needles and pins, and it seems excessive to decorate such a functional structure with its tall central tower with elegant Serlian window, and flanking side pavilions. Perhaps these were the accretions of age. Whatever the reason, the mill now makes a superb garden pavilion.

In an area where everything is roofed in the local grey Welsh slate, the alien red roof comes as a culture shock. But this is indeed an alien building; it came from Frogmarsh Mill in Woodchester, Gloucestershire, where it started life in about 1720 as an ornamental garden building. In 1863 the mill was taken over by a firm of pin manufacturers, Perkins, Critchley & Marmont, who traded there until 1934. The second Lord Aberconway acquired the pavilion in about 1938, presumably in a closing-down sale. So it began as a garden ornament in England, became a factory and finally reverted to being a garden ornament in Wales.

23

Castle Ward

County Down

Castle Ward, 1765;
temple, early 18th century

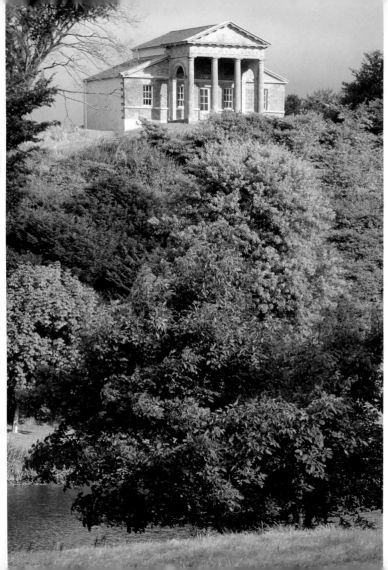

The temple

A grand garden building

Castle Ward's west front is a restrained and tasteful essay in Ionic classicism. Go round to the east front and one might be looking at a completely different building. Here stands a Gothick pile, as different an architectural style as could be conceived in the mid-eighteenth century, although the two facades share identical seven-bayed fenestration. Bernard Ward, 1st Viscount of Bangor (1719–81), chose the conventional classical vocabulary, while his wife Anne, 'a whimsical and imperious personality', preferred the then radically fashionable Strawberry Hill Gothick. Such contrasting styles echoed contrasting temperaments, and the couple divorced in 1766, shortly after the house was completed.

The architecture of Castle Ward is more folly-like than the classical temple in the grounds. This is a grand garden building, with a Doric tetrastyle portico flanked by half-pedimented wings. What sets it apart from the other garden buildings is its spectacular situation.

Bess of Hardwick and the Duke of Marlborough used genuine ruins as adornments to their landscapes, emphasising the antiquity of their lineage. The nouveaux riche of the eighteenth century could boast no crumbling ruins, so they set about constructing their own. Here at Castle Ward, Anne was fortunate to have the derelict fifteenth-century Audley's Castle to use as an eye-catcher when she laid out the park from 1710 to 1759. This was a transitional period in landscape gardening, when the formal canal of traditional garden design confronted the past in the shape of the ruined castle to provide a foretaste of the Romantick.

Claremont Landscape Garden

Surrey

Belvedere, 1717;
Garden buildings,
18th–19th century

Opposite:
The Belvedere

Author, architect, soldier, spy

Thirty years ago the lowering, threatening Claremont Belvedere was hidden in a thick wood, invisible beyond about 20m (66ft) away. Today, restored, it is in full proud sight on its hilltop, terminating an allée from the equally splendidly restored Claremont Landscape Garden. The National Trust acquired 20ha (50 acres) in 1949, and over the years has gradually uncovered a series of eighteenth-century treasures: a 1.2ha (3 acre) turf amphitheatre by Charles Bridgeman, a grotto, statues, a dovecote and a bowling alley. In 1735 William Kent designed a serpentine lake with a pavilion on a naturalistic island. The National Trust has done its usual impeccable re-creation of the park, which had virtually vanished, but its central focus, the Belvedere, is in separate ownership with limited access.

Claremont's lineage reads like a eighteenth-century copy of *Tatler* magazine. Sir John Vanbrugh, a famous soldier and spy who became a renowned playwright and then the most fashionable architect of the day, created an estate which he sold to 'Hubble Bubble' Pelham-Holles, Duke of Newcastle and later Prime Minister, who sold it to Clive of India, who sold it to the state, purchased as a wedding present for George IV's daughter Princess Charlotte and Prince Leopold of Saxe-Coburg-Saalfeld (later King of Belgium). Queen Victoria later bought it for her son Leopold, Duke of Albany, but when the Duchess of Albany died in 1922 the government confiscated the estate, otherwise it would have passed to her son the Duke of Saxe-Coburg, a German citizen. Instead it came under the obliterating, unseeing eye of the Forestry Commission. Part of it became a girls' school in 1931.

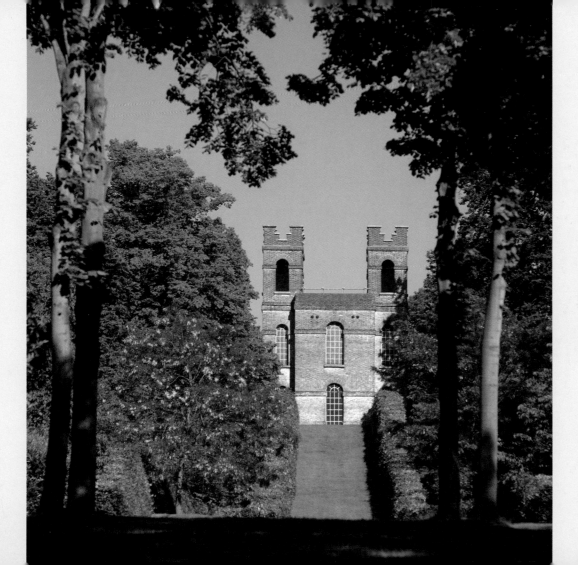

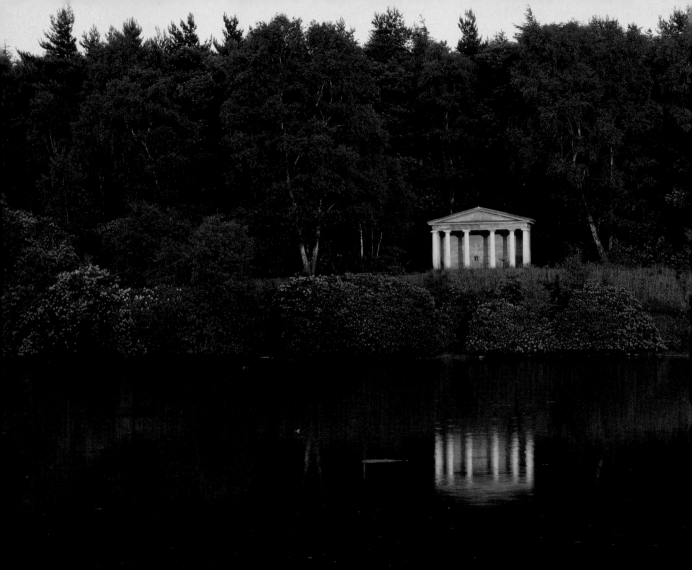

Clumber Park
Nottinghamshire

Temples, 1765

The Greek
Temple

Haunt of the hawfinch

There used to be so many aristocrats living in this now overlooked region of England that in mocking homage to the Staffordshire Potteries the area was known as the Dukeries. Today dukes and other relics of high society are as hard to spot as the reclusive hawfinch – Clumber Park being one of the few places in Britain where it can still be seen.

Here the duke in question was Henry Clinton, the 2nd Duke of Newcastle, who employed Stephen Wright, a former assistant of the architect William Kent, to create and build not only his grand mansion but also, following the taste of the time, two classical temples in the grounds, on the north and south banks of the serpentine lake, built c.1765.

A great lime tree avenue, 3.2km (2 miles) long, dates from the 1830s, when the garden architect W.S. Gilpin worked at Clumber. The park that survives today has a heavy, ordered Victorian atmosphere, with a rather wonderful 1889 chapel by G.F. Bodley and outbuildings and garden seats surrounding a great lacuna. It seems most strange to arrive at Clumber through the imposing lodge entrance at Apleyhead, promising a palace of staggering magnificence within, to find – nothing. The house is long gone, demolished in 1938. Although it had been partly rebuilt, it never fully recovered from a disastrous fire in 1879. All that remains is the Duke's study.

But the temples survive, as we must hope do the hawfinches. Let's hope the National Trust plant some cherry trees at Clumber – it takes 40kg (88lb) of pressure to crack a cherry stone, but the little hawfinch can do it with its bill.

Cotehele

Cornwall

Prospect Tower, 1789

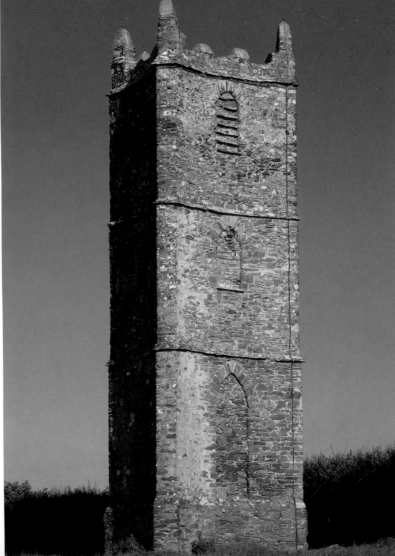

The Prospect
Tower

Triangularity

From almost every angle this looks like a church tower that has simply escaped from its church, conventional in most aspects – until it shyly reveals its triangularity. Most three-sided buildings exult in their rarity, but here it is unassuming; it passes for normal.

Why has this tower been built with three sides? Only the patron, builder or architect can answer the question with authority, and in their absence we have to devise our own understanding – which is why follies are so often misunderstood. Even when the reason for a building is recorded, local memories can easily be changed when a more suitable or amusing story comes along. Thus it is that we can be told that this excellent tower was built so that servants could signal the movements of Lord and Lady Mount-Edgcumbe between their houses at Cotehele and Maker, when a more likely explanation appears in Fanny Burney's diary: the Edgcumbes were excited by a possible royal visit. King George III and Queen Charlotte actually came to Cotehele in August 1789, and it was long thought the tower may have been built to celebrate that. However, the family acquired a barony in 1742, a viscountcy in 1781 and finally an earldom in 1789, and it is reasonable to propose that it was actually built to commemorate their elevation. The Edgecumbes owned Cotehele for nearly 600 years, and although they moved to Plymouth in the seventeenth century and further afield to New Zealand in the nineteenth, they retained their manor until 1947, when they gave it to the National Trust.

The tower is built of random grey stone, each face elegantly concave. Along with Montacute and Paxton's Tower, this is another of those few folly towers that we are permitted to climb.

Crom Estate

County Fermanagh

Crichton Tower, 1848;
castle ruin, 1829

Opposite:
Crichton's Folly

Circularity

Crom Castle is still the private residence of the Earls of Erne, but the 769ha (1,900 acre) Fermanagh estate has been in the care of the National Trust since 1987. In old Irish the word *crom* meant 'bent', and it describes the way the plantation nestles in a crook of Lough Erne, the second longest waterway in Ireland after the River Shannon. On Gad Island, a half-submerged rock at the heart of the demesne, John Creighton, the 3rd Earl of Erne, contributed yet another round tower to Ireland's wealth of them – Devenish, another island in Lough Erne, has perhaps the finest in the country. The squatter-looking Crichton's Folly (the family changed the spelling of their name in 1872) had a purpose: as an observation tower to watch boat races in the lough, and also to relieve famine – this was 100 years before the welfare state, and in those days the concept of paying people without getting work in return would have been incomprehensible to both worker and master.

The Creighton/Crichton family seat was an ancient castle built in 1610 by a Scottish planter, Michael Balfour, on the shores of the lough. In 1655 it was acquired by the Creightons, withstood Jacobite sieges in 1689, then burned down in 1764, watched by the 1st Lord Erne. It was never restored, and the Creightons abandoned the estate. They returned in 1829, when the 3rd Earl Erne called in Edward Blore and W.S. Gilpin to build him a new castle and park. Blore added sham ruined walls and towers to the old castle to leave it as a mighty garden ornament, there being nothing better than a ruin to enhance a park and a pedigree. In 1841 Blore's new castle also burned down, and was rebuilt by a Dublin architect, George Sudden.

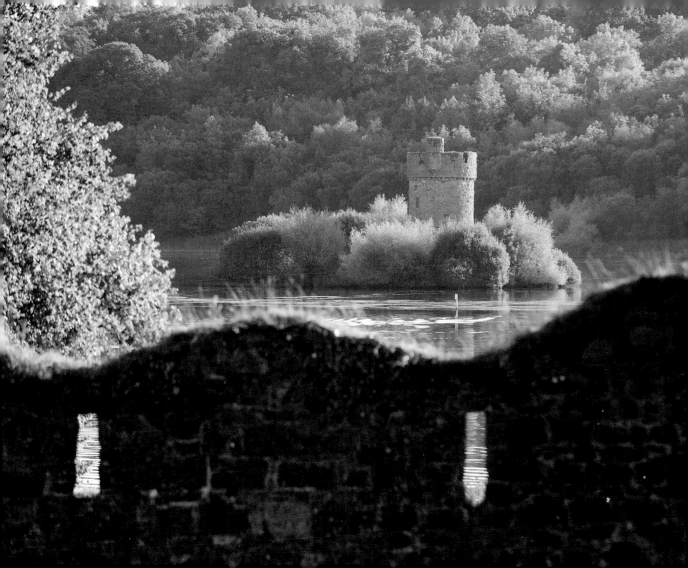

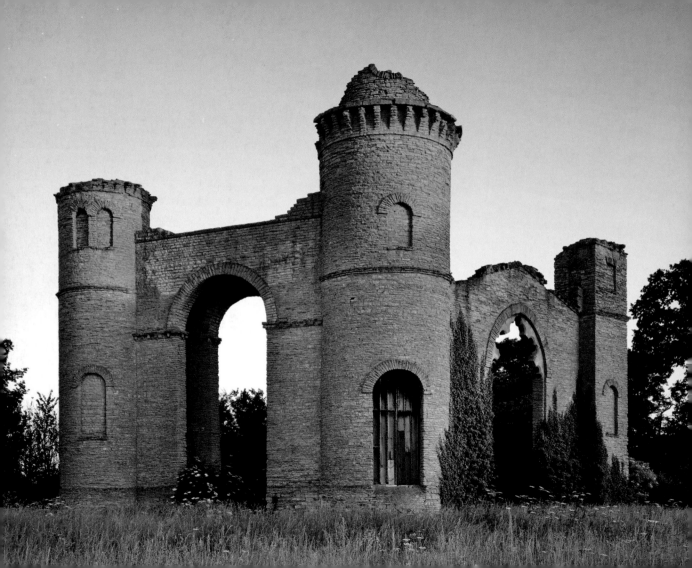

Croome Park
Worcestershire

Garden buildings,
1760s and later

Dunstall Castle

Motorway madness

The M5 motorway is driven like a dagger through the heart of one of England's great estate parks, created for the Earl of Coventry by the most famous landscape architect of all, 'Capability' Brown. From any point in either half of the grounds, the noise of traffic whines perpetually through the countryside. The National Trust has now acquired the lease on the great house, the inspiration of Sanderson Miller and the creation of Brown, and work sturdily continues in the grounds, where the Trust has a ten-year plan for the restoration of the park to its eighteenth-century appearance – if it is possible to ignore the motorway in the middle. On Cub Moor in the western half of the estate stands Robert Adam's 1766 Panorama Tower, surmounting a low-rising hill. The eminent architectural historian Howard Colvin disputes the attribution to Robert Adam, preferring to credit it to James Wyatt in 1801. In the eastern half, the most outstanding building is Adam's Orangery, the detail of the cornucopia carving on the pediment still clear after 200 years.

Plenty of other garden buildings remain at Croome Park. They include the sophisticated Rotunda, dating from Adam's time, the slender Corinthian Island Summerhouse, the Alcove Seat by Adam, the Nymphaeum and the mighty sham castle dating from *c.*1766 at Dunstall Common, some 5km (3 miles) away. James Wyatt was consulted by the 6th Earl from 1794 to 1801, and from that period came the Dry Bridge of 1797 and the Gothick Ruin in the Old Park by Pirton Court, visible from the motorway. Wyatt's most notable contribution to Croome is nowhere near the estate – it's the triangular Tower at Broadway, 24km (15 miles) away as the rook flies, built in 1799 for the Countess of Coventry to flaunt her wealth.

Downhill Estate
County Londonderry

Mussenden Temple,
Bishop's Gate, Hervey
Cenotaph, Lady Erne's Seat,
Lion Gate, all 18th century

Opposite:
Mussenden
Temple

A raw, dramatic setting

Downhill, houseless, treeless, combines sublimity and austerity. The old entrance to the estate was through the Bishop's Gate, an elegant essay in mingling classic with Gothic, two contrasting architectural disciplines. This strange alliance would deserve more attention were it not for the nearby Mussenden Temple, probably the most beautiful building in Northern Ireland, in its raw, dramatic setting on the edge of a cliff. Commissioned by Frederick Hervey, Bishop of Derry and 4th Earl of Bristol, and built by the Cork architect Michael Shanahan, it was dedicated to Frideswide Bruce, a 22-year-old friend of the 52-year-old bishop. Frideswide had become Mrs Daniel Mussenden a year before she met the Bishop in 1782. It was clearly a sudden and intense friendship; the same year he was accused in a letter of being more to Mrs Mussenden 'than was consistent with his rôle of a "Bon Papa"'. She died the following year.

Like the Mussenden Temple, Lady Erne's Seat is circular and as it has no roof one might be tempted to regard it as unfinished – but it is complete as it stands. A castellated drum with six arched openings, its roughness has more of the folly about it than the sophisticated Mussenden Temple. Not far away is the Hervey Cenotaph, erected to the memory of the Earl-Bishop's brother George, who appointed Frederick to the Bishopric of Derry before dying young and thus enabling him to inherit the earldom as well – reasons enough to build a splendid memorial, designed by Sir John Soane but adapted and erected by Shanahan.

This is a panoramic estate, in the way that a sweeping view of nothing much becomes a vista. Downhill is bleak, windy, cold, even more rigorous in winter – and simply unforgettable.

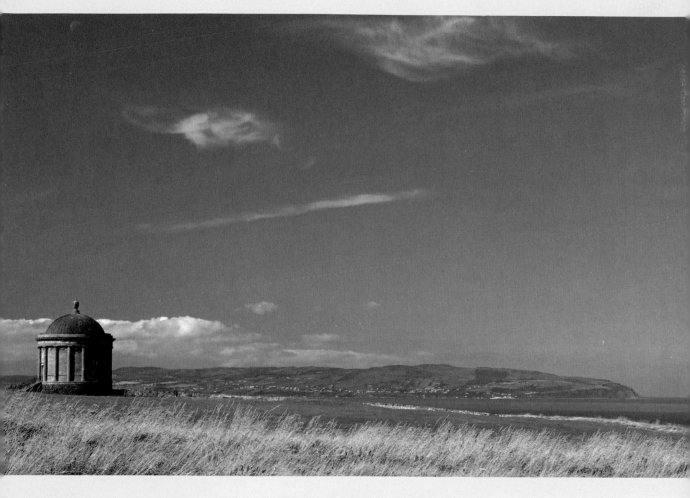

Dunster Castle

Somerset

Conygar Tower, 1775;
folly arch, 1775

A hilltop folly

When visiting Dunster it is possible to overlook entirely the ancient castle of the Luttrells, artfully concealed as it is, but the Conygar Tower, designed as an eye-catcher, admirably fulfils its purpose. Eye-catchers are supposed to pique curiosity a little way, but not too far; they are not meant to stand up under close examination. So inevitably we have to examine it closely, and after an energetic climb we discover what we knew all along; only a fool or a folly fanatic would bother to get any closer. What remains is a three-storey hollow shell, a structure to remark on from a distance.

Perched on the end of the escarpment where the ground falls steeply away towards the coast, the short tower must have been used as a destination, the end of a walk or drive – but the ascent is so steep, it must have been a challenge. That doesn't make sense. Access surely must have been easier; it was considered undignified for eighteenth-century ladies of quality to scramble up hillsides. And then discovery is made: the ghost of an avenue runs west along the ridge until it abruptly terminates in a wistfully beautiful sham ruined gateway with two standing arches, elaborate curtain walling, circular bastions, mantled in ivy and elegant in its forgotten decay.

The Luttrell family have been the lords of this corner of England since Sir Geoffrey allied himself with King John in 1215. They have given us a lasting monument in Dunster itself. Being an estate village, its development has been carefully controlled and monitored with an eye for beauty; the Yarn Market, a picturesquely gabled octagonal covered market hall, stands in the centre of the high street, loved by locals and tourists alike.

Opposite:
Conygar Tower

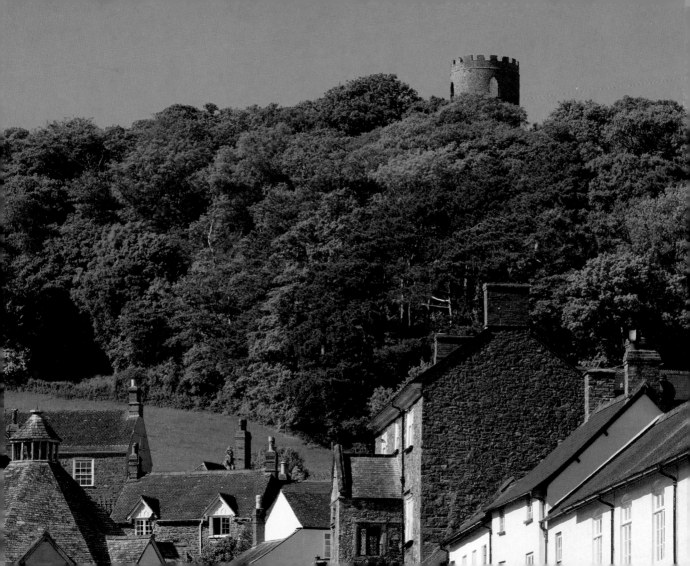

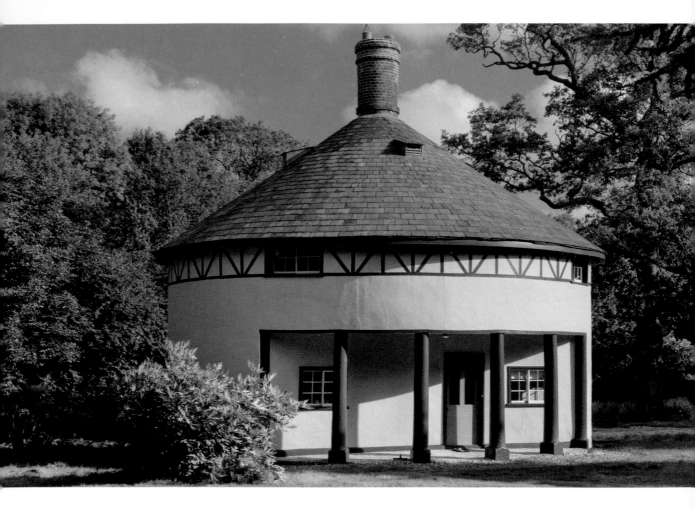

Ickworth

Suffolk

Obelisk, 1804; The Round
House, 19th century

The Round
House

Eccentric circles

There are a surprising number of round houses in Britain, and the largest and stateliest is Ickworth, the creation of a remarkable man who features elsewhere in these pages, with another, earlier circular building. Frederick Hervey may have been one of the most fortunate men of his time. The third grandson of a politician, he was destined for holy orders and a quiet living in some rural parish, but through a succession of fortunate (for him) deaths and preferments he became an earl, a bishop and a millionaire – not just an everyday millionaire, but one of the richest men in Britain.

What has never been satisfactorily explained is the Earl-Bishop's passion for building circular structures (also apparent at Downhill – see page 36), though to be precise Ickworth is ovoid. Although there is a gigantic obelisk praising the feats of Frederick, Earl of Bristol and Bishop of Derry, the actual folly here is the house. The only other interesting building on the estate is, unsurprisingly, called the Round House. This is a private, half-timbered house with a conical roof and central chimney. When the Earl-Bishop died on a lonely Italian road in July 1803 the great house had still not been completed, having been begun in 1796 by the Irish architect Francis Sandys from a design by Mario Asprucci.

Frederick's obelisk bears the inscription: '… endeared himself to all denominations of Christians resident in that extensive diocese. He was the friend and protector of them all … and hostile sects which had long entertained feelings of deep animosity towards each other were gradually softened and reconciled by his influence and example.' The sad circumstances of his death came about because a Catholic Italian hotelier would not allow a Protestant to die on his property.

Kedleston Hall

Derbyshire

Gothick Temple, 1758;
Fishing Pavilion, 1760–70

Opposite: The
Fishing Pavilion

A most superior person

In the days when local landowners could tear down and relocate villages on a whim, the Curzons swept away Kedleston village and left the old church tower standing as an eye-catcher, in obeisance to their temporal powers. In an age when snobbery was *de facto*, a mocking doggerel verse from the 1870s indicated the blistering poshness of the family:

> My name is George Nathaniel Curzon
> I am a most superior person.
> My face is pink, my hair is sleek,
> I dine at Blenheim once a week.

Kedleston is as warm as a cold shoulder. Even the fishing pavilion faces north, so angling ladies would be shielded from the pitiless Derbyshire sunshine. Robert Adam built it in 1771. The ladies could be rowed to the pavilion, where the main two-storey block is flanked by two single-storey rusticated boathouses with shallow pediments; they could cast their lines from the Serlian window in the banqueting room on the first floor. From the land entrance on the south side, the entrance is an arch framed by Doric pilasters with two carved roundels above, decorated with sea horses.

The prettiest building on the estate is the Gothick Temple, built by Adam in 1758 for Sir Nathaniel Curzon, a politician who was created 1st Lord Scarsdale in 1760. Adam's draughtsman George Richardson designed the orangery and the hexagonal domed summer-house. There is also a small circular hermitage, now roofless. What the Curzons may have lacked in warmth they certainly made up for in both taste and acumen.

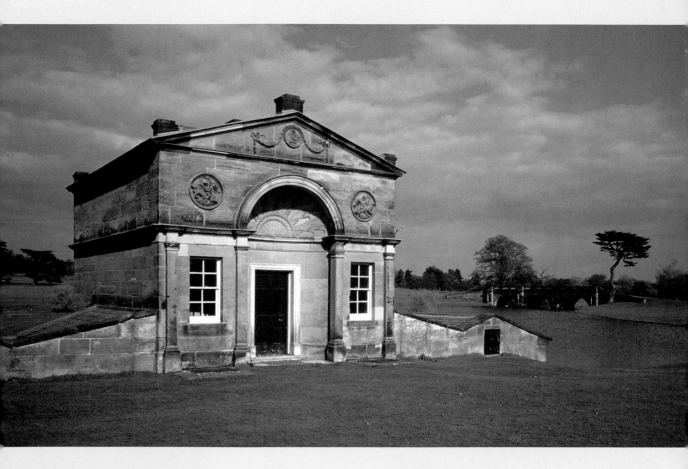

Killerton

Devon

Hermit's Hut or Bear's
Hut, 1808/1831

Bare necessities

You will go to Killerton to see the famous arboretum, the costume
collection or the superb gardens before any of the buildings. The main
house was only intended as a temporary measure until James Wyatt
completed the palace on the hill, but somehow they never got around to
it, and the pleasant, unpretentious boxy villa that sits almost
apologetically in the huge estate demonstrates that the Acland family
generally preferred horticulture to architecture. So the surprise when
Sir Thomas Acland presented his wife with this picturesque thatched
cottage for housing a hermit must have been so much the greater,
particularly since the fashion for keeping hermits had passed away some
50 years earlier. The hut is depicted in drawings by John Gendall of
Exeter dated 1831, so was presumably built before that time. Now known
as the Bear's Hut, it is a rustic cabin with a hipped roof and lancet
windows, one of which, set in a mighty tree-trunk, is made up from
recovered fragments of stained glass.

The hut is divided into three rooms, one with a floor made from deer
knuckles and roofed in deerskin, the next decorated with pine cones,
lined and roofed with matting with the floor inlaid with sections of tree-
trunks, and the last has a cobbled floor, with wicker walls and ceiling.
Fashions change even in rural Devon, and eventually it seemed more
logical to keep a bear in the hut as hermits were becoming very scarce,
and as one of the Aclands had managed to come back from Canada with
a black bear, the hermit's hut was converted into the bear's hut. However
bears, like hermits, soon lose their early novelty, and the poor creature
eventually ended up in London Zoo.

Opposite: The
Bear's Hut

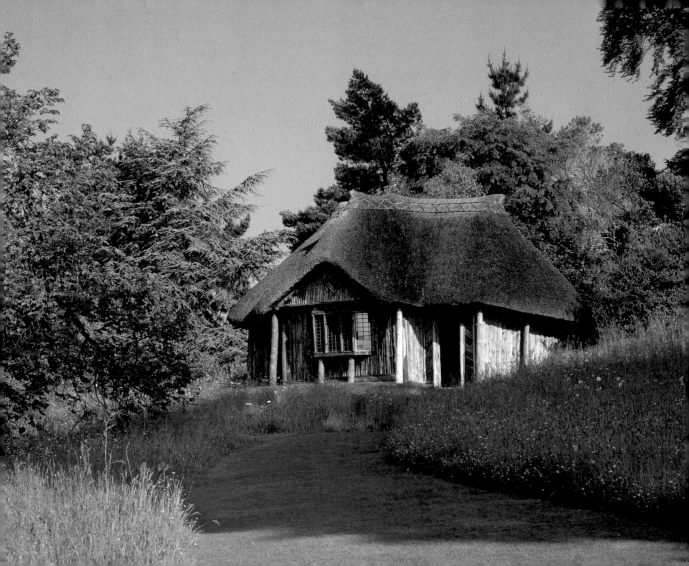

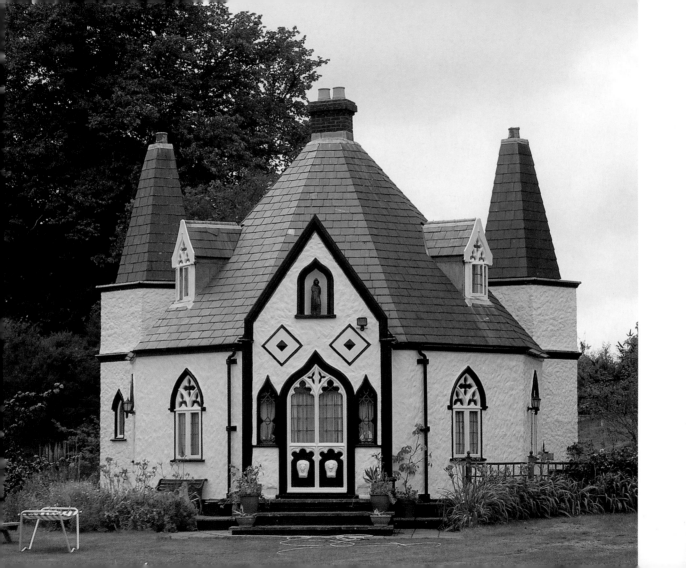

Knole

Kent

Birdhouse and
sham ruin, 1761

The Birdhouse

Lady Amherst's pheasants

Said to be the largest private house in England, Knole was created in the fifteenth century by Thomas Bourchier, Archbishop of Canterbury, then confiscated by Henry VIII and later given by Elizabeth I to her cousin Thomas Sackville, since when it has been continuously occupied by the Sackvilles. Sometimes described as the Calendar House, Knole is said to have seven courtyards, 52 staircases and 365 rooms. It would be sad to discover the house actually had only 360 rooms and 49 staircases, but sadder still the person who embarked on such a quest. Part of the house is still a family home, so not all rooms are open to the public.

In the 405ha (1,000 acre) park is an ornamental octagonal 1761 Gothick building, now a privately tenanted cottage. The jolly little black, white and grey Birdhouse has a conical slate roof with a central chimney and supporting towers at each side, with a projecting gabled porch. The entrance door is an ogee arch, above which are two diamond patterns and a statue in the apex of the gable. For those who dismiss Gothic architecture as heavy, solemn and overbearing, this is the perfect antidote; it is light, frothy and gay, in the old-fashioned sense of the word. Nearby is a sham ruin built around the same time, with stone taken from the ruins of the Archbishop's Palace at Otford, 5km (3 miles) away.

It was at the Birdhouse that William Pitt Amherst, who had been Ambassador Extraordinary to China, is said to have kept the exotic pheasants which now bear his wife's name. Long before the rise of MTV the Birdhouse also achieved some reflected glory by being the location for one of the first music videos: the Beatles' video of 'Strawberry Fields Forever' in 1967.

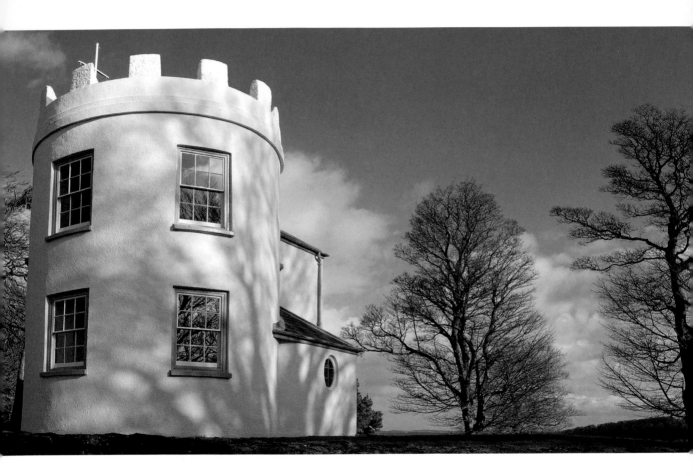

The Kymin

Monmouthshire

The Roundhouse, 1794;
Naval Temple, 1800

The
Roundhouse

Built for the view

The view from this 3.5ha (8½ acre) hilltop is quite spectacular, although the hill is less than 250m (820ft) high. A higher hill would have afforded a vista; this is a proper view, an intimate flight over orderly fields and neat little houses. In the late eighteenth century Philip Hardwick's Monmouth dining club used to meet up here on summer evenings to enjoy a cold collation and drink in the view, and much else besides. This proved so enjoyable that a subscription was raised to build a permanent circular dining room, castellated, naturally, against predators, and provided with windows to frame the view all around. Four years later a small temple with a stepped stone roof surmounted by a Soanian arch and topped with a figure of Britannia was built to celebrate Britain's national heroes, who at that time were sailors.

Imagine the excitement when the greatest of those heroes, Admiral Nelson, arrived at Monmouth in 1802. He was genuinely impressed, as he returned three weeks later to breakfast at The Roundhouse and to comment favourably upon the view. Even seen through one eye it is remarkable; it is among the prettiest in Britain. Charles Heath, an enterprising Monmouth man, wrote a booklet economically titled 'Descriptive Account of the kymin pavilion and beaulieu grove, with their various views: also, the naval temple, with new notices of buckstone, a supposed druidical relique, near it: to which is added, lord nelson's visit to monmouth, his speeches and conversation at the dinner table, his own remarks on his important victories, with his public reception at rudhall, hereford, and other places, on his tour.' The chapbook gives details of the view from each window of The Roundhouse.

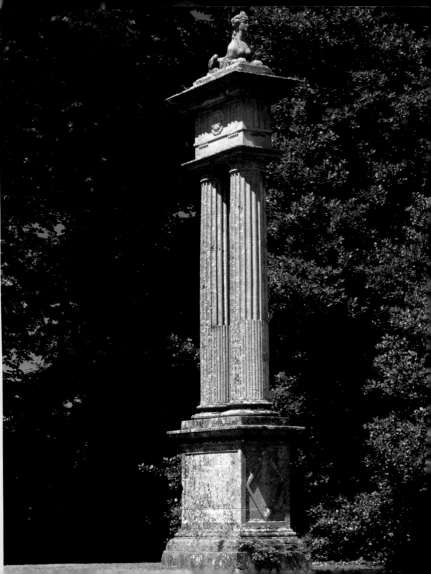

Lacock Abbey

Wiltshire

Columns, Gothick
Gateway, 1754–5

The Lacock
Abbey columns

Columns or chimneys?

Lacock Abbey was founded in 1232 as an Augustinian nunnery by Ella, Countess of Salisbury, who ended her days there 'having outlived her understanding', as John Aubrey so gracefully described the condition we now call Alzheimer's disease. Such a romantic building in such a romantic setting demands a suitably romantic legend – and fortunately there is one, even laced with a suitably English touch of slapstick. John Talbot, younger brother of the Earl of Shrewsbury, fell in love with Olave Sharington of Lacock, but her father, Sir Henry Sharington, refused his consent. Like Romeo, young Talbot wooed his lady from under her window, but the would-be Juliet leaped and landed squarely on top of her swain, knocking him out. Talbot was borne into the Abbey and after quite some time he eventually recovered. Sir Henry told Olave that 'since she had made such a leap she should e'en marrie him', so Talbot was granted her hand and, with it, the Abbey.

The Tuscan Doric columns on a pedestal in front of the Abbey were once a pair of chimneys, taken down when the new Great Hall was built by the doyen of eighteenth-century folly architecture, Sanderson Miller, in 1755. The creature on top of the columns is a sphinx, carved by the mason Benjamin Carter. The Lacock columns narrowly missed iconographic fame in 1835 when the then owner William Henry Fox Talbot chose to photograph one of the new oriel windows he had recently installed in the Abbey instead, creating in the process the first photographic negative. In 1841 he photographed the rose garden, and this ancient image enabled the National Trust to re-create it in the 1990s.

Leith Hill

Surrey

Leith Hill Tower, 1765

The world turned upside down

In 1765 Richard Hull of Leith Hill Place sought permission from John Evelyn of Wotton Hall, the Lord of the Manor and owner of the land, to build a 'Prospect House' on the top of the highest point in southern England, the 294m (965ft) Leith Hill. Hull enjoyed his tower for seven years before he died in 1772. Without his love and protection, the tower fell victim to the depredation of vandals. In 1796 William Perrin, the subsequent owner of Leith Hill Place, carried out some repairs, but eventually the door and windows were bricked up and the shaft was filled with concrete and rubble.

Many years later, in 1864, William Evelyn of Wotton Hall decided the building should once again serve as a prospect tower. The aggregate inside proved too difficult to remove, so an external stair turret was built and picturesque battlements were added. At the top of the tower, bronze topographs were installed in 1929 to point out distances to major landmarks, and prospect glasses were provided to take in the view.

Over the years an unshakeable rumour sprang up that Hull was buried head downwards at the bottom of the tower, so that when the world was to be turned upside down on the great day of judgement, he would be left standing on his feet. It was one of the stories that had passed into folly lore and lodged there – until in 1984 the National Trust finally managed to clear out the rubble in the trunk of the tower, and at the bottom they shone a torch around three beautifully pointed walls to find Hull's tomb, with Hull himself inside, a very tall man laid flat on his back as tradition demanded, arms crossed. He's still there, directly underneath the National Trust tea room.

Opposite:
Leith Hill Tower

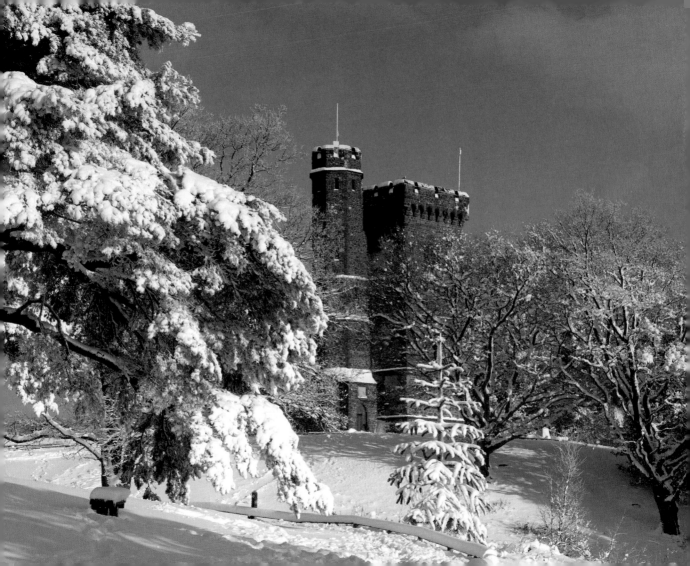

Lyme Park

Cheshire

Lyme Cage, 1580/1737;
The Lantern, *c.*1580/*c.*1700

Opposite:
Lyme Cage

The big cage

Lyme Cage is one of the most menacing, threatening buildings in the National Trust catalogue. Although it hovers on the outskirts of a sprawling conurbation, it seems eerily detached from the environment. Any large, solitary building invokes curiosity, and the Lyme Cage rejoices in our definition of a folly as a misunderstood building. What was it for? It looks ill at ease in the soft northern sunlight, like a werewolf in a shopping centre. Much better to be seen under roiling black clouds, lit only by frequent flares of lightning.

The Cage dates from 1580, seemingly built for pleasure as a hunting tower: to allow ladies, the aged and the infirm (grouped as equals in those days) to follow the pleasures of the hunt. The Cage appellation is said to have come from its sometime use as a lock-up for poachers on the Legh estates; penitential architecture indeed. Around 1730 it was Palladianised by Giacomo Leoni, who added the four corner towers, and if this was intended to beautify the late-medieval structure it cannot be said to have been a success. In 1891 John Haig, the head shepherd for the Leghs, lived there with his family, but the structure has been abandoned for years. It suffered some damage at the end of the Second World War in 1945 – not from Nazis but from 12-year-old local girls – but otherwise has turned its back on history. Today the Cage crouches malevolently on its ridge, its purpose either forgotten or illegal, snarling at the world. The National Trust has carried out recent restoration work, but its future use, other than that of a folly and a wonderful statement in the landscape, remains uncertain.

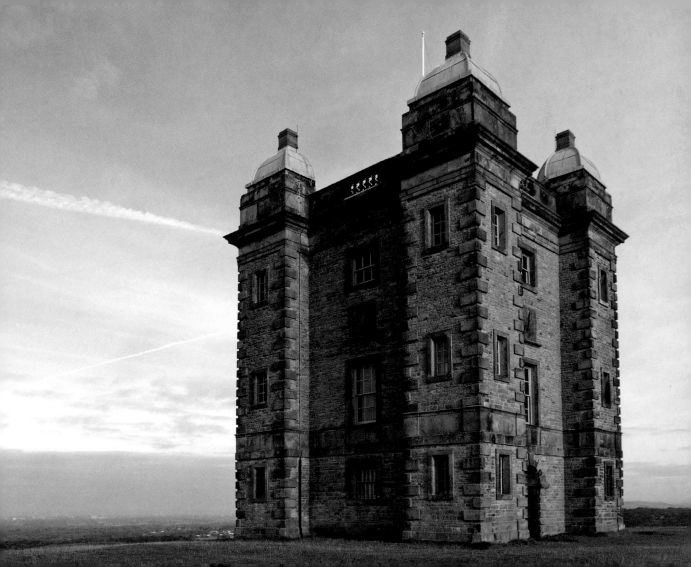

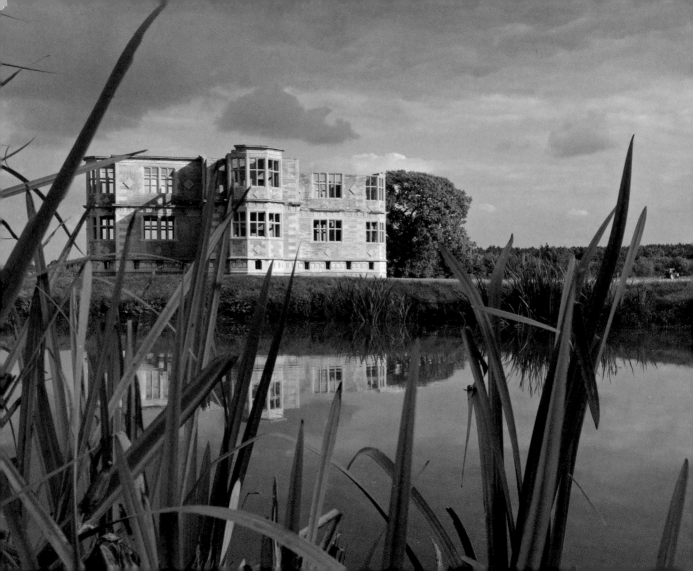

**Lyveden
New Bield**

Northamptonshire

Unfinished house, 1605

Lyveden New
Bield

Not ruined, simply unfinished

Without doubt this is the most romantic and passionate building in the National Trust's cabinet of curiosities. It is not a ruin, as it may appear at first glance – but no eye could be content with a mere glance at such a heartbreakingly beautiful object in the landscape. Part of its glory is of course its situation. Lyveden New Bield is hidden beyond the crest of a hill, far away from any road, serene in the quiet English landscape. It was not born of serenity, however; it represents the obsession of a committed Christian.

The construction of Lyveden began in 1595 and stopped when the builder, Sir Thomas Tresham, died in 1605. Tresham was a recusant, a Catholic who refused to convert to Protestantism. When he was not in jail for his beliefs, he committed them to stone. The Bield is symbolical of the Passion and the Mater Dolorosa, and layer after layer of inscriptions and emblems of the Passion confirm this. The numerology is based on 3, 5, 7 and 9. Each bay window is five-sided and 5ft long, each wing has a frieze inscription of 81 letters (9 × 9; 3 × 3 × 3 × 3), and the perimeter of each wing measures 81ft. To give the measurement in metres would be invidious. The numbers three and nine signify the Trinity. Five is for the Five Wounds on the hands, feet and side of Christ, seven represents the Seven Sorrows of Our Lady, the Seven Instruments of the Passion, the Seven Stations of the Cross, the Seven Last Words of Christ, the Seven Gifts of the Holy Ghost. Few churches can compare with this building for religious fervour, a testament of faith in stone.

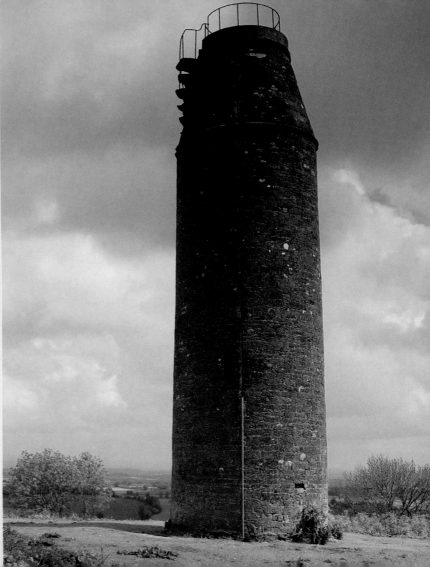

Montacute House

Somerset

St Michael's Tower, 1760

St Michael's
Tower

Steep mount

The round St Michael's Tower at Montacute was built out of Hamstone as a belvedere by the Phelips family in 1760 on the actual Montacute – *Mons acutus* is the Latin for 'pointed hill', while the Greek inscription above the door means 'look out'. 'Look out' as in 'belvedere', not as in 'beware', of course. Like most follies, this one actually had a function: for years it was used as a signal tower. We tend to forget that the speed of overland communication used to be no faster than a horse could gallop. Signal towers provided communication at the speed of light, and St Michael's Tower was used to transmit messages to the Phelips's relative Swayne Harbin near Yeovil.

The tower is said to have been joined by a secret tunnel to Montacute House, but scholarly opinion now believes this to be hogwash. The house itself is a little north of the tower, and it is one of the classic English country houses, a many-windowed late-Elizabethan Renaissance trophy house. Sir Edward Phelips built Montacute in the 1590s and the family decided to sell it for scrap in 1931. It was rescued by Ernest Cook, grandson of travel agent Thomas, and he gave it to the National Trust. The strange fins on the top of the tower that used to puzzle visitors have finally been restored and their purpose revealed as external stair treads to a platform on the roof – with absolutely no guard rails. Perhaps 'Beware' would have been a more accurate inscription over the doorway.

This is one of those rare beasts, a folly tower you are permitted to climb. It's there for the views across South Somerset, of course – every folly has its purpose – and on a good day they are spectacular, considering the tower is only 12m (40ft) high.

Mount Stewart House

County Down

The Temple of
the Winds, 1782

Opposite:
The Temple of
the Winds

Forever young

The Temple of the Winds was built in 1782 for Robert Stewart, later the 1st Marquess Londonderry, by James Stuart, the pioneer of the Greek Revival in architecture, and was based on the first-century BC Tower of the Winds in Athens. It is one of the most perfect small buildings in the National Trust's care: the stonework – local smooth grey Scrabo stone – is exquisite and the workmanship is flawless throughout. On the first floor the exuberant plasterwork of the ceiling echoes the marquetry of the floor, highlighted in local bog fir and bog oak.

A folly is a misunderstood building, but the purpose of the Temple has never been misunderstood; it was built as a banqueting house. However, to Lord Londonderry a banquet almost certainly meant what we would now call pudding, dessert or the sweet course. This was an era where it was not unknown to build a small spare house to retreat to simply while your main house was being swept, so the idea of going for a short walk or ride to take your banquet was perfectly understandable.

A romantic prospect of turrets and towers rises beyond the serene lake at Mount Stewart, glimpsed among exotic shrubs and graceful trees. They speak of a plaintive nostalgia for a half-remembered land of eternal sunshine and youth. This is precisely the sentimental effect that Lady Londonderry wished to achieve when she created Tir nan Og in 1926, named for the fabulous Gaelic Land of the Forever Young, an earthly paradise beyond the setting sun. Tir nan Og is a walled garden of remembrance, flanked by two low towers set high on the hill, giving the appearance of distant height. It is a private burial ground, but one can walk around it and peer through the iron gate.

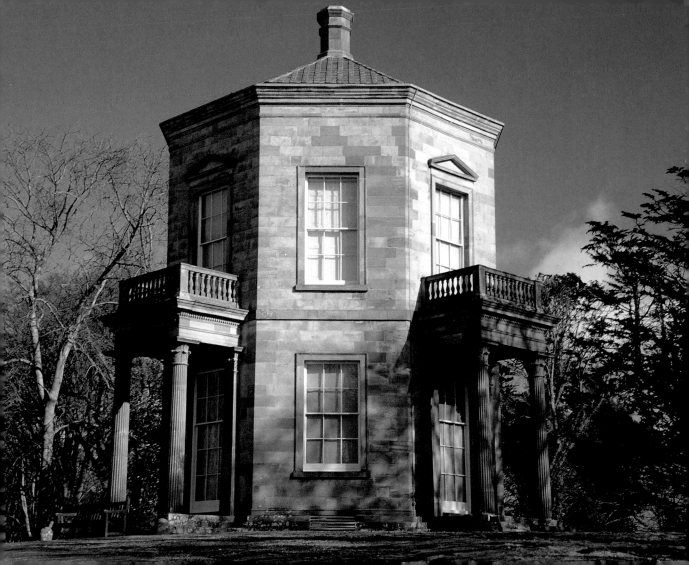

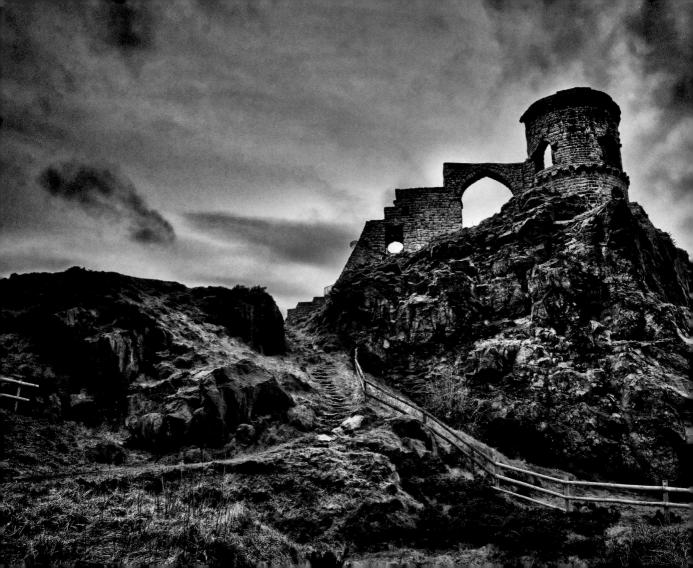

Mow Cop
Cheshire/Staffordshire

Sham ruin, 1754

The folly

Primitive Methodism

Randle Wilbraham paid a shilling a day to John and Ralph Harding to build him a tower on top of the Old Man o'Mow, a prominent escarpment 5km (3 miles) from his new house, Rode Hall in Cheshire. This is a perfect example of a folly built for fashion rather than passion; Wilbraham had a new house, he had money, the rest of Society was building prospect towers and ruined castles, he was not going to be left out. The design probably came from a pattern book rather than the fevered dreams of a passionate romantick, and its importance in the folly canon comes more from its spectacular site than any contribution to architecture.

The most folly-like aspect of Mow Cop was the battle between Randle Wilbraham and his neighbour Ralph Sneyd, who complained that Wilbraham had erected the folly on his land. A long court case then took place, and the Solomonaic judgement was handed down that the boundary between the properties ran straight through the middle of the building, so both parties were responsible for its upkeep. This strange situation obtains to this day; it is the only building in England to have two separate Grade II listings; one for its Staffordshire side and one for its Cheshire side. As you might expect, the listings are not quite identical.

The Wilbrahams sold their interest to a quarryman in 1923, which was the beginning of the second legal battle of Mow Cop. Protestors fought to keep public access to the land, and the matter was not fully resolved until the property was handed to the National Trust in 1937.

Outside the world of folly-fanciers, Mow Cop is famous as the birthplace of Primitive Methodism. In 1807 the first open-air camp meeting was held here, and in 1812 the movement was formally founded.

Paxton's Tower

Carmarthenshire

Tower, 1811

The big breakfast

Scottish born, India blessed, the 40-year-old William Paxton voyaged back to Britain in 1785, having made his fortune as a drug dealer and usurer on such a scale that he was knighted by his grateful country. As Master of the East India Company's Mint in Calcutta and an international banker with his agency house Paxton & Cockerell, he sold indigo to England and opium to China, and took 5 per cent commission on all the trade through India's busiest port.

Captivated by south-west Wales, Paxton resolved to move to the area. He developed Tenby into a sea-bathing resort, bought the Middleton Hall estate outside Carmarthen and employed Samuel Pepys Cockerell to remodel it. The next step was to be elected MP for the county of Carmarthen, but Paxton was an outsider, running for the Whig cause against James Hamlyn Williams, a local Tory. While it was illegal to bribe voters, it was deemed perfectly permissible to entertain them. Prodigious is the only word for Paxton's entertainment. His bill of £15,690 included 11,070 breakfasts, 36,901 dinners, 25,275 gallons of ale and 11,068 bottles of spirits. Having sated themselves at Paxton's expense, the worthies of Carmarthenshire went off and elected his rival.

The house burnt down in 1931, and the site now holds the National Botanic Garden of Wales, but one visible testament remains to Paxton's headlong career: Paxton's Folly, a glorious triangular tower which was intended as a memorial to Lord Nelson. Cockerell was the architect, mighty castellated Gothick was the style. Plaques inside, now gone, recorded Nelson's feats in English, Latin and Welsh, the last a remarkably liberal statement at a time when that language was effectively proscribed.

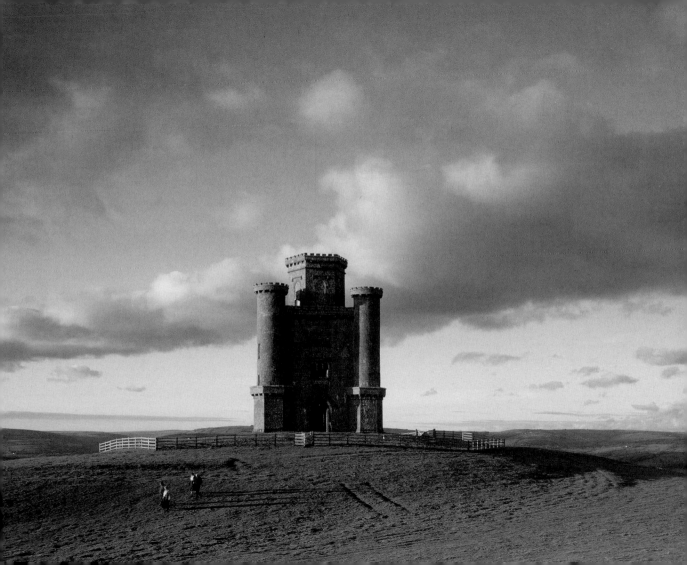

Penshaw Monument

Tyne and Wear

Monument, 1844

Opposite:
The Penshaw
Monument

The Lambton Worm

This blackened acropolis is one of the most impressive visual statements in what is now a deprived region of England, once rich through coal and shipping. During the area's first flush of brash prosperity, freemasons erected it as a memorial to 'Radical Jack' Lambton, the 1st Earl of Durham. He had supported the Reform Bill in 1832 (hence Radical Jack), was the Lord Privy Seal, the Ambassador to Russia and, in 1838, the first Governor-General of Canada.

The roofless memorial, formally known as the Earl of Durham's Monument, was said at the time of its construction to be a double-size copy of the Temple of Theseus, the Theseion in Athens, but it is not: the only similarity is that they are both Doric Greek temples. Penshaw was designed by John and Benjamin Green of Newcastle and built by Thomas Pratt of Sunderland. One of the columns contains a staircase winding up to the unguarded cornice; in an early example of health and safety control the door has been locked since a teenager was killed falling off the parapet on Easter Monday 1926, the only recorded death at the building.

The hill on which the Monument stands was the legendary lair of the Lambton Worm, a fearsome dragon which would wind its tail round the hill after rampaging through the neighbourhood. Centuries ago Sir John Lambton had fished the worm out of the River Wear and thrown it down a well. He then went off to the Crusades, and while he was away the worm 'growed and growed' and ate most of County Durham. News of its appetite reached Palestine, so Sir John came back to sort things out by cutting it into three parts. Thus the suitability of the site for a monument to a later Lambton cannot be bettered.

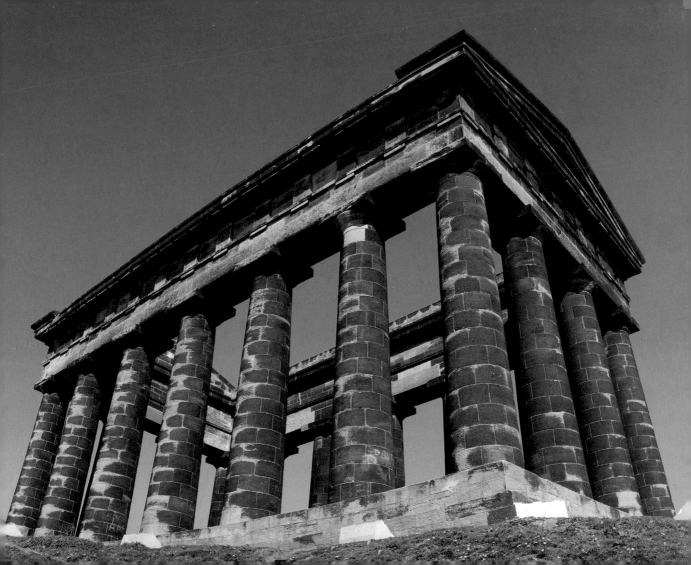

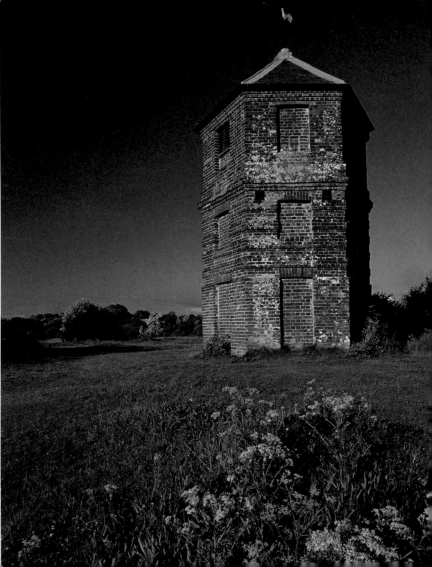

Pepperbox Hill

Wiltshire

The Pepperbox, 1606

The Pepperbox

Singularity

Isolated, unprotected, enigmatic, blank – the sudden sight of this strange, anonymous small building will always provoke a question from the passer-by: 'What the hell is that?' It's always the same question, and the answer is always 'It's a misunderstood building, therefore we call it a folly.'

We know a little bit about the Pepperbox. The official grade listing dates it to the early eighteenth century, whereas every other authority gives a firm construction date of 1606, a hundred years earlier. Hexagonal, with three storeys and a low, pyramidal Welsh slate roof with weathervane, it bears a remarkable familial resemblance to the octagonal Tower of the Winds (see also Mount Stewart and West Wycombe, pages 60 and 86) but pre-dates James Stuart and Nicholas Revett's visit to Athens to record that influential building by some 150 years. We know Giles Eyre of Brickworth House built it around 1606, three years after his marriage, for some perfectly sensible reason, perhaps so his wife Jane could watch the hunt in comfort. All the windows – one per face – have long been bricked in.

You may be wondering why it was built out here in the open countryside. Look around you at the sweeping views. See how the land has been shaped and formed by generation after generation of farmers and hunters. Think how it will be formed in the future by people hundreds of miles away in unnecessarily air-conditioned offices who will never set foot on this good earth. Now you begin to understand why Giles Eyre built his little pepperbox here, with its views over the land he thought would last forever.

Port Isaac

Cornwall

The Birdcage,
1830s

The Birdcage

Cornish cage

What is the romance of fishing villages? A genuine fishing village is small, smelly, messy and dangerous, usually planted below cliffs, but the dream of Cornish fishing villages lives on — if only in dreams. Real sea fishing is now carried out by corporate megagalleons, while the surviving villages fish only for tourists and television companies. But Port Isaac is a genuinely quaint jumble of narrow dead-end streets (one named Squeezeebelly Alley is claimed to be the narrowest street in the world) and a house with the name of The Birdcage is sufficiently curious to attract attention, and the only possible reason for its name is that the cottage is scarcely big enough to hold a bird.

It was not even a fisherman's cottage as one hopes; it was said to be the cobbler's cottage, a word that might spring to the lips of the traditionally built visitor attempting to negotiate the 25cm (12in) wide staircase inside. For this tiny folly can be rented from the National Trust by holidaymakers, although they are obliged to be small and thin. It has three floors and is basically pentagonal, not through any architectural fantasy but because that was all the plot of land allowed.

The house, described by The Listed Buildings of England as 'a rare survival of an unaltered 1-room plan, 3-storey detached house', was built before 1834 by a Captain Valentine Powell Richards, a strange title for a cobbler. He married Rebecca Tanner in 1843, and as she was the daughter of a coastguard captain perhaps that was Capt. Richards' calling as well; indeed The Birdcage has west-facing windows overlooking the little harbour, convenient for a coastguard's vigilant eyes.

Narrow streets and narrow houses. Let's hope Valentine and Rebecca weren't too comfortably upholstered.

Port Quin

Cornwall

Doyden Castle, 1830s

The smallest castle in Cornwall?

A tiny jewel of a castlet, mounted in a perfect setting – this must be the stuff of myth, magic and fairytale, the fount of a cavalcade of stories and legends. At the very least some epochal event must have taken place on this spot or some crime of passion, a smouldering beauty and a rugged swain doomed to replay their fatal midnight moment of madness for eternity … but no, nothing.

Nothing but the wind soughing through the tiny battlements, no spirits disturbed, no heartbreaking legends of unrequited love, just a boxy little castle in a picturesque location, said to have been built as a drinking den.

We know little more about it. A local farmer, Samuel Symons, built it c. 1830. It has a cellar where bottles may have been stored, hence it must have been a drinking den. But ten years later Symons, from Govenna House in Wadebridge, was the owner of 320 ha (790 acres) of farmland and leasing another 20 ha (49 acres). He clearly didn't let his drinking interfere with his work.

No ghosts either, although a visitor (it's let out as a holiday home by the National Trust) once heard a plate fall in the kitchen. No spectral apparitions at the windows, only groups of cheerful, ruddy-faced hikers peering in, as the castle straddles the Cornwall Coastal Path.

Not every picture tells a story.

Opposite:
Doyden Castle

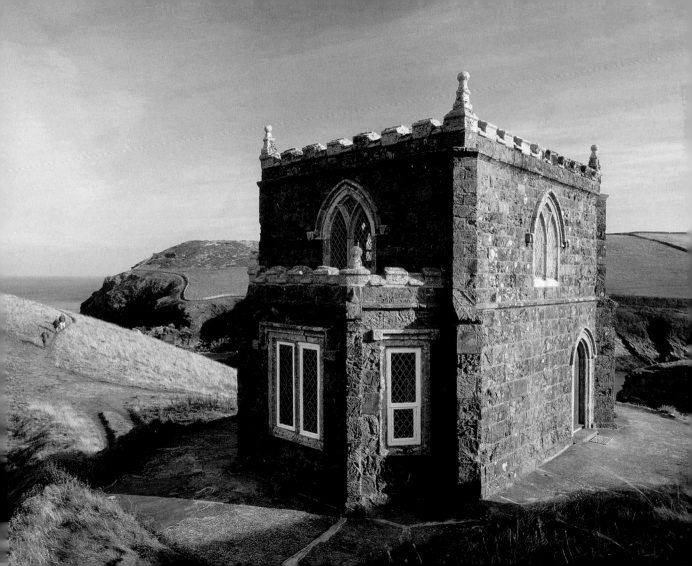

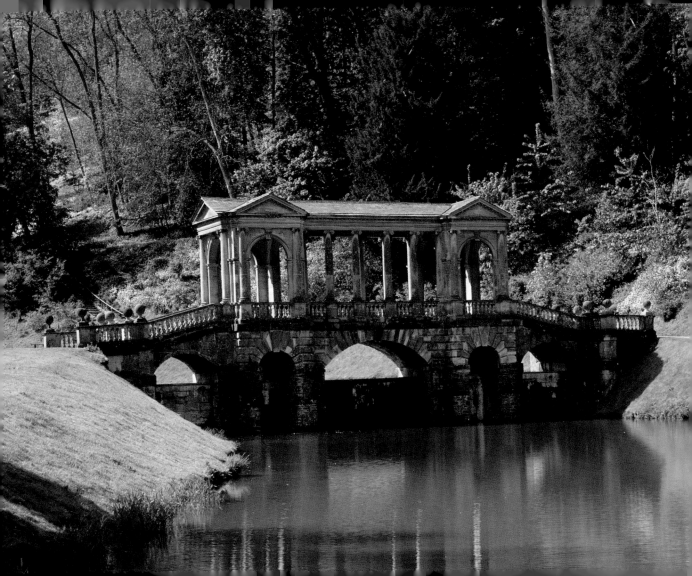

Prior Park Landscape Garden, Bath

Somerset

Palladian Bridge, *c.* 1750;
Mrs Allen's Grotto, *c.* 1740;
Gothic Temple, *c.* 1745

The Palladian
Bridge

To see all Bath

In 1707 a postal surveyor named Quash went into a post office in Cornwall and found it being run by a 14-year-old boy named Ralph Allen. So impressed was he by the boy's abilities that he took him to Bath, where he became Postmaster by the age of 19 and then went on to amass a huge fortune, become Mayor and Member of Parliament for Bath, and acquire quarries that provided the stone to build the city. He famously built the mansion of Prior Park and enhanced the grounds with fashionable artefacts by the most celebrated designers of the day. His finest folly stands outside the park: Ralph Allen's Sham Castle, a two-dimensional façade simply erected as an eye-catcher, one of the best follies in the country. However, Allen's champions have claimed it was built to prove the strength of Bath stone, and therefore as it had a function it was not a folly.

A substantial restoration programme has been carried out, rebuilding the Gothic Temple, the Grass Cabinet and Mrs Allen's Grotto. The original Gothic Temple was sold in the 1920s to Rainbow Wood House on the other side of the valley, where it still stands, prized by the current owners. The Palladian bridge is a manifestation of wealth and taste. Architectural historians will tell you there are three Palladian bridges in England. The first is at Wilton House, still owned by the Earl of Pembroke, and the next two are in the charge of the National Trust (here and at Stowe Landscape Garden). The utility of such structures was considerably less than their architecture; certainly they successfully crossed water but their primary function was, admittedly, ostentation.

Rowallane Garden
County Down

Witches' Crag, 1870s

Pyramids of cannonballs

In 1860 the Reverend John Robert Moore acquired this small estate outside Saintfield in County Down and named it Rowallane after his ancestral home in Ayrshire, Scotland. He enlarged the demesne by relentlessly acquiring surrounding properties, to the extent that a contemporary remarked that there was so little spare land left that Moore would have to be buried standing up. His nephew Hugh Armytage Moore inherited the park in 1903, and although he continued his uncle's work on the gardens he did not move into the house until 1917. Later in life Armytage Moore became a renowned horticulturalist. He was awarded the Victoria Medal of Honour by the Royal Horticultural Society in 1942, and Rowallane became and still remains an inspiration for professional and keen amateur gardeners; the rhododendrons provide a magnificent display, and are in flower from February. The great walled garden has an elegant umbrello garden seat in one corner erected in the memory of Annie Quinn, the Moores' housekeeper, who died aged only 25. Mrs Armytage Moore was said to be less than impressed with the gesture.

Rowallane contains some pleasantly inexplicable structures erected by the Reverend Moore. Most noticeable are the giant cairns flanking the long drive, like pyramids of cannonballs; the round granite stones come from Bloody Bridge, cheerfully named for the site of a sectarian massacre in 1641, near Newcastle, 32km (20 miles) away. The garden has a number of enigmatic erections, among them a pile of rock known as the Witches' Crag, a large throne-like garden seat and a most excellent blank-faced clock tower in the stable yard. Go for the plants rather than the follies, and you will not be disappointed.

Opposite:
One of the
Rowallane cairns

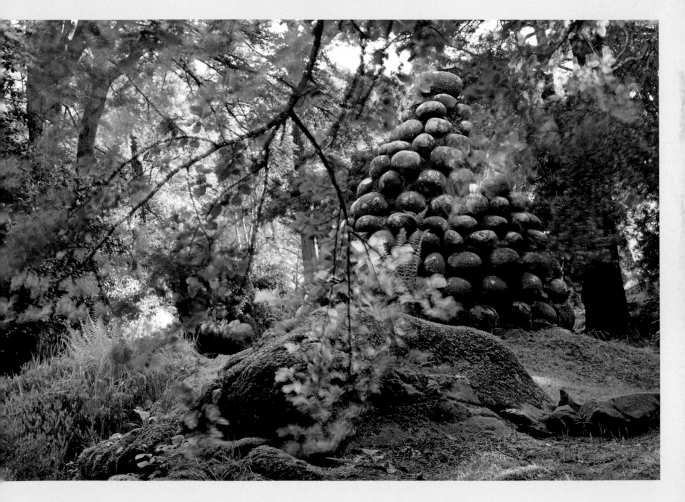

Slindon Estate

West Sussex

Nore Folly,
18th century

The folly on the slope

Slindon, a hamlet nestling on the Sussex Downs and packed with listed buildings, is noted among folly enthusiasts for one of the more baffling buildings in Britain: the Nore Folly on Court Hill. This is a castellated archway to nowhere, constructed of knapped flint and serving no conceivable purpose. Mighty buttresses hint at it being a remnant of a building of colossal size, but it seems that a small thatched construction abutting it was all that ever might have existed. Its definitive purpose forgotten, this is one of the closest examples of a true folly in England. Only one story lingers: Lady Newborough had a print of an Italian arch and instructed a local builder, Samuel Refoy, to re-create it. No dates – certainly none that match – and no provenance.

What can the name Nore mean or refer to? 'Ore' was an old Sussex word for a bank or slope, and Nore Wood, where the folly stands, slopes steeply down to the south. 'Atten ore' meant at, or on, the slope, and was shortened to Nore. This helps supply the etymology of the name. It is purely descriptive: the folly on the slope. While a building doesn't have to be purposeless to qualify as a folly, and indeed the great majority of such structures did have a purpose, now lessened by the passage of time or changes of fashion, Nore Folly seems to have none. It didn't even serve as an eye-catcher from the Slindon estate house. England's register of listed buildings is unusually definitive, stating it was 'built for luncheons on shooting parties … It forms an archway flanked by octagonal turrets and buttresses with room behind. Also known as Nore Folly.' So, a picnicking house in which to rest from the rigours of the hunt? Perhaps, perhaps.

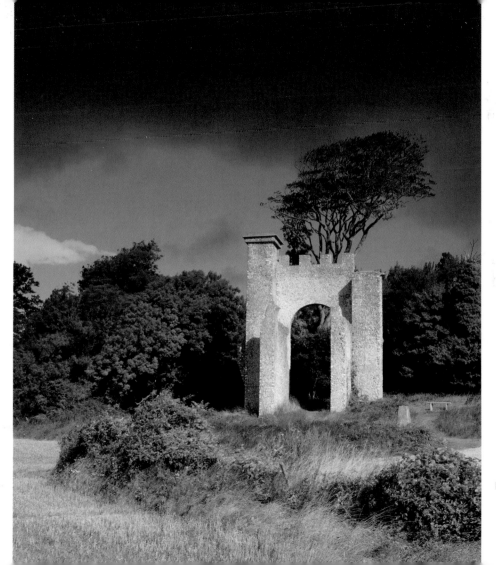

Nore Folly

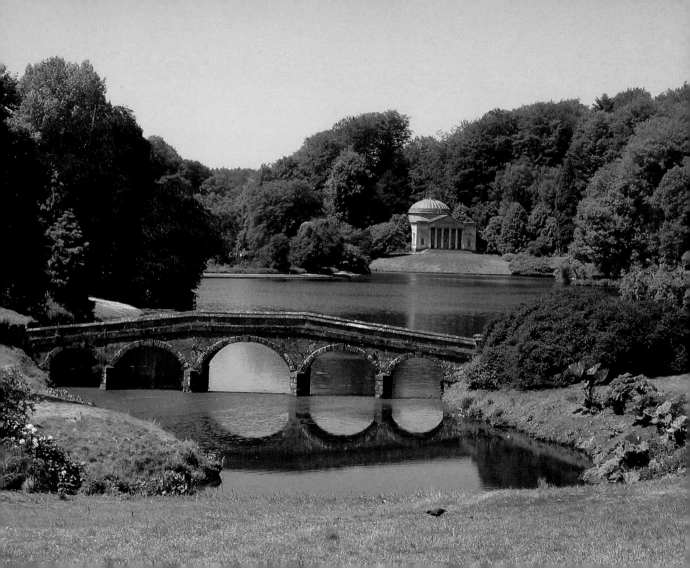

Stourhead

Wiltshire

Garden buildings,
18th century

The Pantheon
and the Bridge

Arcadia in England

Stourhead is so beautiful it has become a cliché of the English landscape garden – though this is where many of the formulae to create one were first tried and tested. The first necessities for a major landscape garden are a lake and a hillside, followed by the temples, then the planting to achieve the necessary effect. Stourhead supplies all the essentials, and it is as familiar as the face in your mirror.

So rather than listing the garden buildings – for there is no real folly within the garden (the park is another matter) – we will look at how this so-familiar landscape came into existence. The Hoares are bankers; astute ones. In 1672 Richard Hoare founded the bank which is still owned by the family. His son Henry bought Stourhead in 1720, and his grandson 'Henry The Magnificent' (1705–85) created the garden. Working with his favourite architect, Henry Flitcroft, he built a grotto and the Temple of Flora before damming the river Stour in 1757 to create the lake. Next came the temples and garden buildings, though long gone are a Chinese bridge and alcove, a Gothic greenhouse, a hermitage, statues of Neptune and his horses in the grotto, a Venetian seat and doubtless more.

The great folly is 3.2km (2 miles) away. Flitcroft's Alfred's Tower was completed in 1772, the prototypical triangular folly tower. It is 5m (160ft) high and although that is not a tremendous height, the isolation of the building on top of its low hill lends it an exaggerated magnificence. Ostensibly built to mark the summit where Alfred the Great erected his standard against Danish invaders in 870 AD, it is a splendid belvedere with panoramic views over the Hoares' estate.

This is Arcadia in England. Wiltshire has much to be proud of.

Stowe Landscape Garden

Buckinghamshire

Follies, 18th century

The Palladian Bridge, the Gothick Temple and the Cobham Monument

Templa quam dilecta

The gardens at Stowe were created by a succession of landscape gardeners which included Charles Bridgeman, William Kent and Lancelot 'Capability' Brown, complementing architects such as Sir John Vanbrugh, James Gibbs, Giacomo Leoni and Kent himself. What this great assemblage of creative talent achieved was an artificial landscape of such refinement that it can fairly be said to have improved upon nature. The buildings in the park were far from conceits; they were erected to demonstrate the yarn of history, a thread of culture and civilisation running in an unbroken line from Ancient Greece to eighteenth-century England, the natural successor and protector of the flame. The tour of the grounds would take one past the Temple of Ancient Virtue, pristine in its purity and innocence, then to the Temple of Modern Virtue, a decaying, corrupted ruin of all that once was fine and good. Some debased Gothick was allowed to muscle in to demonstrate the cutting edge of the Temples' taste – the Gothic revival was starting to gather speed at that time – but the overwhelming mood of Stowe is hard-edged classical elegance.

The Gothick Temple, also known as the Temple of Liberty, was completed in 1744. It is a different colour to the other follies, russet Northamptonshire ironstone as against patrician white Portland stone. It looks asymmetrical; in fact it is triangular, with pentagonal towers at the angles, one two storeys higher than the others.

There are so many extraordinary buildings at Stowe that there is not enough space here even to list them all. Personal favourites are the Gibbs buildings: the Cobham Monument, a tall, solitary tower of 1747; and the 1740 Bourbon Tower, squat, solid and pleasantly ugly.

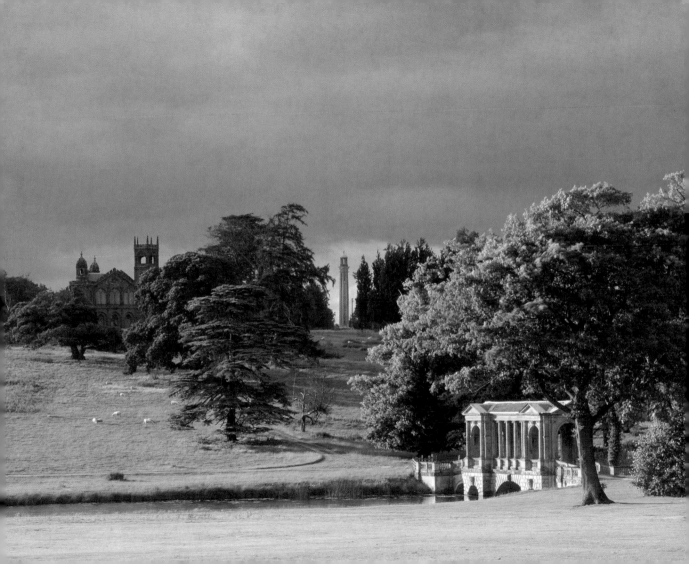

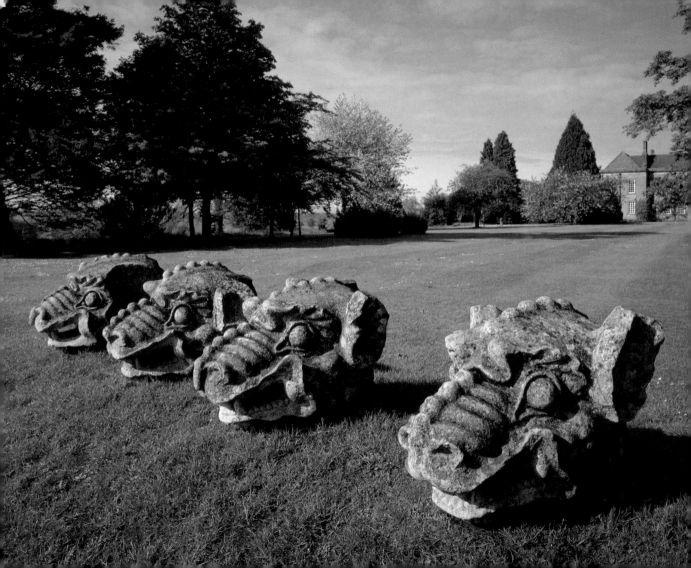

Wallington

Northumberland

Arches and griffin heads,
mid-18th century;
Rothley Castle, 1755;
Codger's Fort, 1769

The griffin heads

A landscape of capabilities

Landscaped parks and golf courses around the world share faint similarities, and there is a reason why; they are all echoes of the Northumbrian landscape. In the little school in Cambo, near Wallington, Lancelot Brown, the most influential landscape architect of all, was educated. Around him yawned his fellow pupils and the visual glories of Northumberland. In retrospect what 'Capability' Brown did seems simple; he just exported his vision of the rolling hills and clumps of trees of his native countryside, re-creating little patches of the North across the South. As the influence of the English garden style began to dominate, so Northumberland became the default world's park.

Brown did some early work for his neighbour Sir Walter Blackett of Wallington Hall. Wallington has a pleasant removal folly: the arch and screen wall of the old stables were taken down and fashionably re-erected as an eye-catcher in a field north of the house. On the east side of the house are four grimacing stone heads – griffins taken from London's Aldersgate. They are snarling mammals, fangs bared, muzzles wrinkled and with wild, staring eyes.

The griffins were first placed on the battlements of Rothley Castle, not a castle at all but rather a place for a break in a strenuous day's hunting. Massive, square-towered and lancet-windowed, it was built by Daniel Garrett about 1755, ostensibly as a defence against a possible Jacobite uprising. A little further north is Codger's Fort, scarcely more than a fortified wall with arrow slits, designed by Thomas Wright for the same purpose.

West Wycombe Park

Buckinghamshire

Follies, mid-18th century

Opposite: The Temple of Music

Hellfire and damnation

The hills and vales around West Wycombe are rich in chalk and flintstones, and the local vernacular architecture uses brick with flint infills, homely and welcoming. This is not the style required by grand country houses, so the several architects of West Wycombe House eschewed a country roundelay of brick and flint and chose the safer symphony of ashlar and marble. However, while Nicholas Revett played safe with his porticoes for the house, he specified brick and flint in his re-creation of the Temple of the Winds, one of three descendants of the Athenian Tower of the Winds in the ownership of the National Trust. The material does not speak comfortably with a classical vocabulary, particularly as Revett reversed the traditional formula and used flint with a brick infill.

The park has many of the folly attributes of the period, largely inspired by the landowner, Sir Francis Dashwood. St Crispin's, a cottage disguised as a church, is also in brick and flint, and was created by a Captain J. Moody. Revett himself produced the Island Temple and the now demolished Temple of Flora, as well as the cascade. The Temple of Venus, in ruins by the 1820s, was reconstructed in 1982 by Quinlan Terry. The original skirted just this side of blatancy, John Wilkes writing that 'the entrance to it is the entrance by which we all come into the world … you ascend to the top of the building which is crowned with a particular column designed, I suppose, to represent our former very upright state.'

This effortlessly segues into West Wycombe's most famous creation, the Hell Fire Club. Sir Francis Dashwood and his cronies seemed to enjoy sex and debauchery, so they indulged – and look what happened to them. As you might expect, every one of them died.

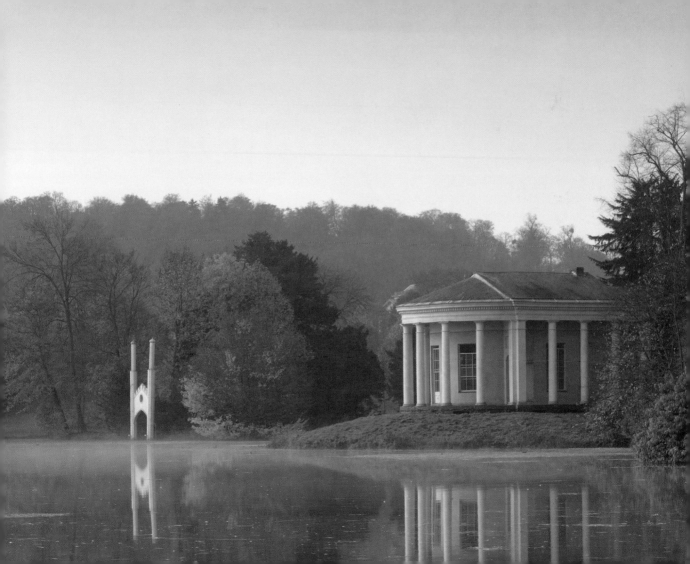

Wimpole Hall

Cambridgeshire

Sham ruin, 1749/1772

'My Lord desired it merely as an object'

The fiercely ambitious Philip Yorke, 1st Earl of Hardwicke, was appointed Solicitor-General by the time he was 30. As Regent, he had a claim to being the most influential man of the mid-eighteenth century; what he didn't have was an ancient name, or ancestral estates mouldering through time. They had to be created, and the way to do it in the eighteenth century was to build a sham ruin in your park. The premier purveyor of sham ruins at the time was Mr Sanderson Miller, gentleman, of Warwickshire, but being untitled he was unworthy of direct contact with my gracious Lord. His instructions were relayed to him by his neighbour in Warwickshire, Sir George Lyttelton, later Chancellor of the Exchequer, who acted as go-between. 'As my Lord desired it merely as an object he would have no staircase or leads in any of the towers, but merely the walls so built as to have the appearance of a ruined castle.'

In the following century practicality overcame objectivity; a staircase was installed, the roof was leaded and by 1891 gamekeeper Frederick Kohn was living in the Tower. The architect James Essex is now credited with the actual building of the castle, together with Lancelot Brown, but the inspiration was clearly Sanderson Miller's. The design was based on his drawings of 1749 but not completed until 1770.

This is a very large and grand folly. It consists of three towers linked by ruined curtain walls meandering along the low hill, with the four-storey central tower acting as an eye-catcher to answer the view from the house. In 1938 Rudyard Kipling's daughter bought Wimpole Hall, and she bequeathed the estate to the National Trust in 1976.

Opposite:
The sham ruin

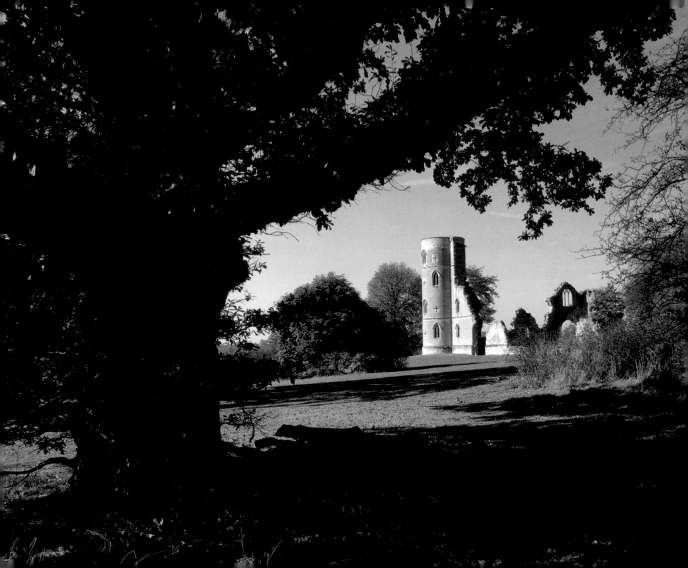

Visitor information

Most of the follies illustrated in this book are open to visit, and in some cases to climb to the very top to admire views of the surrounding countryside, often as their original builders intended. Others are let to private tenants, as holiday cottages, or are garden buildings or other outbuildings (as noted in the text), and may rarely be open, or may have other uses which prevent them being regularly open.

Please contact the relevant property before visiting to find out access details, or check the information in the National Trust Members' Handbook or on the National Trust website at www.nationaltrust.org.uk. Information on opening times and admission prices can also be found from these sources.

National Trust Holiday Cottages is a unique collection of over 370 follies and other unique properties in outstanding locations in England, Wales and Northern Ireland, for short breaks, weekends away and holiday lets. Please visit www.nationaltrustcottages.co.uk for more information.

A La Ronde
Summer Lane
Exmouth
Devon
EX8 5BD

Alderley Edge
Nether Alderley
Macclesfield
Cheshire
SK10 4UB

Belton House
Grantham
Lincolnshire
NG32 2LS

Biddulph Grange Garden
Grange Road
Biddulph
Staffordshire
ST8 7SD

Blaise Hamlet
Henbury
Bristol
BS10 7QY

Blickling Estate
Blickling
Norwich
Norfolk
NR11 6NF

Bodnant Garden
Tal-y-Cafn
Colwyn Bay
Conwy
LL28 5RE
Wales

Castle Ward
Strangford
Downpatrick
County Down
Northern Ireland
BT30 7LS

Claremont Landscape Garden
Portsmouth Road
Esher
Surrey
KT10 9JG

Clumber Park
Worksop
Nottinghamshire
S80 3AZ

Cotehele
St Dominick
near Saltash
Cornwall
PL12 6TA

Crom Estate
Upper Lough Erne
Newtownbutler
County Fermanagh
Northern Ireland
BT92 8AP

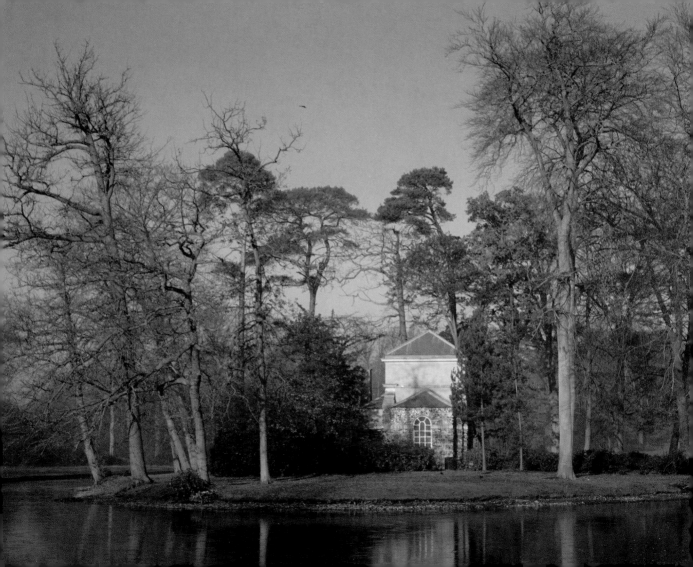

Croome Park
near High Green
Worcester
Worcestershire
WR8 9DW

Downhill Estate
Mussenden Road
Castlerock
County Londonderry
Northern Ireland
BT51 4RP

Dunster Castle
Dunster
near Minehead
Somerset
TA24 6SL

Ickworth
The Rotunda
Horringer
Bury St Edmunds
Suffolk
IP29 5QE

Kedleston Hall
near Quarndon
Derby
Derbyshire
DE22 5JH

Killerton
Broadclyst
Exeter
Devon
EX5 3LE

Knole
Sevenoaks
Kent
TN15 0RP

The Kymin
The Round House
The Kymin
Monmouth
Monmouthshire
NP25 3SF

Lacock Abbey
Lacock
near Chippenham
Wiltshire
SN15 2LG

Leith Hill
near Coldharbour village
Dorking
Surrey

Lyme Park
Disley
Stockport
Cheshire
SK12 2NR

The Island Pavilion,
Claremont Landscape
Garden, Surrey

Lyveden New Bield
near Oundle
Northamptonshire
PE8 5AT

Montacute House
Montacute
Somerset
TA15 6XP

Mount Stewart House
Portaferry Road
Newtownards
County Down
Northern Ireland
BT22 2AD

Mow Cop
Mow Cop,
Staffordshire

Paxton's Tower
Near Dinefwr Park and Castle
Llandeilo
Carmarthenshire
Wales
SA19 6RT

Penshaw Monument
Penshaw Hill,
The Avenue
Washington Village
Washington
Tyne & Wear
NE 38 7LE

Pepperbox Hill
Off A36 south of Salisbury,
Wiltshire

The Birdcage, Port Isaac
The Birdcage
11 Rose Hill
Port Isaac
Cornwall
PL29 3RL

Doyden Castle
Port Quin
Port Isaac
Cornwall

Prior Park Landscape Garden
Ralph Allen Drive
Bath
Somerset
BA2 5AH

Rowallane Garden
County Down
Northern Ireland
BT24 7LH

Slindon Estate
Top Road
Slindon
Arundel
Sussex
BN18 0RG

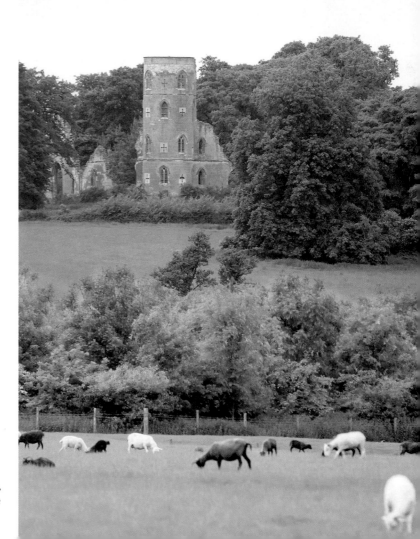

Stourhead
near Mere
Wiltshire
BA12 6QD

Stowe Landscape Garden
Buckingham
Buckinghamshire
MK18 5EQ

Wallington
Cambo
near Morpeth
Northumberland
NE61 4AR

West Wycombe Park
West Wycombe
Buckinghamshire
HP14 3AJ

Wimpole Hall
Arrington
Royston
Cambridgeshire
SG8 0BW

The sham ruin,
Wimpole Estate,
Cambridgeshire

Picture credits

page 10 © NTPL / David Garner; page 13 © 2012 Liz Mitchell / fotoLibra; page 15 Martin Cameron / Alamy; page 16 © NTPL / Ian Shaw; page 18 © NTPL / Mark Bolton; page 21 Graham Corney / Alamy; page 22 © NTPL / Ian Shaw; page 24 © NTPL / Joe Cornish; page 27 © NTPL / John Miller; page 28 © NTPL / Andrew Butler; page 30 © NTPL / Andrew Butler; page 33 © NTPL / John Millar; page 34 © NTPL / Andrew Butler; page 37 © NTPL / Robert Morris; page 40 © NTPL / Andrew Butler; page 43 © NTPL / Robert Morris; page 45 © NTPL / Andrew Butler; page 46 © Trevor Harris; page 50 © NTPL / Andrew Butler; page 53 © NTPL / John Miller; page 55 © NTPL / James Dobson; page 56 © NTPL / Paul Harris; page 58 © 2012 Shaun Dymond / fotoLibra; page 61 © 2012 William John Haggan / fotoLibra; page 62 © 2012 Greg Daly / fotoLibra; page 65 © NTPL / Chris Warren; page 68 © NTPL / Steve Day; page 74 © NTPL / Stephen Robson; page 77 © NTPL / Stephen Robson; page 79 © NTPL / John Miller; page 82 © NTPL / Andrew Butler; page 84 © NTPL / Matthew Antrobus; page 87 © NTPL / Andrew Butler; page 89 © NTPL / Nick Meers;

Jacqueline du Pré

IMPRESSIONS

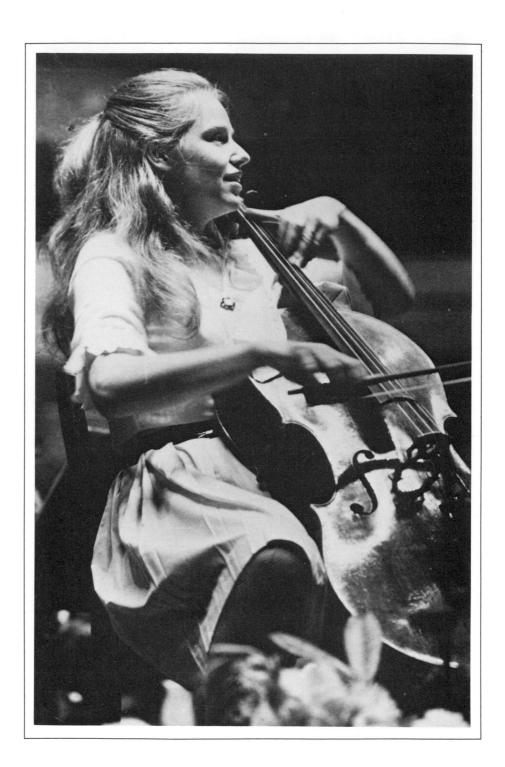

Jacqueline du Pré

IMPRESSIONS

Edited by
WILLIAM WORDSWORTH

Foreword by
HRH THE PRINCE OF WALES

New York
THE VANGUARD PRESS

Published by Vanguard Press, Inc., 424 Madison Avenue, New York, N. Y. 10017.
Published simultaneously in Canada by Book Center, Inc., Montreal, Quebec.
All rights reserved.

Library of Congress Cataloging in Publication Data
Main entry under title:

Jacqueline du Pré: impressions.

Discography: p. 139
1. Du Pré, Jacqueline, 1945– —Addresses, essays,
lectures. 2. Violinists, violoncellists, etc.—England—
Addresses, essays, lectures. I. Wordsworth, William.
ML418.D85J3 1983 787'.3'0924(B) 83–5726
ISBN 0–8149–0867–5

Whate'er the theme, the Maiden sang
As if her song could have no ending;
I saw her singing at her work,
And o'er the sickle bending;
I listened, motionless and still;
And, as I mounted up the hill,
The music in my heart I bore,
Long after it was heard no more. ★

*When Jacqueline du Pré received a doctorate from HM Queen Elizabeth, the Queen
Mother, then Chancellor of London University, Professor John Barron read the
oration which he concluded with the last verse of 'The Solitary Reaper' by the poet
William Wordsworth

Foreword
by
HRH THE PRINCE OF WALES

I was surprised and flattered to have been asked to write the foreword to this book about Jacqueline du Pré and I am writing it as someone who admires her very deeply – both as a musician and as a person. I shall never forget the first time I saw her perform in the Festival Hall when she played the Haydn C major Cello Concerto. I know that her mother says I saw her perform in a children's television concert when I was about ten years old, but I regret to say that I simply cannot remember anything about it! The Festival Hall concert was a revelation for me. Suddenly the cello took on a new significance in my experience. I was positively electrified, and deeply moved, by the way in which she extracted such magical sounds from the instrument and my memory of the evening is dominated by a pretty girl with a powerful personality and with unbelievably long, blonde hair which flew about her shoulders as she put her heart and soul into the music.

As a result of that memorable evening I became fascinated by the prospect of trying to learn the cello in my last year or two at school. Although I really was very mediocre in my ability, playing the cello gave me immense satisfaction and pleasure – both at school and university. There is nothing quite like the joy of making music with other people, whether it be in an orchestra, a quartet or in a jazz group and I shall always be thoroughly indebted to Jacqueline du Pré for arousing my interest in an instrument which is by no means easy to play!

I have met Jacqueline du Pré on numerous occasions since I saw her in the Festival Hall. It is always great fun when she appears since

her sense of humour is infectious and she has a wonderful ability to giggle uncontrollably. The real tragedy, of course, is that we can no longer hear her produce exquisite music. If it is a tragedy for us, what can it be for her? It is very nearly impossible to comprehend why such a thing should happen to someone so uniquely talented, so young and with so much future potential. I have often tried to imagine what it must be like for her – the sense of desperate frustration and impotence when you have so much inside you (God's gift), which you long to impart to others, but which is prevented by a physical barrier. Human existence on this earth is plagued by a never-ending succession of such incomprehensible, and sometimes almost intolerable, occurrences which seem to be designed as some kind of inequitable endurance test. Perhaps, however, one day the scales will be lifted from our eyes and these mysteries will be revealed to us.

Jacqueline du Pré is a courageous individual with a generous and affectionate spirit and many more people, better qualified to judge, who have contributed to this book will attest to that. Their contributions show what an effect she has had on so many people throughout her life so far.

Contents

ACKNOWLEDGEMENTS 13

INTRODUCTION 15
 by William Wordsworth

BORN FOR THE CELLO 21
 by Mrs Derek du Pré

MY GODDAUGHTER 32
 by The Earl of Harewood

PUPIL EXTRAORDINARY 36
 by William Pleeth

REVIEWS OF JACKIE'S DÉBUT AT WIGMORE HALL, 1961 43
 The Times
 Daily Mail
 The Guardian
 Daily Telegraph
 Musical Opinion

FROM EVELYN, CON AMORE 48
 by Lady Barbirolli

FIERY TALENT 51
 by Gerald Moore

JACKIE TALKING TO WILLIAM WORDSWORTH, 1969 56

GREATNESS AND MODESTY 59
 by Antony Hopkins

A TALE OF TWO CELLOS 63

AN ANGEL OF WARMTH 66
 Review in *New York Times*, 1965

SHARING A LANGUAGE 68
 by Yehudi Menuhin

'THE BOLT OF CUPID' 73
 by Dame Janet Baker

CARDUS PAYS HOMAGE 76
 Review by Neville Cardus, *The Guardian*, 1968

CASALS IS DEEPLY MOVED 78
 Review in *New York Times*, 1969

MUSICALITY COMES FIRST 79
 by Placido Domingo

THE IMPORTANCE OF BEING A TEACHER 83
 by Sir Robert Mayer

FUN AND LAUGHTER 87
 by Zubin Mehta

A GENIUS ON RECORD 94
 by Suvi Raj Grubb

MY DEAREST FRIEND 102
 by Eugenia Zukerman

SENSUOUS SOUND 106
 by Pinchas Zukerman

A FILM CALLED 'JACQUELINE' 110
 by Christopher Nupen

JACKIE'S MASTER CLASSES 117
 by Sir Ian Hunter

ABSOLUTE BEGINNER 121
 by James D. Wolfensohn

JACKIE AND THE WOLF 125
 by Janet Suzman

'I WAS LUCKY, YOU SEE' 129
 by Jacqueline du Pré

EXTRACTS FROM JACQUELINE DU PRÉ'S NOTEBOOKS 135

JACQUELINE DU PRÉ'S HONOURS TO DATE 137

DISCOGRAPHY 139

THE JACQUELINE DU PRÉ RESEARCH FUND 143

Acknowledgements

The Editor thanks all those who have provided this affectionate collection of tributes and the Barenboims' many friends who always willingly gave of their time to talk with him. He is greatly indebted to Mrs Derek du Pré for letting us reproduce family photographs and other illustrations. He also thanks Roger Schlesinger, until recently of Granada Publishing, and Anne Charvet, a senior editor at Granada, for their enthusiastic help and encouragement.

Thanks are also due to all those who have kindly given permission to reproduce copyright passages and photographs. Sources of extracts and photographs are given in the appropriate places.

Introduction

'Nobody can write the life of a man but those who have eaten and drunk and lived in social intercourse with him.' So said Samuel Johnson according to his biographer James Boswell. Here then the good doctor's definition of those qualified to subscribe to biography is fulfilled most precisely. That the remark was made by the great lexicographer will give particular pleasure to the subject of this book. A recent gift from her husband, Daniel Barenboim, was a large and splendidly bound volume of the famous English dictionary which Dr Johnson spent eight years compiling.

Unable to express herself through music, Jacqueline du Pré has discovered a great fascination in words and with it developed a talent for writing to convey her feelings. A few brief examples are included later in the book.

Amusing, witty and extremely good company, Jackie always displays an incredibly impressive attitude of strength and determination to live life uncomplainingly and as fully as possible. Quick to reject insincerity and humbug, yet appreciative and compassionate, she has a most resilient nature and is rarely depressed; at least not when she has friends around her.

Many moments occur when her irrepressible sense of mischief and fun have to assert themselves. In sharp contrast are her serious periods of deeply concentrated thought and determination to overcome problems, together with a remarkably spontaneous feeling for life; these are some of the things that contributed to her brilliance as a musician. In his extremely entertaining book about music festivals, *Conducted Tour*, Bernard Levin refers to 'that

group of younger musicians . . . who give the appearance of making music for fun. They attend each other's concerts, which is a clue; the fun is shared.' Jackie was one of that group.

When I began to collect contributions from Jackie's colleagues I was warned that it was likely to take longer than I imagined. It was certainly not that the contributors were reluctant to cooperate, simply that sometimes it was not always easy to establish contact as some of them make such mercurial movements around the world. Regrettably it was not possible to include a contribution from Artur Rubinstein although he had expressed a wish to provide one.

Talking with so many of the Barenboims' friends I soon realized how extremely affectionately they are both regarded. Two of their actor friends, Joanna David and Edward Fox, told me of their first meeting with Jackie, when she joined with other actor friends at Upottery to read some of her favourite poetry, during the festival held in the tiny Devonshire village in 1980. Moray Welsh, a fellow cellist, recalled his visits to Jackie's concerts during his student days, how he managed to get to know her and eventually became a friend.

The violinist and orchestra leader, Rodney Friend, told me a sadly amusing tale of good intentions. He and his wife, Cynthia, have been close companions of the Barenboims for many years. The story was about the traumatic occasion when the business of buying a wheelchair for Jackie finally had to be faced. Knowing it was going to be no easy undertaking for Daniel Barenboim, Rodney Friend offered to go with him. There were ghastly moments in the shop as they slowly realized all the attendant implications. Somehow the transaction was concluded and they found themselves in the street with the wheelchair. To lighten the emotional strain they applied themselves to the rather ludicrous problem of how best to transport the object to Rodney Friend's car, which was in a multi-storey car park some three hundred yards away.

'Two men pushing an empty wheelchair along a busy London street tend to be a rather curious spectacle,' Rodney Friend explained. 'So we decided Daniel would sit in the wheelchair and I would push.

'All was well until we reached a roadside kerb, which I had no idea how to negotiate. I could see that to push the chair down it I would tip Daniel out and, with my brief experience, I had not yet concluded that I must make the descent backwards. Seeing my dilemma, a kindly man approached us and solved the problem and

"invalid and chairperson" went on their way convulsed with hysterical laughter.

'On arrival at the carpark lift, Daniel was just about to jump out of the chair when the kindly man who had previously assisted us appeared again. I put my hands on Daniel's shoulders to indicate he must stay seated and all three of us travelled up together to the eighth floor. By now "invalid and chairperson" were shaking with ill-disguised laughter as I carefully assisted Daniel into my car under the baleful gaze of the kindly man.'

All of which seems to indicate that once being committed to such a situation, there is little to be done except to continue on with it to the end.

This small group of constantly attentive friends also includes the cellist, Joanna Milholland, and her husband, Jose-Luis Garcia, leader of the English Chamber Orchestra, with whom Daniel Barenboim recorded all the Mozart piano concertos and made his opera-conducting début at the 1973 Edinburgh Festival.

The quite extraordinarily devoted care and consideration of Daniel Barenboim for his wife has been mentioned to me by practically everyone who knows him. The strain of such a situation for someone with a heavy schedule of international concert engagements is something that can hardly be imagined. Since the start of Jackie's illness, few days have passed without her having a telephone call from her husband and he so arranges his commitments that, at most times, scarcely two weeks go by without him returning to London, however brief the visit may have to be.

A dedicated band of people have devoted themselves to helping Jackie live her life as normally as possible. In the early days of her illness, Olga, a wonderful Czechoslovakian housekeeper looked after her needs and ran the household. Aida Barenboim, her mother-in-law, makes periodical trips from Israel to help with the supervision of domestic arrangements whenever it becomes necessary as a result of holidays or illness of any members of the resident team.

For some years now, Ruth Anna Cannings, who comes from Guyana, has been Jackie's nurse, companion and friend, caring for her and going with her to most of the numerous concerts and on the other outings to which Jackie looks forward so eagerly. Jackie first met Ruth Anna in 1973 when she became ill and returned from America to go into the Lindo wing of St Mary's Hospital in London for a month. Ruth Ann, as she is generally known, was one of the nurses assigned to her.

Three years later, during the City of London Festival of 1976, Daniel Barenboim was conducting the Beethoven 'Choral' Symphony in St Paul's Cathedral and Ruth Ann, always a music lover, decided to go to the performance. As she was leaving she saw Jackie and they talked for a few moments. Making her way to a bus stop, Ruth Ann was surprised to be overtaken by Aida Barenboim, who asked her if she would consider nursing Jackie. Never having thought of undertaking private nursing and with plans to return to New York, where her parents live, she asked for a little time to think over the proposal. After giving careful consideration to the restrictions that such a job would impose by contrast with hospital work, she finally agreed. A deeply religious person, Ruth Ann has a steadfast belief that it was ordained that she should 'have the privilege of caring for Jackie'.

With her doctors Jackie has a remarkable rapport; they are all good chums together and, as she herself says, she loves them. Whenever their duties allow, they will accompany her to a concert or some social occasion.

With Jackie's physician, Dr Leonard Selby, a great friend of mine, I first discussed the idea of compiling this book, and I would like to thank him for his considerable help, encouragement and guidance.

Dr Leo Lange, who is Jackie's consultant neurologist, has kindly given me a brief description of the symptoms and effects of multiple sclerosis. As so little is generally known about the illness, I thought that his notes should be included here:

> The central nervous system functions as a means of transmitting impulses from one part of the body to another. There are millions of nerve fibres and each is individually insulated. In multiple sclerosis, the sheaths of individual nerves are damaged and this causes various disabilities.
>
> It may affect vision, causing blurring of vision or giving double vision. In later stages of the disease it may cause permanent disability, but in the initial stages usually not. It may affect different parts of the nervous system and may give rise to weakness of the limbs and difficulty in controlling the natural functions, such as the bowels and the water works. It can paralyse one limb, or any number, sometimes producing paralysis of both legs, rarely producing paralysis of arms and legs. Of course, these disabilities do not start abruptly and all together. Many people have a few attacks during their lifetime but may recover virtually completely and their lives are not impaired in any way. At the other end of the scale, there are patients who may have increasingly severe attacks over a matter of

months, or more usually years, and may become severely disabled quite rapidly.

MS is totally unpredictable. You can have a series of attacks, from which you may recover almost completely, depending on how well the sheaths which protect the particular nerves heal themselves; this retreat of the disease is termed a 'remission'. The previous symptoms may never recur, but if they do you cannot tell in advance what part of the nervous system is going to be attacked next, or how badly, or when the attack will come. This unpredictability is one of the most frightening aspects.

Although in itself it is not terminal, severe MS will almost certainly shorten the life-span, because of the secondary complications that arise. For instance, if the legs and sphincters are paralysed, one may get infections in the kidneys that may lead to death, or if the whole body is severely paralysed, one may develop bed sores and chest infections and these may lead to premature death. But less severe MS as a rule does not shorten the life-span, and patients, if they're well looked after, may go on for many years with quite severe disability.

Recent research seems to indicate quite strongly that there is an environmental trigger for MS which may be viral. In addition to that, there is probably a constitutional-immunity factor, as it may well be that we have all been infected by the virus and only those with the appropriate genetic make-up develop the full disease. If this is confirmed and this may take several more years of research, it is reasonable to expect that one might be able to develop a vaccine and possibly vaccinate people against the possibility of developing the disease.

If this treatment is effective one might improve many patients who have the established condition and reduce their disability, although if there has been permanent nerve damage, it is unlikely that complete recovery will take place.

We tried for some time to keep the prospect of this book a secret so that it would be a surprise for Jackie, but somehow she learned what was afoot and one day confronted me with a direct question. 'Well,' she said, 'please don't just use my first name, in solitary isolation, as the title, otherwise people are bound to think it's about a Paris street-walker.' There has been full regard for this injunction and I hope, dear Jackie, that you will like the contents. It is but a small tribute to a remarkable person and will, I think, cause some outbursts of what you describe as your other complaint – 'giggleitis'.

W.W.

Born for the Cello
by
MRS DEREK DU PRÉ

Jackie could sing in tune before she could talk. One day after her bath I was drying her on my lap and I started to sing 'Baa, Baa, Black Sheep'; she began to sing with me – just the tune. After a short while I stopped singing but she continued right through to the end.

Jackie, our younger daughter, was born at Oxford on 26 January 1945. As her father was a member of the Senior Common Room of Worcester College, the Provost gave permission for the christening to be held in the college chapel. Her godparents included Mrs Theodore Holland, wife of the composer – then professor of composition at the Royal Academy of Music – and Lord Lascelles (now Lord Harewood), who was a fellow cadet at Purbright with Jackie's father.

My other recollection from those early years of her musical abilities was when she was about three or four. It was at Christmas time and quite unexpectedly she said she would like to sing 'Away in a Manger'. So she duly stood up and sang it quite perfectly. I was very conscious that there was a great deal more to it than just a little girl singing. There was a special quality about it, quite devoid of the slightest precociousness. It was a perfectly rounded little 'performance'.

The whole of our family have their musical interests. Our eldest daughter, Hilary, is a professional flautist and teaches. Piers, our son, is an airline pilot and a keen singer although, admittedly, only as a hobby.

Jackie's choice of the cello as an instrument was firmly established one afternoon when we were listening to various

instruments being demonstrated in a Children's Hour programme. As soon as she heard the cello she said: 'Mummy, that's the sound I want to make.'

The first time she actually grasped a cello to play was when she was four. Mrs Garfield Howe, who was the pianist Denis Matthews's mother-in-law, came down to our home when we were living in Purley, Surrey, to instruct a small class of local children and brought with her a cello for Jackie to play. When I said to her afterwards: 'Jackie, good, that was very nice', she was absolutely enraptured.

'Oh, mummy,' she replied, 'I do so love my cello.' She said this with such a wealth of feeling, or so it seemed to me at the time, that I remember I started seriously speculating to myself about the future. For the following three months Mrs Garfield Howe continued coming each Saturday and it soon became obvious that Jackie was improving rapidly, far more quickly than any of the other children; her progress was quite phenomenal.

Jackie at eight months

Two of Mrs du Pré's illustrated compositions for Jackie

It was about that time that I began to write little pieces of music for her, pieces suitable for someone of her age and ability. I illustrated them with small sketches around the sides and slipped them under her pillow while she slept. In the morning she would waken early, leap out of bed to get her cello and play the latest composition, before even bothering to get dressed.

Her father and I were a little concerned about what next was best to do with her, as it was clearly apparent that she not only wanted but needed individual tuition. The dilemma was eventually solved

by her godmother, Mrs Theodore Holland, who knew Mr Whalen, then running the London Cello School. It was accordingly arranged for Jackie, then aged five, to give an audition for Mr Whalen. He was extremely impressed and at once suggested she have lessons with Alison Dalrymple, who taught at the school and had a great reputation for being good with children. On our way to her lessons, we would call in at a near-by café for an ice-cream or a cold drink. That was really the big moment of the day, because at the café there was a chef with a tall hat, and tall hats of every type had always held a great fascination for Jackie.

After her lesson she would usually go to see Mr Whalen and sit on his knee for a short chat. On one such occasion she interrupted the conversation by putting her head on one side and listening intently

Aged three

to the chimes of the grandfather clock in his office. After a moment or two she said: 'Do you know that that clock is out of tune?' She has always had the most amazingly good ear. After Jackie had been having lessons for about three years at the London Cello School, sadly, Mr Whalen died. It was anyway time for her to move on to another teacher and it was agreed that she should go to William Pleeth. She was supremely happy with him both as a teacher and a friend. He has a rare gift as a teacher; he is not merely a good instructor, he has the outstanding ability to coax from his pupils their latent potentialities. Under his gentle guidance Jackie developed apace.

When, aged ten, she competed for the Suggia Gift she was by far the youngest of the competitors and was in fact the first ever to receive this award. Her winning it meant that her lessons were paid

Jackie, aged five, practising with her mother and sister Hilary, aged seven

for and all manner of wonderful things were done for us; Jackie and I – she was too young to go alone – were sent one summer to Zermatt, where she had lessons with Casals. He, of course, had not heard of her. It was a summer school and each pupil played for him in turn.

After Jackie had played, he said to her: 'Are you English? No, of course you are not.'

And she replied: 'Yes I am.'

Then he asked her: 'What is your name?'

When she told him he roared with laughter, being fully convinced that she could not possibly be English if she had such a name (her father's family is from the Channel Islands) and played with such uninhibited feeling and intensity. It was, I recall, a memorable moment, for the great cellist was clearly very deeply impressed with her vital performance. She admitted to being rather 'bolshie' with Casals because she was so proud of her own teacher William Pleeth and was rather unreasonably reluctant to accept things Casals was trying to convey to her.

We always kept a firm restraint on our younger daughter as far as public performance was concerned. We were absolutely determined that in no way would her talent be forced or prematurely exploited.

Early concentration

However, she did make what was her first real public appearance when she played the first movement of the Lalo concerto on television at the age of twelve. Not long after that she returned to the television studio to play the first movement of another concerto, which was the Haydn D major.

When, after a competitive festival in London, a concert was given by the prizewinner, at which Princess Marie Louise presented the prizes, I recollect very clearly that we had a disappointed and rather dejected daughter to cope with because the Princess was not wearing a crown.

Early recognition of fun

Her first real concert-hall appearance was a recital at the Wigmore Hall in 1961 when she was sixteen, although she had previously played at the Sir Robert Mayer children's concerts.

There was, I believe, at one time, some talk of Jackie giving cello lessons to the Prince of Wales, who has shown a keen interest in the instrument. I can remember the Prince sitting in front of us at the Royal Festival Hall, during a performance of the Haydn C major Cello Concerto. I was told at the time that he was too shy to go round to see Jackie afterwards but, of course, I have no idea if that

*Pupils of the London Cello School, 1951; Jackie is seated, second
from left*

was true. They had met, though, some years before, after a
children's television concert in which Jackie played. Prince Charles
would have been about ten. He was most interested and afterwards
asked if he might examine the cello. Jackie happily agreed. But
when the Prince got astride the instrument and started to ride it like
a hobbyhorse she became absolutely furious, saying very angrily:
'Please don't treat my cello like that.' Another encounter with the
Prince was at St George's Chapel, Windsor, when Jackie and her
husband Danny gave a recital which he attended. That meeting was
enthusiastic if a little less exuberant. They all three talked happily
together afterwards.

Between the ages of sixteen and eighteen Jackie won most of the
available musical prizes and awards. But after her first batch of
concert appearances and the excitement of them she became greatly
depressed, mainly because she would then accept only a few
engagements and she seemed to be developing doubts about her
ability. It became imperative for her to find something else to do. As

if to create some yardstick, she took up all sorts of activities. She painted, she fenced, she did yoga; all manner of things were embraced in her efforts to overcome her frustration. It was not until a long time later that one felt she had finally come to terms with herself and made the decision to become a really good cellist. All this was possibly the metamorphosis of teenager to adult and one must accept that she doubtless felt a little bit lost, particularly after so much early success. Everything seemed to be resolved for her when she went to Dartington for Master Classes with Paul Tortelier, and afterwards to Paris for private tuition with him. Later she went to Moscow for lessons with Rostropovich. She told us that her studies with her three brilliant masters of the cello were, as one would expect, not only exciting but completely fascinating, although she has always considered Pleeth her real mentor and what she liked to call her 'cello daddy'.

She first became really busy when she returned from the Tortelier Master Classes. This was her first taste of travelling abroad alone and she thoroughly enjoyed the experience. In 1965 she toured America with the BBC Symphony Orchestra which was also there for the first time, winning a new and enthusiastic audience for the Elgar Concerto. She had a ten-minute standing ovation in New York. She recorded the concerto with Barbirolli and later on, again in America, with her husband, and she took it to Russia.

Jackie was in Israel with Danny giving concerts and recitals in 1967 during the Six-Day War. She rang up one Monday and said: 'We're getting married on Thursday, can you come?' It was not all that easy as planes were not running to regular schedule, owing to the war. Anyway her father, her brother and I finally arrived after making three changes, rather less than twenty-four hours before the wedding.

The ceremony took place in the old part of the City of Jerusalem, in the house of a rabbi very near the wall. It was rather like a scene from the Old Testament. A large table was in the centre of the room around which the men sat. The women, as is customary, were obliged to sit back around the perimeter of the room. It was a charming and fully traditional ceremony, children and chickens wandered around, as the front door of the house was open to the street. Afterwards there was a special lunch at the King David Hotel and amongst the guests were Ben-Gurion, General Moshe Dayan, Dame Janet Baker and Sir John Barbirolli. In the evening Sir John was conducting Beethoven's Choral Symphony, with Dame Janet as

*Jackie, aged six, rehearsing with her mother for a concert at the
London Cello School*

one of the soloists, in celebration of the Israeli victory. In proposing the toast Sir John made a most delightfully amusing speech and was obviously excessively happy. It was a most emotive occasion and a treasured memory.

The fact that Jackie cannot play is, of course, a great loss and sadly frustrating for her. But she continues to have her absorbing interest in music and to participate in the enjoyment and interpretation of the music-making of others. Her television Master Classes were so successful that they were screened a second time. Recording them not only gave her great pleasure, but a really profound sense of satisfaction in being able to pass on some of her knowledge and experience to others.

She has the pleasure, too, of occasionally returning to the concert platform with an orchestra to do readings, as with *Peter and the Wolf*. She also enjoys going to concerts as well as listening to recordings. Some of her own early recordings of various short pieces have recently been released.

There is another extremely comforting and tremendously important aspect of her life: she is fortunate in having a marvellous and devoted husband. With his tightly packed schedule of engagements he never fails regularly to set time aside to devote to her. Considering how much he is obliged to be abroad this is no easy matter. In spite of life's ills, Jackie is happily well aware and most appreciative of its comforting compensations.

My Goddaughter

by

THE EARL OF HAREWOOD

When I came back from the war in May 1945, one of the first people I heard from was Derek du Pré who told me he had a few months before had a daughter and asked if I would be a godfather. Derek and I had become friends when on an Officer Cadets Training Unit course in 1942, a rather dreary period relieved only by the expeditions one could make with friends. He and I used to bicycle over to Aldershot where his wife was in hospital, having just presented him with their first child, Hilary.

It was not until autumn 1945 that Jacqueline was christened and I went to Oxford for the occasion, agreeing with Derek that it was a moot point whether any of the godparents was in a position to support her at the font or whether the rapidly-growing child might not do it better herself.

I saw Jackie only intermittently as she grew up but news of her prowess as a cellist (her mother is a talented musician) was noised abroad, not least by Yehudi Menuhin, and I heard that she was keen to study with the great Russian cellist, Mstislav Rostropovich, whom I knew fairly well. Jackie and her mother came to the house where I then lived and played a Beethoven sonata to Slava's evident satisfaction. He sat down opposite her and made her imitate progressively more difficult exercises and figurations until she had reached the end of her technique. But a little later she went as one of his pupils to Moscow.

She played once at the Edinburgh Festival while I was there and in the late 1960s was quickly accepted as one of the best string players – the best? – England had ever produced. The prodigious talent was

not only unmistakable but irresistible, and the tremendous physical energy, which no watcher could miss, was in no sense a cover-up for a lack of it in her approach to the music nor did it contradict a wonderful smoothness and richness of tone in lyric passages. While I worked with the New Philharmonia Orchestra, I remember a not-so-successful performance of the Brahms Double Concerto with Giulini conducting, but that it was followed only a few days later by a performance of the Elgar Cello Concerto which was such stuff as dreams are made on.

Jackie was always in demand as a soloist and after she and Daniel Barenboim were married I used sometimes to visit them to fix up rehearsal details with one or other. I went to their flat early one evening to find Jackie with immense good humour throwing things together before rushing off to play in Paris. She kept the car waiting worryingly long but in the end dashed off confident she would make the plane. Daniel and I had more or less finished an hour or so later when she rang up to say she had missed the plane but would still

Aged eight

The whole family on holiday in Jersey, 1954, L to R: *Jackie, Iris, Piers, Derek and Hilary*

catch the last one of the day. It's not the helter-skelter life that impressed me so much, rather the enviable insouciance with which it was conducted.

My efforts as a godfather have come rather later than is usual, when Jackie could no longer play. So much has been written and said about her courage in adversity that it would be trite to add further words to the mountains which already exist. But certain aspects of her performing personality seem vividly apparent to this day. Her sense of fun, which must have made musical collaboration with her a total joy, is unabated; Jackie's bubbling laughter is familiar to anyone who sees her now. What may perhaps have been less evident in her playing days is the concern she has shown for other cellists, evident not least in the Master Classes she undertook a few years back for the BBC. She showed more than a talent for teaching; this was a true communicator at work on the material she understood best: human beings and music.

I suppose the only piece of luck she has had since 1970 has been hearing music which had not come her way before. I have been with her at the Coliseum at opera or ballet when it has been a privilege to share her joy in music she was meeting for the first time. Records not only give her pleasure but allow anyone with her to witness the sheer concentration and involvement she brings to *listening.*

Whether the music is of central importance or no more than an encore piece, she hears it as if it would fade without her effort, and, when one of her own recordings is on, that seamless 'legato' and rare, even tone seem to come almost as much now from this great listener as it did then from that great cellist.

Pupil Extraordinary

by

WILLIAM PLEETH

It was over twenty-five years ago that the child Jacqueline du Pré came to my house with her mother for her first cello lesson with me. In the previous year her name had been mentioned to me by a young lady of the Hampstead Choir – a Miss White – who chanced to hear Jacqueline and made the prediction that the child would almost certainly be coming to study with me one day. Some months later that prediction came true.

I shall never forget my first meeting with this ten-year-old child, who radiated a lovely sort of innocence, and played to me with complete lack of pretension. It was decided that we would work together, but the extraordinary thing was that, whilst I was immediately aware of a tremendous underlying talent, I didn't as yet realize what a powerfully explosive emotional force I had to deal with. The speed at which she could progress was so rapid that it was like trying to keep pace with a good thoroughbred horse that must be given its head. For instance, I vividly recall how, when she was thirteen, she came for her lesson one Wednesday, and I said: 'Well now, Jackie, we're going to start the Elgar Concerto, and one of the Piatti Caprices. So you'll get the book of Caprices, which are, of course, fiendishly difficult, and we'll start sketching one on Saturday.' Well, lo and behold, this child turned up on the following Saturday, sat down and gave a really fine performance, from memory, of the first movement of the Elgar; and then the first Piatti Caprice, which is extremely difficult, very fast, and two pages long, also from memory. And both very nearly impeccably performed!

When Jackie first played to me, I was struck by one quality in

Piers, Hilary and Jackie, 1955, the day before Hilary played the piano in the BBC programme All Your Own

particular, which is a rather unusual feature in very talented children – a complete lack of precociousness. In many cases early talent is accompanied by external signs, as though the children had an instinctive knowledge of their own abilities – occasionally they are aided unwittingly by parents – resulting in a certain amount of precocious confidence. But in the case of Jackie, the converse could not have been more pronounced.

She had a simple, calm confidence which was brought about by her complete involvement in the music she was playing, and was matched by a concentration of purpose most rare in any child. Even as the need became apparent for opening up a wider field for her study programme, this quality remained intact throughout the years. It was a quality on to which one could graft her other remarkable gifts, and which, in later years, was to make her performances so compelling.

On some of the occasions when my wife and I have visited her during the last two or three years, Jackie and I have indulged in a few minutes of playing cello duets together. So strong is this quality, that one's hearing of what is coming from her instrument soon becomes submerged in the spiritual quality that takes over – something that cuts right through the notes she is trying to play, and emerges as a moving force of great feeling. And this reminds me of another of her indomitable qualities – her humour!

On the first occasion following the onset of her illness that Jackie decided to 'have a go' with our cellos, the telephone conversation went something like this: '. . . and please,' she said, 'can you bring your cello? It will be an awful noise, and my bow will keep slipping over the other side of the bridge, but we can cross that bridge when we come to it!' What a courageous approach and remarkable sense of humour!

It would be impossible for me to capture so many years of study together in so few pages. She was never one of those machinelike fanatics about practising, and it was easy for me to encourage the courageous aspect of music-making – the very heart of spontaneous performance, which made her so exciting to listen to, totally devoid of the still-born qualities so often met with in some performers.

The excitement of making demands on her talents, and her ability to respond to these demands, made for an endless feeding and re-feeding that had the action of a pendulum – or a continuous series of brilliant volleys on Wimbledon's Centre Court. However, there always remained this quiet external calm of her 'outer' person – the

Some very early certificates and awards

outer shell never giving way to great dynamic 'inner' growth – a force which she brought to her playing very early in her victory at the Queen's Prize Competition, and, again, a year later at her remarkable début at Wigmore Hall. As we continued our work, not surprisingly, the demand for her playing began to gather momentum from the concert-giving world.

Everyone is aware of the dangers that lie in the path of such rapid conquests. I myself often pondered as to when Jacqueline should take a few months' break from concerts for the vitally important task of assessing and reassessing the direction in which her career was moving. But it is almost as though some secret agent knew what lay ahead, and brought about a concert timetable of long duration, condensed into a small time-span, thereby enriching the lives of so many people. And for this we, and future generations of music lovers, must feel eternally grateful and privileged.

*Jackie's first pupil, Anthony Pleeth, watched by William Pleeth,
1959*

Reviews of Jackie's Début

at

WIGMORE HALL ON 1 MARCH 1961

Over the past few weeks London musical audiences have heard several promising and more or less young recitalists. Of these Miss Jacqueline du Pré, who played the cello at Wigmore Hall last night, is but sixteen years old, and yet to speak of promise when reviewing her performance would seem almost insulting, for she has attained a mastery of her instrument that is astonishing in one so young.

The long programme seemed to tax her not one whit. Even a recalcitrant A string which forced her to make a second beginning to Handel's G minor Sonata at the start of her recital, could neither unseat the conviction of her interpretations nor disturb her technical control for an instant. After Handel she tackled the E minor Sonata of Brahms and gave it warmth and breadth in the first movement, an enchanting grace in the second and a vivacious intensity in the last that entirely dispelled the workaday gruffness of much of its counterpoint. Debussy's mercurial Sonata was equally well done, and after the interval Miss du Pré presented an account of Bach's C minor unaccompanied Suite that thrilled the blood with its depth and intuitive eloquence. She ended her programme to good effect by displaying her technique and the complete range of tone colours that she and her Stradivarius can command in a transcription of Falla's *Suite Populaire Espagnole*.

The Times

A tribute from Pablo Casals, Zermatt 1960

In Jacqueline du Pré, just sixteen, who gave her first Wigmore Hall recital last night, England has a cellist bound, in my opinion, to become a world-beater.

She has a prodigious talent. I reckon that already she is of virtuosic rank.

It was astonishing to listen to the sound that issued from her nut-brown Strad, sound enchanting, spontaneous and marvellously organized, thrilling in its emotional range.

The maturity of this child's performance was, indeed, almost incredible.

Jacqueline was born to play the cello. She thoroughly understands its genius, and so instinctive is her reaction to the music that one feels the subtlest ideas of the composer to be embraced.

She is in love with the cello. She sways it with her in each work. Her feelings – serious, stern, proud, triumphant – are shown in her movements and in her face.

With rich and burnished tone, decisive bow-strokes, dramatic pizzicato power, with keen articulation, fire, gentleness, the most delicate shading, she played Handel's G minor Sonata, the Brahms

Sonata in E minor, Debussy's D minor Sonata, and the Bach unaccompanied Suite No. 5.

What we saw and heard from this schoolgirlish artist was cello mastery.

<div align="right">Percy Cater, Daily Mail</div>

It is not often that the 'house full' notice is needed at Wigmore Hall, but it was on Wednesday for the recital by Jacqueline du Pré. She is that rarity, an infant prodigy of the cello, and rarer still in that at the age of sixteen she is already well on the way to a place in the top flight of cellists. At present her playing is rather impassive in its quiet mastery. The pleasure it gives is purely and 'classically' musical, and the beauty of her phrasing is in its poise, its perfect control of rhythm and tone, its purity of sound, rather than in any extra-musical or supra-musical expressiveness. The dexterity of her fingers and bowing wrist in the quick figurations of Handel's G minor Sonata had us gasping with the same sort of admiration as for a bass or a baritone who executes with ease coloratura passages that a soprano might delight in.

It was this work, with its strikingly Purcellian idiom, that produced her most stylish and animated playing, but her response to the wit of Debussy's Sonata was hardly less keen, and there was much that was beautiful and moving in her intimate, introspective and amazingly mature performance of Bach's unaccompanied Suite in C minor. She avoided Beethoven, and found herself slightly out of her depth only in Brahms's E minor Sonata, in which the form of the weighty outer movements was not fully mastered, and her tone, through no fault of her excellent partner, Ernest Lush, did not always get through. The deep boom of the instrument was there, but the actual notes did not always penetrate.

<div align="right">Colin Mason, The Guardian</div>

This country has produced very few string players of the first rank, but it may well be that last night's concert at Wigmore Hall revealed a cellist who will reach international rank. At sixteen Jacqueline du Pré plays with a technical assurance, a range of tone and a musical understanding that challenge comparison with those of all but the very finest cellists.

Her ability to carry through a phrase to its very end and the gravity and poise of her line-drawing were already remarkable in the finale of a Handel sonata. Her instinctive rubato in the trio of Brahms's E minor Sonata only emphasized the vigorous strength of her rhythms in general.

Brahms's last movement demands a greater volume of tone than she could quite muster (not that the duel with the piano is ever a very happy one).

But she brought to the Serenade of Debussy's Sonata a mock-rhetorical incisiveness and a gamut of colour from which only the composer's favourite silvery tone was perhaps absent . . .

Bach's unaccompanied C minor Suite showed her innate musical character. If the meditative movements were a trifle laboured and literal rather than freely expressive, this can hardly be held against so young a player.

We are accustomed to British artists who seem instinctively to divorce themselves from their music, but here is a young player whose technical accomplishments have not prevented her from being wholly committed to whatever she plays – and this is one of the first essentials of a great player.

Martin Cooper, *Daily Telegraph*

. . . Miss du Pré has already won important academic awards and has studied, *inter alia*, with Casals. She is, however, no mere industrious student and never once gave the impression of repeating a well absorbed lesson; on the contrary, she played with extraordinary maturity and assurance and in all her undertakings revealed pronounced interpretative individuality. In Handel's G minor Sonata, as elsewhere, she revealed an innate sense of style, produced a pure, rich tone and established a firm yet flexible line. The same virtues were again applied to the more searching test of Bach's unaccompanied Suite No. 5 in C minor; throughout, the technical control of an intractable instrument was consummate, while the clarity of articulation and luminous phrasing were *per se* a source of unstinted admiration. More important, the effect of the performance as a whole was to present unaccompanied Bach, for once, not as a dry academic exercise or essay in virtuosity, but as living music, and it is not an exaggeration to aver that such playing reminded us forcibly of Casals in his prime. Miss du Pré was fully equal to the

exacting demands of Brahms's Sonata in E minor; her reading had all
the requisite length and breadth of phrase, and to this was added a
warmth and expressive eloquence that seemed incredible in one so
young. Versatility was further demonstrated in a keenly perceptive
account of Debussy's elusive Sonata (1915) to which Miss du Pré
brought a remarkable range of tone-colour, and a long and taxing
evening ended with Maurice Maréchal's transcription of Falla's
Suite Populaire Espagnole. England has produced many capable
pianists, but only two cellists of the first order, both of whom have
now retired; if Miss du Pré continues to develop at her present pace
she should soon attain international status. She was greatly helped
by Ernest Lush who once again proved to be an ideal collaborator.

Musical Opinion

From Evelyn, Con Amore
by
LADY BARBIROLLI

Jackie was very fond of John, my husband. I believe she completely trusted his opinions and advice, which she would always listen to and follow assiduously.

She has such great vitality and warmth. John always said that all she ever needed to learn was to 'govern it a little'.

It was at one of the Suggia Awards that I heard her for the first time. John was one of the adjudicators and I had gone along to collect him. All the other adjudicators knew me and I was invited in to listen, instead of having to wait outside in the car.

Jackie, I would think, must have been about ten years old; her mother was accompanying her, but I am ashamed to say I cannot remember what she was playing. I do recall, though, being absolutely fascinated by what I heard. The girl was clearly so gifted, so immediately compelling. I still remember John talking enthusiastically about her as we drove away, and saying with absolute conviction: 'Well, today we have heard someone really special.'

I discovered later that Jackie herself had vivid recollections of that occasion. She told me that John had been most kind to her. In fact, she said he had helped her to tune her cello; being rather nervous, she had particularly appreciated this. As a cellist himself, he no doubt felt he should be helpful to a fellow instrumentalist.

Some while after John died I went to visit Jackie when she was living in Hampstead. It was soon after her illness had developed and she was in bed at the time. We had dinner together and talked about her predicament. I remember being amazed at her incredibly philosophical attitude, which was quite wonderful to witness. She told me that she considered she had enjoyed a jolly good run, even

Associated Press

*Jackie, winner of the Queen's Prize in 1960, presents the
traditional bouquet to the Queen Mother. Sir Charles
Kennedy-Scott, President of the Musicians' Benevolent Fund, is
in the centre*

though she was so young, and that this was something which was
not given to many people. She said that she was prepared to accept
the situation and make the best of things in whatever way she
could. I cannot believe that this is always so, although it was her
attitude that day. It is difficult for anyone, no matter how resilient
of spirit, to be resigned to the harsh blows of fate with constant
equanimity.

Now I would like to move back in time to 1967 and a really joyous
occasion. John had been asked to conduct the Verdi Requiem in
Israel, and our arrival there coincided with the end of the Six-Day
War.

There were some nine scheduled performances of the Requiem,
which were being given in memory of Toscanini and to mark the
twenty-fifth anniversary of the Israel Philharmonic Orchestra.
When we arrived at the airport we were met by the manager and
directors who thought the Requiem was far too solemn a work with
which to celebrate Israel's victory, and it was immediately agreed

that a change be made to Beethoven's Choral Symphony, a really appropriate choice and one which would use the soloists who were already there. I think the only rather disappointed person was Janet Baker who had particularly been looking forward to singing the Verdi.

It also transpired that Jackie and Danny had chosen the day following our arrival on which to be married in Jerusalem. They returned later to Tel Aviv for the reception and celebrations in the evening, which fortunately we were able to attend. It was a wonderful party, particularly so because we were celebrating not only the Barenboim wedding, but the fact that peace had once again returned to the troubled land of Israel.

A source of the greatest possible satisfaction to me were the television Master Classes. Maybe I was a little biased because I was so overjoyed to see Jackie making a comeback as a public performer, which by nature is basically her métier. I thought the programmes were really good; the fact of Jackie being unable to demonstrate mattered to me not in the least. The only minor comment I could possibly make is that, early in the series, she was so eager to help, advise and instruct that sometimes she would give the students hardly sufficient time to get going! I felt throughout each programme what a great inspiration she was and it was this that made them so compelling for me.

Teaching has provided a new dimension in Jackie's musical life. 'I have had to become far more articulate than I used to be,' she told me when we were comparing notes on teaching. 'When you can't demonstrate, words must be chosen with the greatest care and precision.'

There were times when I recall my husband saying that in his opinion she was touched by genius, and that was a word he never used lightly. So I was particularly happy last year, as President of the Incorporated Society of Musicians, when it was decided to give Jackie the Society's medal for outstanding musical achievements. The award was made not only for her work as a performer, but in recognition of her new and valuable contributions as a teacher.

There is a photograph of Jackie of which I am particularly fond. She sent it to me about two years ago. It was taken in the artists' room of a Moscow concert hall; on the back she has written: 'From Russia with love'. For her friendship, her remarkable contribution to music, her sense of humour and indomitable blitheness of spirit, I reciprocate sincerely: from Evelyn *con amore*.

Fiery Talent
by
GERALD MOORE

It is lèse-majesté in my opinion, concerning an artist of international repute, to want to know who was his teacher. Why must we be reminded that this past-master of his art had to be taught to draw a bow on the open string or play the C major scale on the pianoforte?

I now propose to commit the very offence which I condemn. In extenuation I must add that, like others, I have been a fortunate witness of the blossoming of Jacqueline du Pré from the precocious brilliance of her childhood to the radiant artist of authority that she is now. Therefore, with apologies, back to the drawing-board.

Under the auspices of the Arts Council of Great Britain, 'A Gift for the Cello in memory of Madame Guilhermina Suggia' was founded a year or so after the Portuguese cellist died, its object being to help promising students of the instrument. Sir John Barbirolli, who was a cellist before becoming a conductor, Lionel Tertis, Arnold Trowell and other distinguished string players and musicians were enlisted as a panel of adjudicators under the chairmanship of Eric Thompson, to hear these annual auditions.

When Jacqueline du Pré first appeared in 1955, she was ten years old, scarcely taller than her cello; her auditors were electrified after she had been playing for only half a minute. It was not until her third performance for the panel that I heard her for the first time; she was then thirteen, and it was obvious to us all that here was a genius in the making. I heard this amazing child for three successive years and her talent continued to flame. She was a bonfire.

Every musician knows when he faces the public that the first essential, before one single note is sounded, is concentration; every

With Paul Tortelier and George Malcolm (left) at Dartington Hall, 1961

other consideration must be banished from his mind. Only the music matters. He attacks! He does not indulgently allow himself a little time to 'warm up' or 'to get in voice'. Whether the player is a seasoned professional performing to a large audience or a child playing to a group of grey-beards on a jury, the impression made by the very first phrase has its effect. The truth of this was made plain at this particular audition. Before Jackie appeared, we listened to several talented youngsters. One of them, a young cellist of some fourteen summers, had been playing for less than a minute when a member of the panel sitting next to me hissed in my ear, 'This boy is asleep.' This neighbour, breathing fire, was none other than Lionel Tertis, in his nineties and wide awake.

Then Jackie appeared and she attacked.

What a responsibility to have such a girl as this under your musical tutelage! To this day she is grateful to William Pleeth for all the guidance he gave her. Here is an excerpt from his letter of recommendation when she was heard at the Suggia Award for the first time:

> She is the most outstanding cellistic and musical talent I have met so far, to which she adds incredible maturity of mind. I am of the opinion that she will have a great career and deserves every help to this end.

I quote this letter, not only as a compliment to Jackie, but to pay tribute to the generosity and unselfishness of Pleeth. A teacher, once in a blue moon, suddenly finds that a young student under his care is unusually gifted and is sometimes loth to part with him or her for fear of losing the glory that will rub off on to the teacher. Years ago I wanted a young cellist to go to Casals for lessons and she was as keen as mustard, but it was a fight to induce the London teacher to part with her. 'What can Casals give her that I cannot?' she demanded of me. Similarly, I know of a gifted singer whose brilliant voice is eminently suitable for the operatic stage, but when I made the suggestion to the young hopeful that a year's course at an operatic school was essential, I was told: 'I shall never, never leave my present teacher.' This attitude is not the fault of the student but of the teacher.

One can say that William Pleeth taught Jacqueline du Pré wonderfully and then, when the time was ripe and the moment opportune, helped to launch her into less sheltered waters to broaden her outlook and enrich her mind.

By the expression 'less sheltered waters' I am not suggesting that when she went to Moscow to study with Mstislav Rostropovich he gave her a rough time! He was, as always, an inspiration to the girl and when she returned to England an international career was opening out for her.

She had developed mentally and physically, musically and technically. Beneath the quiet surface were hidden all the emotion, the feeling, the sensitivity of your finished artist. In addition, to give them expression, were a wonderful bowing arm and a string hand strong and sure; intonation impeccable – quality of tone beautiful.

I partnered Guilhermina Suggia (often alluded to as the Teresa Carreño of the violoncello) very frequently and we were great friends, but I think that Jackie's tone had more body. I do not say this to belittle the Portuguese artist, for she would herself have acknowledged it, so ungrudging was she in her appreciation of her fellow players. In fact she played like a woman, whereas the English girl had the strength of a man. (To acquire a big tone becomes a fetish with some cellists and often – like singers forcing their voices – they gain it only at the expense of quality. Hans Kindler from the Netherlands forsook his instrument to become a conductor of the Washington Symphony Orchestra, but in his playing days would pretend to identify rival cellists in this manner: When asked: 'Do you remember X?' he would answer, after affecting to cudgel his

Daily Mail

Playing the Elgar Cello Concerto at the Royal Festival Hall, 1962

brains for a moment, 'Oh yes, now I remember him. Small tone.')

Strength, however, was probably the last thing that Jackie thought about when she played, for she was simply obsessed by the music and flung herself into it with utter lack of self-consciousness. I nearly wrote 'with fierce concentration' but the adjective would be false, for I have seen her and Daniel Barenboim at public performances exchange smiles or ecstatic glances during the course of some inspired dialogue between cello and piano.

There are no half measures with this young woman and there were no half measures when she was seized by multiple sclerosis. It was not a gradual attack which would enable her to carry on for a few years before it affected those wonderful hands and arms; it struck completely and with devastating speed. And this is where her greatness of soul has won the love of us all, for she has a radiance rising above all physical impediments.

'Wait a moment,' said Barenboim after one of his concerts, 'there is a beautiful girl coming along in a minute', and there she was in her wheelchair looking at her husband with love and pride, shedding gladness all round her.

And Danny, illustrious musician that he is, wanted everywhere the world over as a conductor, puts his beloved wife first and his dazzling career second. So as not to be too far apart from Jacqueline, he only accepts engagements that necessitate him being away from her for two or three days at the most, within an hour or so of flying time from their home in London. He and his wife are still perfect partners and no greater tribute can be paid than that.

I listened to her melodious speaking voice on the radio recently, and her high heart, her love of beauty, were made clear when she told her interlocutor that she hoped to express in poetry what she could no longer express in music. This was modesty indeed for she expresses herself cogently, kindly and to the point, in her Master Classes.

I shall always treasure the moments when I was associated with this wonderful artist; they were all too few, but I am grateful for them.

(Adapted from Farewell Recital, *London 1978)*

Gerald Moore joking with Jackie, from Country Life,
28 August 1969

Jackie Talking to William Wordsworth, 1969

When I married I became a convert to Judaism; it all seemed to happen quite naturally. I love Israel and the people. Marrying into a Jewish family presented no problems at all. It all seems to flow so smoothly.

I never had particular leanings towards any specific religion before I became a convert. The only feelings I had were, I suppose, of something abstract when I prayed. I think the thing that made it so easy for me is that the Jewish religion is perhaps the most abstract. Since I was a child I had always wanted to be Jewish, not in any definite way, because, of course, I didn't understand anything about it. Possibly it may somehow have been to do with the fact that so many musicians are Jewish. It seemed to be something that went with the profession and something somehow almost related to music. There's no person or image with Judaism or with music – nothing completely tangible – so the two things for me seem somehow bound together.

Life is incredibly important and every minute one must try to cherish. Since I changed my religion, I don't think I've made any startling leaps in character. This is something I have always felt I must try to nourish and improve every day.

I would like to think I play better now than before I was married. If I do, then it's most certainly due to Daniel's help and influence. To have such a common understanding and feeling about music is a wonderful basis on which to build a life together, a good 'compost heap'. To be compatible in every way and yet to offend each other musically would have been a ghastly situation leading, I suppose, to

eventual disaster. Of course, don't imagine we think completely identically about everything in music. We are simply agreed about basic principles. There is plenty of latitude left for trimmings and other details. And every performer must be allowed scope for individuality. I hope I'm a help in some ways to Daniel, too. Apart from all the normal joys of marriage, it's marvellous, when one has a musical problem, to be able to nudge someone in bed and say: 'Hey, what about this or that?'

It always annoys me that I need a lot of sleep. Sometimes more than the usual eight hours. Now, Daniel doesn't. Another failing which annoys me considerably is not practising as much as possible. It's fine as long as one's in trim, but if there's stuff to learn it tends to be left to the last minute. I suppose I'm not as self-disciplined as I should be. I love being alone in a room with a cello and just playing. It's a most exhilarating feeling; the practising part, though, I'm not quite so good at.

I find it very hard to appreciate much modern music. Maybe it's sheer laziness on my part, but I find I really don't like the sounds. When related to the cello, I like them still less because I feel they're anti the instrument. It's quite hard because, being a young musician, one's supposed to know about it and to be in with it all. There are, of course, some things that I like, but not very much and I really do try. I suppose it's so lacking in appeal for me I'm not keen enough to wallow in it and find out more.

Daniel really designs the whole shape of our working lives, trying to arrange for us to work together as much as possible or at least to accompany each other to engagements, otherwise we'd be in different parts of the world most of the time. We do manage in this way to get holidays together, too. We haven't had many lately but we shall do. There seems always so much activity and so many people with whom we have to be involved that days upon days go by without us being able to sit down for a quiet talk to one another. It's all most enjoyable, although there does come a longing just to be left on our own sometimes.

When I was ten I was given a scholarship to study for seven years. That was the period when I really did some pretty concentrated practising at what was, of course, the vital time. The thing was, I more or less left school when I was eleven; this was one of the conditions of the scholarship. And here is one of the problems of the English educational system: when one is very young, there is very little provision for doing anything needing special intensive study,

such as music, while still continuing one's education. I was just lucky to have a very understanding headmistress, who agreed I must somehow manage my schooling with about four lessons a week. Afterwards I had a coach brush me up. So, you see, I'm really uneducated or certainly under-educated. The whole world of my schooldays was the cello and I never wanted anything else. I do sometimes regret a little of my lost learning, but never the time I spent with the cello. The problem I had is now being solved by the new schools for young musicians – the Menuhin School and the Central Tutorial School at Morley College, where my mother teaches. Their ideas are marvellous, because they give both a thorough education and the time for students to practise, which is so vitally important. When I was young there was nothing like these schools, and for me it was a question of either/or; if you wait until schooling is finished it's about ten years too late.

Greatness and Modesty
by
ANTONY HOPKINS

I first heard the name Jacqueline du Pré after a long and frankly not very enthralling meeting of the Council of the Royal Society of Arts, of which august body I was then a member. A small concert had been proposed to celebrate some occasion whose significance has now completely escaped me.

'Might I suggest Jacqueline du Pré?' said the secretary with some diffidence. 'She's only sixteen, I know, but she's really very good.'

'If you say so,' I replied, anxious to escape from the stuffy, smoke-filled room in which I'd spent the last three hours. And so it was that I first met Jackie, accompanying her in some city hall on a somewhat formal occasion that could scarcely be classified as a concert; it was more of a diversion to entertain a not specifically musical audience. However, even the least musical person there must have been aware that here indeed was a formidable talent; the glorious tone, the intuitive phrasing, the total involvement that we all came to associate with her playing were already there. I was naturally thrilled as I always am by exceptional gifts in the young, and at once longed to pass on to her any knowledge of my own that might conceivably be of help. With her mother's enthusiastic assent it was decided that Jackie should come to me for an occasional lesson in the appreciation of musical structure, a general widening of her comprehension which, at that time, was instinctive rather than intellectual.

A few days later she arrived at my home in Brook Green, a shy, reticent schoolgirl who, in conversation, utterly belied the extrovert musical personality she had displayed when her cello spoke

Erich Auerbach

*Jackie, aged seventeen, in a solo appearance on television,
accompanied by her mother*

for her. We spent a couple of hours talking about Form, a subject on which her ideas were surprisingly hazy; but though there were prodigious gaps in her theoretical knowledge, her musical instinct was so sure that she could absorb with ease any ideas I put to her. She was able to identify so totally with the music that I soon realized that she could bypass most of the processes by which lesser mortals arrive at their conclusions. To my sorrow the 'lessons' were soon discontinued; here was a flower that could blossom gloriously without any aid from me.

Occasionally she would come of an evening and we would play sonatas together, although her technical command was so absolute that I always felt fumble-fingered by comparison. A trio concert with Hugh Maguire in Northampton stands out as a particularly joyous occasion. It was a rare pleasure for me to find myself playing in such company, though at times Hugh and I both had to offer a gentle rebuke, pointing out that the cello wasn't supposed to lead *all* the time. If I contributed something, however small, to her musical development, it would give me a feeling of pride, for without doubt she proved to be not just a great cellist but a truly marvellous interpreter.

On one occasion, early in her career she came to Norwich to play the Schumann Concerto with me and the wholly amateur Norwich Philharmonic Orchestra. Having played the concerto with deeply poetic insight, earning an ovation from a packed hall, she enchanted us all by sitting at the back desk of the cellos for the final item, Borodin's Polovtsian Dances. It was as though an electric charge had irradiated the entire cello section and they played as never before. It was the first (and only) time that I have known a cello section to have been led from behind to such effect. I am sure that not one of the players present will forget that gesture on her part. She, the acknowledged soloist, joined with them for the sheer fun of the music, showing that she combined greatness with modesty.

The cruel extinction of her meteoric career was something to destroy one's belief in any justice, divine or otherwise. At least, though, she knows what it is to achieve an absolute summit as an artist, and in doing so to inspire not just admiration and wonder but also love.

A sketch of Jackie by Zsuzsi Roboz

A Tale of Two Cellos

When, at the age of five, Jacqueline du Pré was taken to the London Cello School to start regular lessons, she insisted, not entirely unreasonably, on taking her cello with her. It was a full-size instrument and rather larger than its youthful owner. To her great dismay it was immediately put aside by her teacher and a smaller one provided for her use. This was regarded by the young player not only with grave disappointment but also as a serious affront to her dignity.

As if by way of making amends, some ten years later, just before she was to make her professional debut at the Wigmore Hall, she received from an anonymous donor the gift of a cello made in 1672 by the master maker of stringed instruments, Antonio Stradivari.

Another five years passed by and a telephone call came from Charles Beare, the well-known London dealer in stringed instruments. He said that he had a cello in his shop waiting for Jacqueline du Pré to try and, if she liked it, it would be given to her. It proved to be not only a glorious sounding instrument but a beautiful looking one as well. She was utterly overjoyed and immediately accepted the generous gift most gratefully.

The mysterious donor, if it was the same one as before, had been yet more lavish with the second gift. This cello was the 'Davidoff' Stradivarius, so called because it once belonged to the Russian cellist Karl Davidoff (1838–89). It was made in 1712 and the story goes that in the early nineteenth century a Count Apraxin sold the instrument to a Count Wielhorsky. The price was a Guarneri cello, a pedigree horse and about £4,000 in cash. Count Wielhorsky, to

A selection of programmes and posters

celebrate his eightieth birthday in 1847, presented the cello to the young Russian virtuoso Davidoff, who kept it until he died.

Another well-known firm of London stringed instrument dealers, Alfred Hill & Sons, have recorded that the 'Davidoff' went to Paris in 1900, when it was sold to a wealthy amateur. In 1928 it again changed hands, this time going to America, where it was bought by Herbert N. Straus, a music-loving department store executive. He acquired it to complete a quartet of Stradivari instruments which were used for playing chamber music in his home.

When Mr Straus died, his widow asked Rembert Wurlitzer, then a leading firm of fine stringed instrument dealers in New York, if they would find a buyer of the 'Davidoff' for her.

When Charles Beare received a call from a London firm of solicitors asking if he would look out for a really outstanding cello to be purchased by one of their clients as a gift to Jacqueline du Pré, he immediately contacted New York and Mrs Wurlitzer brought the instrument to London where the sale was concluded. The dollar

price paid was believed to have been close to six figures.

The 'Davidoff' is to the pattern of some twenty surviving Stradivari cellos which are recognized as being the very greatest of stringed instruments. Amongst these it is generally considered to rank as one of the three finest cellos in the world.

W.W.

An Angel of Warmth

by

RAYMOND ERICSON

New York Times, Saturday, 15 May 1965

Someone knows Jacqueline du Pré's worth. The twenty-year-old English cellist, who made her New York début last night in Carnegie Hall as soloist with the BBC Symphony Orchestra, was given the 'Davidoff' Stradivarius cello last year after it had been bought anonymously for an estimated $90,000, said to be the highest price paid for a stringed instrument.

Miss du Pré did not play the 'Davidoff', but used another Stradivarius, dating from 1672, also presented to her anonymously. She showed that she deserved the best.

A tall, slim blonde, Miss du Pré looked like a cross between Lewis Carroll's Alice and one of those angelic instrumentalists in Renaissance paintings. And, in truth, she played like an angel, one with extraordinary warmth and sensitivity.

Her vehicle was Elgar's Cello Concerto. It dates from 1919, which made it eligible for the orchestra's series of six programmes here, devoted to twentieth-century works. But it is pure romanticism in style and flavour and could just as easily have been composed in the nineteenth century.

Miss du Pré and the concerto seemed made for each other, because her playing was so completely imbued with the romantic spirit. Her tone was sizeable and beautifully burnished. Her technique was virtually flawless, whether she was playing the sweeping chords that open the concerto, sustaining a ravishing pianissimo tone, or keeping the fast repeated-note figures in the scherzo going at an even pace.

Astonishing was the colour she brought to the concerto's

dominant lyricism, the constant play of light and delicacy of emotion in a fresh, spontaneous, yet perfectly poised way.

At the end of the concert Miss du Pré was brought back to the stage again and again by the large audience, and she was applauded by her fellow musicians in the orchestra. One performance does not indicate the range of an artist, but at least in the Elgar concerto the cellist was superb.

Sharing a Language
by
YEHUDI MENUHIN

How rare it is and what a joy to write with full, free heart and mind about someone one really loves, respects and admires.

Not, I hope, that I have often been a Happy Hypocrite singing praises slightly off-key in an effort to fulfil a courtesy out of duty and demand. For I have been singularly fortunate in my friends and colleagues, and can it be that musicians really are of such a high standard as nice human beings? That question has to remain rhetorical out of modesty, for I am one of the band myself and would dread to think I were perhaps the exception to the rule I have just presented above.

But to return to the young friend and colleague about whom I am writing these words: Jacqueline du Pré. Jackie has always held a very special place in my heart from the time when, as a member of a jury of three, I first heard her play at the Royal College, for seldom can one say that one has been suddenly inspired, not by a professional of long standing and experience, but by a sixteen-year-old girl whose whole language was music, who had that marvellous conviction and comprehension of what she was saying that can only spring from having been born trailing clouds of glory. It is not necessary to talk about technique, for it was her complete control of the cello that freed her to play as she did, to sing the phrases with that full-blooded and yet so sensitive approach that makes her unique and that is her great gift.

To this day I can recall the elation she brought me and all the other listeners whom she set alight with the excitement of her own joy and intoxication with the music. I remember whispering to one

FROM SIR MALCOLM SARGENT, 9 ALBERT HALL MANSIONS, LONDON, S.W. 7.

30th November 1964.

Dear Jacqueline

Alas I have not had a chance of meeting
you with regard to the Delius Cello Concerto -
I have been abroad and am just off again, but
I shall be here from the 13th December and
shall telephone you hoping that we can perhaps
meet and can have an hour together looking at
the Concerto, preparing for the recording.

I am very anxious that we should do a
public performance of this, and the Royal Choral
Society have agreed to make half of one of
their concerts Delius and with you as the
soloist. It is of course a choral concert, but
we shall have this as a solo item with the Delius
Concerto. The date is March 22nd 1966. Would
you please keep this date for me and let me
know when this is definitely booked. We can
then set to work with your Agents if necessary
but I wanted you to be prepared for this as I do
hope you can come.

all good wishes -
Yours very sincerely,
Malcolm Sargent

Miss Jacqueline du Pre,
63 Portland Place, W.1.

Sir Malcolm Sargent's letter and Jackie with Sir Malcolm and Ronald Kinloch-Anderson during a break in the recording of the Delius Cello Concerto, 1965

of my neighbours, 'I'm sure she is studying with William Pleeth' –
and indeed she was.

Shortly afterwards, as President of the National Trust Society's
concerts, I asked her whether she would care to join my sister,
Hephzibah, and myself in giving a trio recital at Osterley Park. It
was quite a new sensation for both of us, I think, suddenly to realize
that we no longer represented the younger musicians as we had for
so long, but were now sedately in our early forties and that this
passionate and gifted young sprig probably felt, exactly as we had,
that mixture of adventure and the unknown adding itself to the
sheer joy of playing. If I turn aside here to say that we still feel the
same thrill, I hope it will be understood as an example of the good
fortune of the musician to be so constantly renewed and not that
dear Jackie had to join a pair of deep-frozen prodigies. Be that as it
may, we had a lovely time together, the rehearsals were minimal for
we found we shared the same language. What more can one say
about a sixteen-year-old girl barely out of the Royal College who
was at one and the same time sweet and easy in character, totally
unselfconscious, and yet sure, steady and utterly musical?

She brought the same combination of ease and profundity, too,
when she joined Louis Kentner and myself in what I believe was her
first BBC broadcast not long after this. And there were other joys:
when Jackie and Maurice Gendron joined in the slow movement of
the Schubert two-cello Quintet for a BBC programme called *The
Menuhins at Home,* or again when were were all together with
Alberto Lysy's Camerata at Sermoneta and we shared that same
natural, joyous music-making that is the dream of all musicians. It
was there, incidentally, that she first confided in me about a
worrying sensation in her right arm – the first indication, I suppose,
of the impending nightmare that would have destroyed any other
young woman than Jackie. Those very qualities: strength and joy,
passion and directness that were her musical voice are palpably her
true character and she has proven this ineluctable fact in the
wonderful way she has accepted the cruel blow that was to cut short
a brilliant career.

But has it cut it short? To my way of thinking, only in the sad fact
that she can no longer perform, but not in any other way, for she is
transmuting her tragedy into what is virtually a triumph – a
triumph of mind over matter, making of herself a shining example
to all other sufferers from her disease. What she is in fact doing is
actively analysing that word 'dis-ease', rejecting the first syllable

and only accepting the second, easing herself from her plight in those inspiring Master Classes, showing with a lightness and intensity that nothing is ever lost. Here is Jacqueline du Pré, the deep musical mind, the intuitive musician offering all her gifts and her experience with generosity, skill and gladness. Here is the living creature of whom Shakespeare wrote:

> In sweet music is such art
> Killing care and grief of heart . . .

And by her side all this time she has had Danny, whose character, like hers, is a reflection of his music: highly gifted, sensitive, sincere, strong and patient – a wonderful piece of good fortune for her and a man for whom I feel the deepest respect.

Looking at her, listening to her, one feels humble before such a spirit, ashamed of ever indulging in self-pity, proud to have shared, however little, in music-making with her.

Bless you, Jackie, you are a lesson to us all.

A change of instrument: Jackie on the violin, Yehudi Menuhin on the cello, Ernst Wallfisch in the centre

Jackie by Zsuzsi Roboz

'The Bolt of Cupid'
by
DAME JANET BAKER

Daniel Barenboim and I used to give recitals together and he was a wonderful pianist with whom to work. It was not until much later in our association that I met Jackie.

In 1967 I went out to Israel where I was to sing in nine performances of the Verdi Requiem, conducted by Sir John Barbirolli. We arrived just after the Six-Day War and, not unreasonably, we were asked to change the programme. Everywhere, as was to be expected, there was a generally infectious air of celebration and rejoicing. From a purely professional point of view I must confess I was most disappointed; I had been looking forward with great anticipation to singing Verdi with Sir John. It is, after all, a much more satisfying undertaking for singers than Beethoven's Ninth Symphony which took its place.

A great compensation for my disappointment was being in Israel then, a time when, quite unexpectedly, at least for me, Daniel and Jackie decided to arrange their own victory celebrations by getting married. I was fortunate in being able to join in the festivities and go to the wedding reception in Tel Aviv. Jackie's parents had flown out specially from England and, I seem to remember, were staying with the visiting musicians and singers at the Orchestra House.

It was all most exciting; the whole time was quite extraordinary. We were all very conscious of participating in what would be regarded as a historic event. In addition to this there was the wonderful personal aspect of the wedding, with the joy and happiness which these two young people were able to share with their families and friends. The two events, one momentous, the

other intimate, somehow seemed to complement each other emotionally.

It was an unbelievable time to have chosen for a wedding, the very atmosphere seemed charged with wonder and rejoicing. Everywhere feelings ran high; Jerusalem was again a united City and the Wailing Wall of Solomon's Temple had been uncovered. Relief and happiness abounded; it seemed to be cascading through the ancient narrow streets and in the midst of it all was this radiant couple. Their sheer blissful elation was really something to have seen; it was such as to have left the deepest of impressions. Far removed from the proverbial happy pair, they were somehow touched, it seemed to me, by an ethereal magic. I remember thinking then that I could well have echoed Oberon: 'Yet mark'd I where the bolt of Cupid fell'.

In the ensuing years, every time we saw them in New York or London, at concerts or around a supper table, the intensity of feeling between them was so clearly apparent. I can so distinctly recall thinking that the affinity between them was so extraordinarily vital as to seem, in human terms, impossible to maintain. They were rather like two shooting stars and every time I saw them I expected to find them orbiting more slowly, calming down as couples do in most marriages. Sometimes, as I watched them, I would have the direst fears that so all-consuming a relationship would burn itself out.

In retrospect, of course, one sees what the cruel fates decreed; how a distillation of an emotional lifetime was crowded into just a few years. With hindsight one is so deeply grateful that they had this quite remarkable time together. The energy emitted by the two of them was quite staggeringly overpowering. They were so closely involved with each other on so many levels, it was a prospect of really great beauty, with mutual involvement enough for seven lifetimes.

Another remarkable relationship which particularly impresses me is that between Daniel and Zubin Mehta. I cannot ever remember seeing a closer comradeship between two men, with such a genuine concern and understanding for each other's personal as well as professional problems. It is clearly a very rare friendship indeed.

Unlike so many of us, Jackie has always had the knack of 'switching off' when she has finished work and this is really a tremendous asset, resulting in her being such an extremely well

balanced person. There was an occasion after a concert when we were together in a small supper party which included Pinky and Genie Zukerman; across the table relaxed fun and witty exchanges were being enjoyed between Jackie and Genie. Then, without warning, to the considerable surprise of other diners, these two young, beautiful women resorted to pelting each other with paper pellets. The rest of us were just busy talking about our work as, I fear, we are rather too frequently prone to do. But Jackie has such a natural ability to digress into frolicsome forms of relaxation which is a joy to see and the envy of those of us who are more inhibited. I have seen this tendency in many great musicians: a great sense of enjoyment of nonsense and trivia, as important in its way as the work on a concert platform.

Always a deeply committed musician, Jackie has a facet of her character which sometimes seems to be that of a disarmingly natural child, added to which she has a highly developed sense of the ridiculous. Fortunately, even now, in spite of everything, she still retains that sense of humour and unreality.

Cardus Pays Homage

With the arrival in Edinburgh of multitudes of Londoners and other aliens, the Scottish summer collapsed last night, and, in spite of torrents of rain, the Usher Hall was packed to hear the London Symphony Orchestra play the fifth symphony of Schubert, Dvořák's Cello Concerto, with Jacqueline du Pré as the soloist, and Bartok's Concerto for Orchestra, all conducted by Istvan Kertesz . . .

After the elaborate orchestral introduction of the Dvořák Cello Concerto, Jacqueline du Pré attacked her instrument with so much energy and thrash of bow that I said to myself 'she is going to break a string', which she did, soon after her first entrance, following the glorious horn melody. She apologized to the audience amid universal applause, retired from our sight for repairs and another string. Her reappearance was the occasion for another ovation from an audience whose reactions had been changed from the musical and aesthetic to the sporting. The concerto was not resumed from the beginning, but from the most convenient bridge passage. The young cellist was not at all put out of mood; and in fact she played with a range and controlled musical energy surpassing even the best I had heard before of her rare and richly endowed art. Her soft playing and her variations of tone in the slow movement were simply beautiful. Not since Casals have I heard a cello sing with so much lyrical warmth as Jacqueline strokes or caresses from it. And added to heart-easing song was strength and breadth of attack and phrase. This Jacqueline du Pré is nature's most precious gift to English music since the advent of Kathleen Ferrier. Pianists are two a penny nowadays; cellists are as scarce as sunshine in the England

of the summer of 1968. And a superb executant of music, an artist of her or his instrument, is a more valuable asset to our music than any second-rate and supposedly 'creative' composer . . .

Neville Cardus, *The Guardian*, 26 August 1968

Casals Is Deeply Moved

Earlier this week, a younger musician brought tears to Casals's eyes with a performance of the Elgar Cello Concerto, a work he had performed in London in the early 1920s before King George V.

Here it was Jacqueline du Pré, the twenty-three-year-old English cellist, who performed the difficult piece, with Daniel Barenboim, her twenty-six-year-old Israeli husband, conducting the orchestra.

Miss du Pré, a tall girl with long wavy fair hair, was called back to the stage six times by a standing ovation. Backstage, after the concert, the two young artists were embraced by Casals, who had listened to the performance from a high-backed chair placed in the wings.

'I always said you can't be English with such a temperament,' he told the beaming Miss du Pré. 'Of course it must come from your father's French ancestors. It was beautiful, beautiful. Every note in its place and every emphasis so right. Beautiful.'

Henry Raymont, *New York Times*, 8 June 1969

Musicality Comes First
by
PLACIDO DOMINGO

I have heard Jackie in performance only twice. In 1969 I was singing in *Carmen* in Tel Aviv and I heard that a concert was to be given in Caesarea, which Daniel Barenboim was conducting. Naturally I knew of Jacqueline's great reputation, but I was certainly not prepared for the incredible brilliance of her artistry. Her striking appearance, the flowing blonde hair, sitting there with her cello waiting for her moment of entry, with all the compelling appeal of a modern Mélisande. From the moment she began to play I found myself hypnotized by her. Immediately I was aware of the artistry, concentration and power that was being marshalled to make her cello sing in a way I had never heard a cello sound before. Those were my first impressions and it was indeed a memorable experience. After the concert I met Jackie and Daniel and we have become the greatest of friends; although, owing to our various engagements, it has never been possible to see as much of them as I would wish.

The second time that the three of us met they were playing the famous Piano Quintet in A major by Schubert, with Zubin Mehta, Pinchas Zukerman and Itzhak Perlman, of which Christopher Nupen made a splendid film which has been seen on television all over the world. This blithe and lyrical quintet earned its nickname from the fact that the fourth movement is a set of variations on the tune of Schubert's song 'Die Forelle' – The Trout. This was another great occasion for me. I was able to attend the rehearsals as well as the actual performance when it was filmed. Again I recognized Jackie's amazing qualities and marvelled at this superb way of

making music. Such a remarkable band of talent combining together, not only to produce a memorable performance for an audience, but the better to enjoy their own music-making. Mingled with my feelings of appreciation and enjoyment, I remember experiencing a great sense of regret that I could not be up there on the platform taking part and enjoying it with them. I am not an envious person, but I never before felt so strongly that I did not want to be just sitting there as a member of the audience. I had a tremendous desire to be up there with them, singing some libretto for tenor which, alas, of course, does not exist.

Sometimes when I had been recording with Daniel I would go home with him to see Jackie. On one such occasion I happened to mention to her that my favourite musical instrument is the cello, which I always like to imitate with my voice, especially in the legato passages. So, as soon as I had said this, Jacqueline decided she was going to start teaching me to play the cello. There is not yet much I can play. Not being very often in London with much spare time I have so far only had about a couple of lessons; consequently I am not yet a virtuoso, although I am really amazed at what Jackie has managed to teach me in such a very short time. When she came to a performance of *Otello* at Covent Garden, I mentioned to her that when I am next in London I will bring my younger son, who is now a teenager – he is also named Placido – and he is studying the cello and I much hope that she will teach him. He is doing very well with his studies and maybe it would be an opportunity for me to continue my so-called lessons. You see, previously I was a very bad pupil because I found it so difficult to separate the feeling of playing an instrument like the piano from the entirely different technique of wrist and arm movements needed for bowing which Jackie tried to explain to me. I found this extremely difficult. Anyway, I was awfully pleased to be told that, in spite of my problems, I made 'a good sound'. From her that was a great compliment.

The incredible thing to me is how seldom in life people will accept sickness in the way she does. She is so wonderfully philosophical. I feel that her love of human beings and music are so very vital and sustaining for her. Her Master Classes are quite wonderful. I do believe that music is for her a really great companion and motivating force. I have to confess that I could not honestly say that, in similar circumstances, I could rely on myself to react so magnificently.

I am very thrilled that on various occasions she has come to the

opera. She came to see *La Fanciulla del West*, *Luisa Miller* and *L'Africaine*, besides *Otello*. This indicates to me that she gets great enjoyment from opera, otherwise I am quite sure she would not come. I had reason to notice how intently Jackie listens to opera from remarks she made about a recording Daniel and I were making of *La Damnation de Faust*. I was singing an A flat when Daniel stopped and asked me to do it piano – really in head-voice. Her comment later was that it was so interesting to hear it done both ways and being able to make comparison. She went on to say she preferred the A flat to be soft because it was more in context, having a far greater feeling of musicality than doing it mezzo forte. She said she could never make herself accept anything that sacrificed musicality to theatricality.

Whenever I come to London I always look forward to getting together with Jackie because I really enjoy her company and sharing her love of music. In fact I think of it as an injection because I find that just by talking with her she can give me a renewed love of life in all its many aspects. My great regret is that I am not able to spend more time with her or even to make music with her. My piano playing is only very average, but one day I would so love to accompany her when she is playing the cello. I shall live in hope.

The Importance of
Being a Teacher
by
SIR ROBERT MAYER

I am not absolutely certain, but I can only think that I must have first heard about Jacqueline du Pré from William Pleeth. Of course I have always known him to be not only an excellent teacher of the cello but a very lively person and, what is most annoying, insufficiently recognized. It has always been a great source of surprise to me that people should want to rush off to so-called celebrated teachers abroad when we have such outstanding ones in this country. To me it is all nonsense.

The Attlee government did an unprecedented thing in Britain by agreeing to support the arts through the Council for the Encouragement of Music and the Arts (CEMA), now known as the Arts Council of Great Britain. We teach children important dates at school and we should most surely teach them that date, which was 1945. Like Pandora's Box, this released great artistic forces which we never knew existed. We were to discover that there were so many artists destined to become internationally famous because of this revolutionary move to help the arts. Perhaps this may seem a far cry from my subject, but it is not. I think we have to thank the enlightened Attlee government for Jacqueline du Pré and many other brilliant artists who have emerged as a result of the encouragement offered by public subsidy for orchestras, theatres and artists.

Jackie was not much older than sixteen when she first played for our children's concerts. She and I have met together many times; after all, the musical fraternity is a fairly small circle. There is something I remember particularly. It was some years ago and I

think perhaps it was at the Austrian Institute and I expect there must have been some distinguished Austrian musicians playing. I distinctly recall seeing Jackie somewhere at the back of the room near the door, watching very intently. I think, although I cannot be absolutely certain, that she was watching Danny Barenboim who was at the piano. She appeared to be absolutely galvanized. I should be surprised if I am wrong because such a recollection cannot be invented. Of course, I must have met her between the children's concerts and that time at the Austrian Institute, not necessarily with William Pleeth but with someone or other. And then, very soon, she became that extraordinary player who was eventually to marry Barenboim. I like to think my strong recollection of her watching him playing was in some strange way prophetic.

I meet her now mainly in concert halls. When she goes everyone knows she is there. I hear, too, a lot about her teaching and her highly successful Master Classes. When I met her recently I told her that next time she was invited out to dinner by one of our many mutual friends, perhaps she could arrange for me to have an invitation for the same day, since we both frequently enjoyed our friends' hospitality but always on separate occasions. Because of her illness and the fact that I am immobilized by arthritis (to say nothing of being more than a century on this earth), we both rely for mobility on wheelchairs. So, when Greek meets Greek I think maybe we should have dinner together.

Today we live in an age of materialism and real values are distorted. It all seems to be a matter of how much you have got in the bank. So, I am particularly pleased and interested that Jackie is giving lessons. This is something of great importance and not mere materialistic value. It is perhaps a cliché now to say London is the musical centre of the world but it is nevertheless a fact. It has more opera houses and orchestras than anywhere else. Only one thing is missing: no one comes to London specifically to learn musician-ship. Not, that is, in the way that in my young days they went to teachers abroad. Then they would go to Frankfurt for piano, Leipzig for conducting, Dresden for singing and to Dr Boulanger in Paris for general musicality. I believe there is now a great opportunity to make London the seat of musical learning.

The first step is for the professors at our musical colleges to be properly paid instead of getting the pittance they now receive. Even though they were recently given what was thought to be a large increase, they are still miserably underpaid. The great teachers, like

Time Inc.

A joke with Mstislav Rostropovich

Eva Turner, for instance, who now teaches privately, and Alfred Brendel, who both plays and teaches, are here in London, although for some of them it means a considerable sacrifice because of taxation. In my opinion we cannot progress much further in London with musical performance, although we can go a hell of a lot further as a centre for teaching. It is most unfortunate that Jackie is now only teaching and not playing. However, one could not wish for a better or more dedicated instructor; it is something for which she most clearly has a gift.

It is really a very great pleasure for me to be able to pay tribute to Jackie and through her to draw attention to London as a prospectively great musical teaching centre. I hope there are those around who will start to recognize this and not just continue to think of London as the place for having their suits made in Savile Row.

I would like to end by mentioning that Jackie is fortunate in having a most marvellous husband. Daniel works so hard, but makes certain he is able to spend time regularly with her, even if it means that he has to cancel engagements. They both have my sincerest and warmest regards.

Fun and Laughter
by
ZUBIN MEHTA

It was in the summer of 1966, at Spoleto, in Umbria, central Italy, that I first met Jacqueline du Pré. I was doing an oratorio at the festival organized annually by Gian-Carlo Menotti; she was playing chamber music. Although I had heard of this new talent in England, so far as I can remember, I did not, on this occasion, hear her play. Early the following year we met again, this time in London at a rehearsal of the Mozart Requiem, which Daniel Barenboim was conducting with the Philharmonia Orchestra. It was in fact a chorus rehearsal and Jackie was just sitting there listening. This occurred to me at the time as being rather odd and I recall it set me wondering and possibly doing a little speculating.

I had then heard not a word of anything that was most probably afoot. No doubt others of their friends may well have been better informed. My friendship with Daniel is of necessity mainly conducted by long distance telephone, which does not give the opportunities to say and discuss all one would wish; person to person meetings are regrettably few.

Later in 1967 we were all involved in going to Israel. This was to prove a momentous time for the three of us. Jackie and Daniel had arrived eight days before me to give recitals at the Kibbutzim; with Israel at war they felt they must make what contribution they could. It seemed extremely doubtful if the concerts I was scheduled to conduct would ever take place, nevertheless I was determined somehow to get to Israel. Having reached Rome, it was with the help of the Israeli ambassador there that I was allowed to board an El Al plane. It was a highly secret arrangement because the plane was

carrying not passengers but arms and ammunition. The plane touched down at night, with Tel Aviv in total blackout. I was met by Zvi Haftel, head of the Israel Philharmonic Orchestra committee, who welcomed me in his pyjamas. From him I first learned that Daniel and Jackie were planning imminent matrimony. At the Orchestra House, where visiting musicians stay, I found Jackie, Daniel and his parents and Sergiu Comissiona, the Rumanian-born former conductor of the Haifa Symphony Orchestra and his wife. All were sleeping in the basement of the building, treating it as an air-raid shelter. Considering that the Israelis, in their first attack, had disposed of the Egyptian airforce, this seemed a rather excessive precaution. We all stayed awake laughing and playing jokes and virtually had no sleep at all. Poor Comissiona was the chief butt of our fun. When he went to get a glass of water, I jumped into bed with his wife. The room was in darkness when he returned and the poor fellow was extremely perplexed. Affected by the tensions of a country at war, we played these childish pranks to retain some sense of normality.

Full of confidence that the war would be over soon, we set to planning a 'victory concert'. I was to conduct, Daniel would play the Beethoven Emperor and Jackie the Schumann Cello Concerto, with the Beethoven Fifth for a big triumphant finish. Surely enough, on the following Saturday, the Gala Victory Concert took place in Jerusalem, at last a reunified city under the control of Israel. With at least half the audience in khaki, it was understandably an overwhelmingly emotional occasion, although I would concede it was not the greatest music the Israel Philharmonic had ever produced.

In the midst of the confusion of the aftermath of war, Jackie and Daniel announced that they would be married on the following Wednesday. I learned that Jackie had been having religious instruction in London, preparatory to her conversion to Judaism and that the wedding was to be strictly in the Orthodox faith, including the ritual *mikvah*, or purifying bath for the bride.

Being the only member of the wedding with transport, I had to drive the chief participants about in my borrowed car. I was absolutely determined to take part in the ceremony too, although Daniel said the rabbis would not allow me to be a witness and probably would not even ride in my car if they knew I was not a Jew.

So Daniel decided upon a plan. He told the rabbi who was to perform the ceremony that I was a recently immigrated Persian Jew

*Daniel Barenboim and Jacqueline du Pré marry in Jerusalem
immediately after the Six-Day War of June 1967*

named Moshe Cohen. In those days I knew not a word of Hebrew,
but most Persian Jews did not speak the ancient language either.

Having collected a venerable rabbi, we drove him and Jackie to
the *mikvah*. As we sat quietly in the waiting-room, Daniel most
unexpectedly became extremely excited and began shouting at
some other rabbis who were gathered in the passageway outside the
waiting-room. He had good reason to be incensed, for he had
realized that what was concentrating their attention was that they
were peeping into the room where Jackie was standing completely
naked.

Order having been restored, we all got back in the car and I drove
out to what is now the Jerusalem Music Centre. It was just on the
border of what then was the 'no man's land' that used to divide the
City. In a small house, just below the big windmill, Daniel and
Jackie were married, and at the ceremony a certain 'Moshe Cohen'
held one of the poles of the *chupah*, the canopy under which the
bridal couple stand.

A celebration lunch took place afterwards at the King David

Hotel. At the adjoining table, discussing Israel's future, sat David Ben-Gurion, Teddy Kollek, Mayor of Jerusalem, and Defence Minister Moshe Dayan. Discussion at the wedding table was about organizing a hastily arranged goodwill tour of the United States and Canada by the Israel Philharmonic Orchestra. It was to be a fund-raising effort to help replenish the depleted national coffers. The plan was for Jackie, Daniel and myself to start the tour by repeating the Victory Concert in New York. It was hoped we would then be able to find others who would volunteer their services. David Ben-Gurion attended the wedding reception that evening, and Sir John and Lady Barbirolli, Dame Janet Baker and other visiting musicians and singers were taken there in force to offer their good wishes to the newly-weds. A while later Daniel, Jackie and I flew off together for New York to launch the benefit tour of the orchestra.

When the three of us are together fun, jokes and usually some pranks are sure to be included in the schedule. Such an occasion was the filming of the 'Trout' Quintet. It was just one big joke; nobody took it seriously and it has become a classic. I must immediately qualify that statement by adding that it was all fun and laughter until we began to play the music; there is no joking with music, let there be absolutely no misunderstanding about that.

At that time, in 1969, I had been married to my wife, Nancy, for only a month and I was most concerned at the prospect of leaving her to go to London for the Schubert Quintet concert and film, as well as having to make a recording of *Il Trovatore* while I was there.

Daniel was musical director of the South Bank Music Festival in those days and one of the concerts he had arranged consisted of the 'Trout' Quintet in the first half, with *Pierrot Lunaire* by Schoenberg after the interval. The filming took place prior to the concert and when it came to the final rehearsal in the Queen Elizabeth Hall, we all agreed at one point to switch instruments, just for laughs and to see if we could raise any comments from Christopher Nupen and his film crew. I went to the piano and I showed Daniel how to manage a few notes on my string bass. Itzhak Perlman took the cello, which, in fact, he can play a little. Pinky Zukerman, who was playing viola, took over the violin and Jackie tried to play a little on the viola.

We were all falling about laughing mainly because nobody seemed to have noticed what we were doing, so intent was the concentration on lining up the camera shots and listening to the

instructions of director Chris Nupen. Well, maybe our antics were noticed and there was tacit agreement to let us carry on with our little game. In any case it could not be continued for long because none of us could manage much more than about sixteen bars on our borrowed instruments. The whole thing was not only a lot of fun but also greatly exhilarating. Basically, in simple terms, we were just five friends getting together to make music. If only it were possible to expand that notion into orchestral proportions, what a wonderful idea that would be.

Daniel and I have always been the closest of friends and Jackie has become almost like a sister to me, our lives have always intermingled. It is the greatest loss in all our lives that this girl, not simply a great cellist, but unique in the world of music, should not still be performing. I saw the film Christopher Nupen made about her for the first time the other day, and I have to admit that I sat there with tears in my eyes; I just could not believe how much we are missing. We have nobody comparable with her; she was like a lovely wild mustang. As soon as she took up the instrument, she had this incredible control that few instrumentalists in the history of string playing have ever possessed.

Having played the Dvořák Concerto with Jackie all over the world, I know from experience that sometimes, in the middle of a performance, she decides to play a phrase with a different fingering or maybe change a phrase itself, and she will do it without even the slightest qualms. Now, few instrumentalists would dare to sit in front of the Berlin Philharmonic, at a Salzburg Festival concert, and suddenly introduce a little divergence of interpretation. Many are the soloists who work eight hours a day to perfect the playing of a concerto correctly in one particular way. But Jackie possessed this flair, control, and imagination, plus a great magnetism for the audience. When she is a member of the audience at a concert I am conducting, in every bar I am conscious of her presence.

The last concert that Jackie gave in London I conducted for her. It was with the Philharmonia Orchestra in 1973; she played the Elgar Concerto and played it impeccably. After that she went to join Daniel in America and it was then that she suddenly started to cancel engagements. Nobody had the slightest idea why. She cancelled a pension fund concert with Bernstein and Zukerman, at which she was to play the Brahms Double and I think she cancelled some of her concerts in America with Daniel.

In the summer of '73 Daniel had undertaken the musical

The wedding reception. Zubin Mehta is on Jackie's left.
Aida Barenboim and Dr Enrique Barenboim, Daniel's parents,
are next to Mehta

directorship of the Israel Festival. It was planned to perform the 'Trout' again with the original five. Jackie came out to Israel, but we played the quintet without her. She was in the audience; she just did not want to play.

That October Israel was again at war – the Yom Kippur war. I was there at this time and Daniel at once cancelled his engagements in Europe and came out to join me in concerts for the Israeli forces. Every day he telephoned Jackie. One day, when he called their home, which was then in Hampstead, he was told she had gone to hospital for a check-up. He asked what was wrong. The answer he received, from an obviously uncomprehending housekeeper, was that the doctor suspected multiple sclerosis – just like that.

At that time, like the Barenboims' housekeeper, neither Daniel nor I had the least idea what the doctor's suspicions implied. Ten years ago little was known about MS, except to the medical profession, unless, of course, it came within one's own range of experience.

Because of our ignorance of this wretched illness, when Daniel

and I received the news in Israel we did not react to the enormity of what we had been told on the telephone. But, of course, we had to find out as soon as possible, so I telephoned to a doctor friend of mine to ask for an explanation. As there was only one telephone in the room, Danny came close to the instrument so that he could hear what the doctor said. That was how first he learned of the tragedy which was to come into his life. We packed him off to England just as quickly as we could, and this is not the easiest thing to do with an Israeli citizen in wartime.

This terrible sadness has drastically changed two brilliantly talented young lives. Danny has been unbelievably marvellous in his understanding. Jackie, as I told her only the other day, never complains and is always smiling, even though the illness has been going on since 1973. Whenever I ask how she is I get the same reply: 'Oh, I'm fine.' Only very occasionally does she mention suffering a little pain, although she refers to it in such a way as to lead one to believe it can easily be cured with an aspirin. They are two extraordinary human beings enduring this incredible trial. What can friends do? They feel so impotent, so helpless. They can only offer their love and support.

To this day Daniel has never accompanied another cellist, either as conductor or pianist. Frankly, I doubt if he could. As for me, on two occasions I have tried to conduct the Elgar Concerto with other cellists and I have found it impossible. It is music Jackie made so much her own. The recording of it she made with Danny in Philadelphia is, for me, the definitive performance, and one which I find I cannot listen to too often.

A Genius on Record

by

SUVI RAJ GRUBB

I became Jacqueline du Pré's recording producer as a result of a casual remark I made on the occasion I heard her in person for the first time. It was on the evening of the last day of 1966; we were at a party to see the new year in, the 'we' including Daniel Barenboim. Jacqueline du Pré and Barenboim had met a few months earlier and the event which brought them together could not fairly be described as glamorous or romantic. Each had been laid low by a bout of glandular fever; when friends had mentioned du Pré's illness to Barenboim he had been sufficiently intrigued to telephone her and arrange for them to meet. They were instantly taken with each other and by December 1966 were constant companions. Wherever Barenboim is, sooner or later, there is bound to be music-making, and this evening was no exception. When we had all dined and wined the decks were cleared for the serious business of the evening and the proceedings were opened by du Pré and Barenboim. He asked her what she would like to play and in a tone of voice which suggested that there was only one work worthy of their collaboration she replied, 'The Beethoven'. There was no need to say which of the Beethovens, for the emphasis on the definite article said it all, the Sonata in A major, op.69

They settled down and Barenboim gave her the 'A' and she tuned her instrument. I did not know then what a perfect sense of pitch du Pré has, but I did notice how very in tune she was with the piano. Having got the preliminaries out of the way, they looked at each other and du Pré launched the noble opening theme of op.69, one of Beethoven's great melodies. No one plays this soaring tune quite as

Jacqueline du Pré does – a suggestion of a slide from the first to the second note and a more distinct, but unexpected one between the A and the F sharp in the fourth bar, a slight swelling and dying away within the 'piano' asked for by Beethoven and the whole melody phrased in one long, arching line, shaped with the affection and tenderness demanded by the composer's marking, 'dolce'. As she reached the low E at the end of the phrase she turned to Barenboim almost as if to say: 'Match that, if you can', and with his delight plainly evident Barenboim responded to the challenge; it was a totally unrehearsed performance and one of the most notable I have heard of the work.

I had heard all the records du Pré had made till then and I knew the history of her astonishing career. My immediate reaction to her playing on records had been one of wonder that someone so young in years could produce music of this quality. Then had followed delight at her insight and instinctive feeling for the music of various periods she had recorded, and at the whole-hearted abandon of her playing. If at times this seemed a trifle excessive it was doubtless

With Sir John Barbirolli (right) and Suvi Raj Grubb, preparing to record the Haydn Cello Concerto in D major, 1967

due to the exuberance of youth; give me always over-enthusiasm rather than a chill remoteness. But the revelation of that evening for me was the sound of her cello heard face to face. Nothing I had heard on her records had prepared me for the singing tone of the instrument and for the sheer volume and opulence of the sound. I whispered to a colleague who was sitting next to me: 'We've not really captured that sound satisfactorily enough', and added, half jokingly, 'Bags I, her next recording.'

Less than four months later I welcomed Jacqueline du Pré to EMI's Abbey Road Studios in St John's Wood, London, as she arrived with Barenboim to make a record with the English Chamber Orchestra of Haydn's C major Cello Concerto and the well-known Boccherini B flat. We first set about the task of getting as natural a sound of the cello through the microphones as possible, subject only to the limitations of the medium. The first hurdle to be overcome for the successful recording of a cello is to ensure that it is not swamped by the accompaniment, whether an orchestra or a piano. It is played sitting down and is therefore on a level with the orchestral instruments. The groups of strings each outnumber the solo cello by at least six to one, the woodwind all have greater carrying power and the cello's range lies within that of some of the heaviest of the orchestral artillery: horns, trombones, bassoons and timpani.

To offset all this I set du Pré on a rostrum some nine inches high, thus raising her clear of the orchestra. Then we tried to find the best position for her in relation to the orchestra and we began with the natural one of her as at a concert, in front of the orchestra and facing away from it. She sounded marvellous but the leakage of the sound from the instruments more distant from her into her microphone made them go out of focus. I turned her around 180 degrees to face the orchestra. This sounded as if she and the English Chamber Orchestra were in, not two separate rooms, but two different towns. Then sideways, facing the conductor and so on till finally by a happy accident (and these things are always achieved by accident through trial and error and not through scientific calculation), I found the best position. I sat her plumb in the centre of the orchestra, facing the conductor, with the other players in a rough horseshoe around her. The conductor could have stretched out his hand and touched her and, wondering whether her proximity would cramp his movements, I asked him: 'Danny, is she too close?' His reply was a crisp: 'She can't ever be too close for me!'

Du Pré sat patiently and uncomplainingly through all this. When I asked her to play for a test she played out fully as she would have to an audience in a concert hall. When the recording began she played all out every time, as to a paying public. She never had the attitude: 'Oh well, if anything goes wrong we can always do it again.' This is one reason for the immediacy and vibrancy of her performances on gramophone records. Another is that she comes to recordings as thoroughly rehearsed and prepared as for a concert.

This recording once begun went very well and fast, for du Pré was in top form and responded joyously to the pains we had taken over the sound of her cello. Even a minor set-back – when she innocently changed her bow without telling anyone and drove us all to distraction trying to investigate all the possible causes for the sudden, inexplicable change in the sound of the cello before realizing that the new bow might have something to do with it and a little guiltily confessing – did not seriously retard progress. This, the first of her records I produced, provides a perfect example of her sense of style – classical propriety for the Haydn and romantic indulgence for the Boccherini.

The second record was also with Barenboim, of very different music, not so easy to perform or to balance, either for the players or for the recording team. The Brahms cello sonatas are probably the most superbly constructed of works for the two instruments, and the most difficult to bring off successfully. You cannot find two more incompatible instruments than the piano and the cello; besides, the cello's entire range lies within the compass of the piano's weightiest and most sonorous section and so when both are required to play loudly the pianist has to take special care not to swamp the cello. Brahms, of course, makes no concessions as far as the piano part is concerned, for it is as heavy and full as in a piano concerto. On the recording, to begin with, I did not set out to balance du Pré unduly prominently and thus make it easier for her to hold her own. This could be done later if necessary. I knew it would not be when she played the opening theme of the E minor and Barenboim's accompanying chords were played with the right degree of weight to support the cello and not drown it. I need not have worried even about the last movement of this sonata, a fugue. The contrapuntal lines were sharply etched whether on the cello or the piano. I marvelled at the musicianship of the two and the understanding between them which made each adjust the volume of sound to allow the important lines to come through. There is an

With Suvi Raj Grubb

eager spontaneity about these performances; du Pré and Barenboim were still in the process of discovering each other and this is reflected in their playing of these works.

Du Pré next visited the studios when Barenboim was recording the Beethoven piano concertos with Klemperer. During one of the intervals the conductor decided to find out for himself how much of what he had heard of her phenomenal sense of pitch was justified. He sat at the piano and played what could not possibly be described as a chord, but was a weird combination of notes. 'Miss du Pré, what notes am I playing?' he challenged and without even having to think about it, she replied: 'A, B, C sharp, D sharp, F.' Klemperer himself had to look down at the keyboard to confirm that she was right, and having done that he said in admiration: 'So!' – a monosyllable he could invest with greater meaning than most with an oration.

Hard on the heels of this she returned to record the Haydn D major Concerto with one of her most ardent admirers, Sir John Barbirolli. Barbirolli had a very special place in his heart for young and enthusiastic musicians, and du Pré (and Barenboim) were

among the élite in his affections. When we were recording the Haydn, Evelyn Barbirolli visited us and as they were rehearsing leaned over to me and said: 'John is obviously having the time of his life', for over the cello you could hear him singing the opening theme of the concerto – this was always a mark of Barbirolli enjoying the music he was conducting.

Everyone who worked with du Pré in the recording studios adored her – the musicians who played with her, the conductor, or pianist who accompanied her, the engineers, the studio assistants and I. She was the ideal recording artist, undemanding, understanding of other people's problems and with no outbursts of what is called 'temperament', which all too often in the artistic world is a synonym for ill-humour. If her chair creaked or she wanted her music-stand raised, even before she asked for help, a watchful studio assistant would rush up with: 'Leave it all to me, Miss du Pré.' For the engineers she was the perfect artist who never complained however long it took to get the right sound through the microphones. For me, the all-too-brief six years in which we worked together are a golden memory of spontaneous, unaffected, joyous music-making. In the world of music it is rare for anyone to be universally liked and admired. It is always: 'So-and-so is a fine pianist, cellist or whatever, arguably the best around', and then the qualification: 'But of course . . .' often the retraction of the first part of the statement. Du Pré is one of possibly the only three artists I have known, about whom no one has ever said anything derogatory.

There was an interval of about six months between the Barbirolli record and the next one. Viewed in retrospect it seems such a great pity that we allowed all that time to elapse instead of cramming in as many records as we possibly could with her – but at the time no one dreamed that a finite limit had already been set on Jacqueline du Pré's musical career. No such thoughts clouded our minds in 1968 as we recorded the Schumann and Saint-Saëns concertos with the New Philharmonia Orchestra conducted by Barenboim. There was an even longer interval, over a year, between this and the next project. In five astonishing days astride New Year's Day, 1970, with Barenboim, Pinchas Zukerman and Gervaise de Peyer, she recorded all the Beethoven piano trios and variations for piano trio and the clarinet trio on five long-playing records. We recorded the 'Archduke' Trio last. When its last movement came to an end none of us knew that du Pré was to make only two more records – the

illness which has laid her low physically but has left her spirit unbowed had already set its chill hand on her. One of the two was the Dvořák concerto with Barenboim in Chicago.

Even du Pré herself cannot pinpoint the exact time when she started experiencing mysterious and inexplicable symptoms such as a tingling in her fingers – a curious feeling of her hands and arms appearing, as she put it, to be made of lead – all these and a general malaise which seemed to drain all her energy. No one could yet explain what it was that ailed her, but she was at times so incapacitated as to have to cancel concerts and engagements, among them a long-cherished project of which I had high hopes. This was to record Schubert's 'Trout' Quintet with Perlman, Zukerman, Barenboim and a suitable double-bass player.

Early in December 1971, I had a telephone call from Barenboim. Was our Studio One free on 10 and 11 December? He explained that du Pré, who had not touched her cello for nearly six months, had a couple of days previously suddenly announced that she wanted to play. She had picked up her cello and Barenboim said had proceeded to play as if there had been no interval since she had last played. They had been running through the Chopin and Franck sonatas and he felt that she was playing as well as ever and perhaps we should try and record these works. I was delighted and made all the necessary arrangements. In those two days we completed the recording. There was no sign of her illness and she played as superbly as always. When we had finished she said she would like to start on the Beethoven sonatas. Barenboim and I were concerned, for she looked tired, but we recorded the first movement of op.5, No 1. At the end of it she placed her cello back in its case with: 'That is that', and did not even want to listen to what we had taped. That was Jacqueline du Pré's last appearance in the recording studio.

In 1973, the illness was at last given its dread name, and in me, as I am sure in the hearts of all who know and love her, there was an anguished cry of: 'Oh, no!'

What was it that made Jacqueline du Pré so special an artist and which makes her loss to music so unbearable? I would place in the forefront her total mastery of her instrument. The cello is basically an intractable instrument. Its very size makes it difficult to control. It requires strong muscles to handle it and to coax a beguiling sound from it. When du Pré walked on to a stage or into a recording room with her instrument, one's immediate impression was that the cello was an extension of herself. She carried it and handled it easily

and comfortably. She is tall and well-built and this contributed to the ease with which she played.

Her technical mastery of the cello was absolute. The tone she produced was rich and sonorous, always in a long singing line and she had an astonishing capacity to colour it with the most delicate shades. It could be dark and foreboding for the opening theme of Brahms's E minor Sonata, impassioned in the first theme of Beethoven's op.69, with a jaunty lilt in the last movement of the Dvořák, wistful and a trifle sad for the slow middle section of the Lalo, or whatever matched the mood of the music. She had an instinctive feeling for the emotional content of any music she played and so had the ability to get to its heart.

She was an unselfish player and so was an ideal partner in chamber music. And added to all this was a sheer delight in making music. You could see this in the smiles she exchanged with other players and the nods with which she acknowledged someone playing a passage especially well. She has often said to me that she hated practising and I have never arrived at her house to find her practising. Playing music, yes, but not scales or arpeggios or exercises. I cannot explain how, in view of this, at concerts and recordings the notes came so easily to her fingers and how she worked out the strongly individual interpretations which characterize her work – but then, you cannot explain genius and if I were allowed to apply that term to only one of the many musicians I have worked with, it would be to Jacqueline du Pré.

My Dearest Friend

by

EUGENIA ZUKERMAN

Since we first met in 1967, Jackie has been my dearest friend and much like a sister to me. Soon after the musical collaboration between Pinky, Daniel and Jackie began, having all become close friends, we decided to take a holiday together, of which I have most vivid recollections. It was August 1968 and we went to the Hebrides. We stayed on the Island of Mull and frequently Jackie and I would go for walks and climb the hills together. For such activities the men did not show any particular enthusiasm. On our many rambles I found it necessary to make quite considerable efforts to keep up with Jackie; she was so full of energy and would walk so fast. She was always full of joy and appreciation when walking in a brisk wind and was absolutely amazed at the rugged beauty of the place. There were moments when I thought of her as some sort of golden bird flying over those hills. I remember experiencing great surges of love for her.

At that time she was not enormously intellectual but I felt there was a tremendous intelligence and a most intuitive mind at work; a very clear, vivid and uncluttered mind, unaffected by much academic schooling. So, as we talked during our long walks, there could be no intellectual discussions, yet in our conversations it soon became clear she had her own very private, very personal and very gentle philosophy about life. After that holiday, when she and I had spent so much time together in that primitive landscape, I was aware that a strong bond had developed between us.

Then, of course, there was the joy of hearing and seeing her in performance. Pinky, Danny and she became a most successful trio

and wanted to be able to play together as frequently as possible. There were several tours and I would always go along with them. Discounting the fact of my great personal affection for Jackie, I would sit there like any other member of the audience and find that I was being completely dazzled by her playing. It was so touching to see this tall, striking girl with the flowing blonde hair come onto the platform rather like Alice in Wonderland, sit down and wrap herself around the cello. The music she produced was so intensely direct, so incredibly emotional, so utterly personal that you, the listener, felt that she was speaking individually to you through that instrument.

From 1968 until her illness I was fortunate in being her frequent travelling companion, not only when the trio was performing, but when she was giving recitals. On one occasion, when she was playing in Oklahoma City, she had an inkling something was wrong. I recall her saying to me: 'I only have strength when I play the cello. I can hardly open a window or fasten my suitcase.' That, I think, was when she was first becoming aware of something disabling happening to her body. As the early seventies progressed it seemed to me her artistry was increasing and reaching tremendous

A joyous moment as husband accompanies wife in September 1967

Reg Wilson

Reg Wilson

heights. Then, when she was at the top of her form, there was nothing like it. Never have I heard anything comparable before or since, recorded or in the concert hall. It was a passion she was able to share; a form of selfless giving; a deep belief in and a commitment to the music. Just watching Jackie play was a treat in itself, always without inhibitions, so unpretentious and totally spontaneous.

When she became ill all her close friends felt involved in the calamity and as it became clear that, at least for a while, she would be unable to play the cello, there was a terrible sense of loss which one shared with her. What was most striking about the way Jackie reacted to the discovery of her illness was her frankness; she made no attempt to delude herself or those close to her. Yet in everything she said and did there was a great dignity. I am sure her secret was that she did not resign herself to her illness and most certainly still does not do so. Nor indeed do her friends, because there is always the chance that at any moment her condition may be reversed.

As a person Jackie is still as she always was, the same cheerful,

unfettered soul. In fact, perhaps because the performance of music is no longer possible, other aspects of her magical personality began to develop and her interests have rapidly increased. She has discovered books, poetry and the theatre. Far from feeling sorry for herself she steeps herself in these things and has learned a great deal from them. Instead of the quick, clever, intuitive girl I first knew, she has become highly self-educated; a new, changed and mature Jackie. And the change is really quite staggering. For instance, I find that, when reading poetry, she is far better able than anyone I know quickly to grasp the full meaning of a phrase. This may well be due to her musical ability, enabling her immediate recognition of a statement profoundly expressed.

Jackie has in fact become a talisman – a symbol of hope and encouragement – for other multiple sclerosis sufferers. It is only reasonable to consider that she has lost more than the average person contracting the illness. She was, I think, aware of the extent of her gift. That she is not bitter and has overcome so much by being perpetually active and helpful to others is deserving of great praise indeed. She is one of the most original women I have ever known.

Sensuous Sound
by
PINCHAS ZUKERMAN

I first heard about Jackie in 1965 from Charles Wadsworth, who was then director of the chamber concerts at the Spoleto Festival. He told me he had met this fantastic cellist and he believed that if the two of us ever got together it would be a match made in heaven. So the name Jacqueline du Pré not unnaturally was firmly fixed in my mind. And, as if this was not enough, later that year I heard from Arnold Steinhardt, of the Guarneri Quartet, that they had, in fact, been playing at Spoleto with this girl and he talked to me at great length about what an extraordinary musician she was. Finally my wife, Genie, and I went round back stage after a concert in New York and at last met Jackie. As we stood chatting, Daniel said to me, 'Look, why don't you come around tomorrow and we can play some trios at Essex House?' I said that would be fine with me. As it happened I was not doing anything at the time, so I took my fiddle along and we all three played. I thought we would just play a movement or so, but as we made music together the rapport between us was quite incredible. It was without doubt the most extraordinary thing that has ever happened to me. To have another player to whom it is unnecessary to say a thing, who, by a look, a movement of an arm, can understand the slightest nuance; for me this was something quite unique in communication. It was also something which I strongly suspect is never likely to happen to me again.

Most great string players have their own particular sound. It is what might be called a 'personality sound' and belongs to the particular player exclusively. Jackie had her own unique sound in

abundance. My description of it would be to call it sensuous. It is a facet of playing which I find extremely difficult to describe. It is something one hears and immediately recognizes: when the player brings out a particular note or phrase in a special way. It was for Jackie absolutely instinctive musicality and few people have this great gift. (I believe today Pavarotti is similarly fortunate in having this instinct and I understand that at one time he did not even read music.) Jackie had an extraordinary physical ability with the cello. Fingering presented absolutely no problems for her; it was as if she was born holding a finger board. There are not a great number of players I can recall with such a facility. Yehudi Menuhin had the gift in his early years, Michael Raeburn, Horowitz . . . It is an ability that string players constantly pursue and is for most of them maddeningly elusive.

Everything about Jackie in performance was completely natural and spontaneous. Sometimes people will ask why she made those flourishes with the bow. I am frequently asked why I 'dance' when I play. It is just a part of the natural and instinctive movement of the body; one has no conscious realization that one is doing it. The flourishes were something that was a part of Jackie's normal reaction when playing the instrument. Certainly it was no affectation or façade. Of course, for some people's tastes such mannerisms may appear at times to be exaggerated, but that is no matter because an instrumentalist will do it with absolute conviction and feeling.

There could be a sense of being slightly left in the shadows when appearing on the same concert platform with Jackie. One had somehow to pull out of the shadows and try to match up to what was happening. You must never fight such a situation; you go along with it and you may well discover that you are being taken along on a marvellous ride. It is a quite tremendous feeling. When we were playing trios Jackie always had the sensitivity and ability to listen to what I was doing. Never was it ever a case of her wishing to establish herself as the focal player; her concern was always for the trio as a unit – ever a matter of give and take. She had an uncanny personality on the platform, partly because of the way she looked and partly because of the way she played. The general impression was of a person completely inspired in delivering a message of the greatest possible importance to the audience.

When we all four travelled together we had great times; there were always lots of giggles and a great deal of laughter. Jackie has a

Camera Press

great instinct for fun and a well developed sense of the ridiculous, so anybody with the slightest tendency towards pomposity has to beware. She is such a happy person with an outstandingly kind and sweet nature, in fact I know one of her friends always calls her 'Smiley'. I cannot recall a single instance of her ever getting angry, although, like so many great talents, there are times when she can be just a trifle absent-minded.

Since her illness Jackie, of course, has had more time for reflection and she has devoted a great deal of it to considering fully the technique of playing the cello. We have had a number of chats about stopping, bowing and the various other facets of execution; she has clearly given considerable thought to this and done a great deal of reading about the subject. Happily it is a subject in which she can still be involved with all the tremendous practical benefits to be derived from her instinct, talent and experience.

Let me say now that there is not the slightest sign from her of

bitterness about her illness, which might reasonably have been expected from an artist whose brilliant career is so suddenly and arbitrarily halted. Her dedication and love of music have been maintained and she still very much wants to be involved. It seems to me that perhaps it would be a good idea if Jackie could be encouraged to write about her feelings today: the way she views music and the musical world. It would be of immense help and guidance to other musicians who might find themselves in a similar situation and, of course, it would provide fascinating reading for all music lovers, not to mention the countless fans who have so much enjoyed Jackie's great talent.

A Film Called 'Jacqueline'
by
CHRISTOPHER NUPEN

There are just a few in any generation, musicians with the unmistakable qualities that make the rare but familiar figure of the internationally acclaimed artist.

It is one of the most totally absorbing of all professions, demanding not only great fantasy and the god-given talent to communicate, but the character and will to develop it and an essential single-mindedness from the earliest age.

The demands are high and are met by just a few. At twenty-two Jacqueline du Pré is already among them.

Those words emerged from a flurry of activity and considerable excitement as the opening commentary to a film called *Jacqueline* which we made for the BBC in much too much of a hurry in 1967. We were given just under three weeks to make a film about what I felt at the time was the finest cello talent on earth. I may have been wrong about this, but the conviction did a great deal to get us through. How do you even start to make a film that would do justice to Jacqueline du Pré? It would have been difficult enough in three months and we were both young and dangerously inexperienced; but youth has its advantages. We shot a sixty-five minute film in less than three weeks and edited it in six, and happily it succeeded none the less in capturing something of her magical qualities.

Films are made in the editing, but they depend absolutely on what happens in front of the camera during the filming. In those three weeks Jackie, who had never made a film before, strode gaily in front of the camera with that curious combination of shyness and absolute conviction that have characterized her personality since

her teens. The camera liked what it saw. She was full of youthful, burning eagerness and fortunately the camera sees such things very clearly.

My conviction that there was no finer cellist on earth obviously had much to do with my affection for her, but the enjoyment of music is a strange thing. There are doubtless better reasons for adopting convictions of this kind, and certainly my enthusiasm to communicate the idea landed me in hot water on more than one occasion with distinguished professionals who knew much more about these things than I did. But how can one argue with that overpowering personal response that some performances can evoke? Some may find the extremes of her fantasy rather heady stuff, but in John Barbirolli's words, 'I love it!'

Sir John was in the middle of recording Vaughan Williams's *Sea Pictures* at the Abbey Road Studios when we asked him if there was anything that he would like to say about Jackie for the film. He paid her as profound a tribute as one could expect from one artist to another, and he concluded with, 'You know, she is sometimes now accused of excessive emotions and things. But I love it. When you are young, you should have an excess of everything. If you haven't an excess when you are young, what are you going to pare off as the years go by? Such heaven-sent gifts don't appear every day.' The years pared off more than any of us dreamed possible and I am profoundly grateful for having been so close to so many of those excessive concerts and so much under the magic of the spells that she was able to weave.

The intervening years and listening to both studio and concert recordings have done nothing to diminish my wonder at her playing. Her command of the instrument and her intonation were on a level that few could match, but there was so much more to it than that. The confidence and sure-footedness in her phrasing which gave her such freedom; her ability to respond to the moment and her apparent total lack of inhibition; these are qualities that she seems to share more with musicians of the past than the present. And there is something else, a miraculous combination of apparently contradictory qualities. She had the ability to phrase with such natural conviction as to give the impression that it really should not be done in any other way, and at the same time to make you catch your breath with surprise and delight at an unexpected sound or turn in the phrase. All so natural that it could not be otherwise and yet so surprising that life could suddenly take on a

Reg Wilson

Rehearsing Schubert's 'Trout' quintet, August 1969, L to R:
Itzhak Perlman, Daniel Barenboim, Jackie, Zubin Mehta on the
double bass, Pinchas Zukerman. The performance of the 'Trout'
was the only time this group of friends worked together

new dimension for a few seconds. To my ears this is a quality that
she shares with very few. I think of Caruso, Lotte Lehmann, Andrés
Segovia, the young Menuhin or the young Zukerman. How do you
explain it? You cannot, but in Jackie's case the apparent contradic-
tions are curiously reminiscent of the shy determination of her
personality.

Hagiography? Why not? Our liberal age seems to have more than
its fair share of inhibitions and taboos about these things. In many
ways Jackie's playing seemed to be the very antidote of inhibition;
perhaps because she suffered so much from the effects of it in her
childhood. I still shudder at the memory of her account of a
pubescent Jacqueline du Pré having to endure the profound affront
of schoolmates dancing around her chanting, 'We hate Jackie', and
all because nature had endowed her with such prodigious gifts.

Most musicians seem to acquire their best qualities with the
passage of time; as much by experience and in response to what
their public demands of them as by native talent. But to my ears
Jackie seemed to arrive almost fully fledged, with most of her

unique qualities virtually intact. Even her idiosyncrasies seemed in some way to form a natural part of a complete musical personality. She was often advised by wiser colleagues in rehearsal to omit some of these in the coming performance; in particular what she now refers to as her 'sumptuous glissandi'. She would agree shyly, modify the rehearsal accordingly and then re-introduce them in the performance with a combination of childlike glee and ferocious determination that would make the effect succeed after all.

I recall one such occasion when I was present at the rehearsal but missed the concert and she later informed me that she had done it in the evening anyway. 'How was it?' I asked. 'Gorgeous!' came the reply. As Daniel Barenboim says in the *Jacqueline* film, 'It is all so natural with her, and comes so much from inside, that you can't help loving it. But those of us who have to conduct, of course, find it sometimes rather hard.'

I first heard Jackie's playing on a BBC Third Programme relay of a solo Bach recital from Fenton House on a summer evening. I had never heard the name Jacqueline du Pré and suddenly she transformed the night into some sort of velvety magic that still echoes somewhere in my memory. Soon afterwards she strode shyly, as was her way, into the flat which I shared with John Williams at the time. They were preparing an arrangement for cello and guitar of Manuel de Falla's *Jota* for her first recording with EMI. She was fifteen years old. I was captured, and have admired and loved her ever since, as much for her incorruptibility and her originality as for her playing.

After making the *Jacqueline* film, which has fortunately been preserved, we made a number of television programmes together for the BBC, all of which have sadly been destroyed. I then left the Corporation largely because I had realized in the making of the *Jacqueline* film that such things could not really be done properly within the unavoidable limitations of the large television stations. Then in 1969 we made *The Trout* as an independent production, when Itzhak Perlman, Pinchas Zukerman, Jacqueline du Pré, Zubin Mehta and Daniel Barenboim played Schubert's Trout Quintet in the Queen Elizabeth Hall one August afternoon. This was arranged by Barenboim as part of London's first season of South Bank Summer Music. We filmed the concert live, on stage, exactly as it happened and without retakes, having followed the preparations and rehearsals at extremely close quarters during the preceding five days.

Until that time chamber music had been thought of as at best suitable for late-night television, but the combination of youthful exuberance and passionate dedication which radiated from the performers, the way in which they related and adapted to each other both in rehearsal and in the performance, and which, once again the camera saw very clearly, made the resulting film probably the most frequently televised classical music programme to date.

We had only one more opportunity to put Jackie's playing on film before her illness began to affect her playing. During 1970 I had heard the Barenboim-Zukerman-du Pré trio play Beethoven's Piano Trio op.70, No. 1 ('The Ghost') in Oxford and Brighton. Their performances were like nothing I had ever heard and left me with the impression that 'The Ghost' was a mightier trio than the 'Archduke'. A few days later we were to have made a film with Andrés Segovia in St John's, Smith Square, London, which had to be cancelled only two days before the event. St John's was booked, needless to say, and the trio was in Brighton and happened to have a free day. They came to London by train early in the morning and went back again by the last train that night, leaving behind them something at least of their miraculous performances on film. Years later, after a viewing of the film, I was lamenting the fact that no film could ever hope to capture properly the extraordinary atmosphere of those concerts in Oxford and Brighton. 'Nonsense,' was Jackie's immediate response. 'It's better on the film. To be able to see what's going on like that adds another dimension.' She was wrong, of course, but such is her uninhibited pleasure in her music-making, and her generosity. That remark also reflects something of the gratitude that both of us feel at having had the unexpected opportunity to preserve something of her playing on film.

Until her illness began to transform her attitude to the world, Jackie was regarded by many who knew her well as a rather fay but blithe spirit who knew little or nothing of worldly things and, in a way, she was just that. She often had no idea what day it was or when or where her next concert might be. She certainly had little idea of what things cost. But her perception of the true nature of things and people was always rock solid and ran extremely deep. This quality has actually deepened with her illness, although it has become less sure-footed because of her desperate need to replace some of the affection that was once lavished on her by thousands of admirers. She misses that.

eg Wilson

Recording a Beethoven trio at the EMI studios, December 1969:
Zukerman, Barenboim and du Pré

Her awareness of suffering has deepened too. Small wonder! Anyone watching and hearing her performance of the Elgar Concerto in the *Jacqueline* film would be likely to think that her projection of Elgar's melancholy could hardly have deepened with the passage of time. I doubt it myself, because I have always thought that in some strange way it was directly related to her youth; a curious combination of youthful sensitivity, uninhibited energy and musical honesty. But to see her lately, sitting in front of an Elgar photograph that hangs in her living-room, and musing about his melancholy as she feels it in his music now, makes me wonder what she would convey to *us* now, if her strength and her co-ordination should be given back to her.

To reflect on these things is to tread close to the brink of hell; and there is another thought that torments me. For years Jackie and my wife, who was also known by her professional name, Diana Baikie, were the closest and most intimate of friends. They had many qualities in common, among them a respect for nature and for all

things on the earth. They never knowingly hurt anyone or anything and never mistreated themselves or anyone else. Indeed, they always brought the best out in others. Why nature should so mistreat them in return is an awesome and unfathomable mystery.

Diana died at the age of thirty-nine and Jacqueline du Pré has to suffer the miseries of multiple sclerosis. In the words of Andrés Segovia, speaking out of the most profound affection for them both, 'I do not understand, and never will, the cruelty of nature.' And yet their capacity to struggle bravely, and Jackie's efforts to transcend her appalling loss, are the most touching things that I have ever witnessed. Her attitude was perfectly summed up in a BBC programme which took for its title her spontaneous phrase, 'I really am a very lucky person.' To understand something of the dialectic of those two phrases in all their profundity is to go some way to understanding the mystery of Jacqueline du Pré.

Jackie's Master Classes
by
SIR IAN HUNTER

Jacqueline du Pré came to Harold Holt Limited in 1967, soon after she married Daniel Barenboim, whose debut in this country we had arranged in 1955 when he was twelve years old, and whose career we have looked after ever since. It seemed sensible that as they performed together so often they should have the same management to co-ordinate their complicated schedules.

But it is not as an agent but rather as a Festival Director or entrepreneur that I want to write about Miss du Pré. She was a wonderful artist with whom to work, always warm and enthusiastic and ready to enter into the spirit of the event. At the first Brighton Festival in 1967 she gave a recital in the exotic Music Room of the Royal Pavilion, later to be badly damaged by fire, and a performance of the Boccherini concerto in the Dome. In 1968 she came again, and gave the world première of a work we had commissioned for her from Alexander Goehr, 'Romanza for Cello and Orchestra', with the Philharmonia conducted by Daniel. She was well aware of the need to increase the orchestral repertory for the cello and she made light of the technical difficulty of the work.

Two years later, in the Church of the Holy Sepulchre, as part of the City of London Festival, she gave a performance of three Bach suites for unaccompanied cello – an evening of unique spirituality which will never be forgotten by those who heard it. In the vestry before the recital began I found her telling a joke and saying, 'I really mustn't be irreverent', whilst at the same time drawing sonorous chords from her cello as she tuned the instrument. Like so many colleagues of her generation she can move from complete relaxation

Reg Wilson

Barenboim and du Pré at work

to deep concentration in the time it takes to get to the stage.

As her playing career reached its height with a performance of the Elgar concerto conducted by Zubin Mehta at the Royal Festival Hall in February 1973 shortly followed by an American tour, her illness became apparent and whilst Daniel was in Israel at the time of the Yom Kippur War in the autumn of that year, it was diagnosed. There are many who will tell better than I of her fortitude during those days but I remember vividly how cheerfully she had accepted the limitations her illness had imposed on her when I visited her in St Mary's Hospital, Paddington. Then she and Daniel moved to Knightsbridge and it became easier for us to see her and to talk. To talk, to plan and for her to try out on her friends words of which she had just discovered the meaning in her dictionary. She seemed fascinated by learning and poetry. 'I was taken away from school when I was twelve and now I am making up for lost time.'

It was during these talks that she began discussing teaching, and various people were brought in to advise. We thought it would be

Reg Wilson

wonderful if she could be persuaded to give Master Classes and I told Daniel that I would happily invite her to start with two classes at the Brighton Festival in 1977. Gradually the idea was advanced and Erica Klien was to undertake the organization of pupils and classes.

When 9 July 1977 arrived Jackie and Daniel motored down from London and we went to lunch at Wheeler's Restaurant on the front where we had in earlier days had suppers with Artur Rubinstein after his concerts which Daniel had conducted; the pair of them told stories far into the night. Jackie seemed in fine form and we had lobster and white wine – I think I also had something stronger to steady my nerves because neither Daniel nor I was at all sure how Jackie would react to appearing before the public again. As she was wheeled onto the platform at the Polytechnic Theatre there was a great wave of applause and the artist in her immediately responded. The Master Class began and everyone was at ease. I was amazed that someone to whom music came so naturally was able to put into words so explicitly her criticisms and appreciation without recourse to demonstrating on the cello. There were many memorable remarks: 'Barbirolli told me to listen for the bass lead,' she said of one moment in the Elgar concerto which was being studied.

Although her health was uneven she taught regularly and in June 1978 I invited her to repeat her Elgar Master Class at the Malvern Festival which is held in the small Worcestershire town where Elgar lived and was buried. Again she had a great success and enjoyed the associations remaining with the great English composer of whose concerto she must surely stand as one of the greatest and most idiomatic interpreters.

Master Classes at the South Bank Festival in London, organized by her friend and colleague Pinchas Zukerman, followed in August 1979, and during the spring and summer of that year BBC TV made programmes which were later to be seen by millions. Many great artists have given Master Classes over the years but those of Jacqueline du Pré are unique in that she has but her speech, her hands and her personality to project to both pupil and audience the musical interpretations which are the essence of her art.

Absolute Beginner
by
JAMES D. WOLFENSOHN

I shall always remember Jackie on those Sunday afternoons in the early seventies, when at forty I took my first cello lessons. After she had been diagnosed as having multiple sclerosis and her concert career was in doubt, I had dined with Daniel and Jackie and we discussed her future – she would teach – but who would be her first student? I volunteered, half in jest, half in hope that she would accept me. She called me at my office the next day to tell me that she had arranged a cello for me with the renowned dealer, Charles Beare, and our two-year adventure began.

As I am a banker, midweek lessons were not possible, so each Sunday afternoon we met. Nervously, I would attempt to tune my instrument, trying to judge from Jackie's eyes and from my untrained ears whether I was sharp or flat. She will never know what a trauma it was for me just getting ready to start playing.

I would take out my work for the week, assigned by her from compositions she had played when she was six, seven or eight years old. At the beginning, I played simple pieces written for her by her Mother and illustrated to attract a child's interest, but this was only briefly, and we were soon into Bach, Fauré and Saint-Saëns.

Never did Jackie make me feel inadequate. She would encourage me when by chance I made a reasonable sound or phrase. I would treasure her 'bravos'. When more often my tone and pitch were poor, she would encourage me to try again. While physically able to do so, she would show me how to draw the bow or to move the hand on the fingerboard, but as her condition prevented such demonstration, she would show me in other ways. She would motion with her

Reg Wilson

hands in time with her music. She would count for me. She would gesture with a sweep of her arms above her head to describe the climax of a phrase. And she would sing, and she would breathe – for string playing is like singing. She would sorrow with its mood. And we would talk of the essence of the music and of the life it portrayed.

I played 'The Swan' for weeks and months. A dozen times she would explain a phrase and the bowings and where to place the bow in relation to the bridge. I could understand, but how difficult it was to follow her instructions. For then, as now, my control of the instrument was limited and without basic technical training, and without those young hours of scales and exercises, my dreams of artistic accomplishment were unfulfilled.

Maybe it would have been better if Jackie and I had spent our first months with scales and with explanations of the positions of the hands, going through the tedium of beginning string players. But that was not her way. We started with complex compositions, for Jackie believed I could learn through playing and it would be more fun. She had never taught a beginner before – and I fear after her experience with me – not since. I cannot believe she was ever a

beginner herself. To her, playing is a natural gift. She gave me a photo at the age of seven drawing a bow with perfect form on a cello almost as big as she. Our sessions revolved around the music; the technique would come from playing and with practice. She wanted me to feel the music, and to learn as she had done, by playing. I am still studying a decade later, now living and working in New York. My technique still suffers, but what Jackie gave me was a far greater gift. It was the unique illumination of music through her eyes, through her ears, through her heart.

In yet another quite different way Jackie has influenced my life and that of thousands of others.

Nearly six years ago I was invited to become President of the International Federation of Multiple Sclerosis Societies, which has twenty national groups around the world, devoted to the care and assistance of MS persons and to research into the causes of the baffling disease. My sole claim to this position was my affection for and friendship with Jackie, and it is to her that I have devoted my work in these recent years. Throughout the world we have highly competent and selfless professional staff, backed by amateurs such as I, of whom many, many more are needed.

So many of us wander around ignoring or shutting our eyes to disabilities in any form; and I was no exception. Happily I now no longer adopt this attitude. MS has never been a 'glamorous' complaint, embraced by outstanding public generosity. Contributory reasons for this are incorrect diagnosis and ignorance of the disease or failure to face up to it by patients or their families.

When I was elected President I decided that we needed to increase both public awareness of MS and the level of research into the causes of the disease. Jackie was in complete agreement with these objectives. Daniel had already gathered together a loose consortium of his musical colleagues who agreed to offer their services in an endeavour to raise funds for MS. It was Daniel's lead, together with my election as President of the International Federation, which enabled us to establish formally a group of celebrities who would give concerts to help in raising much-needed resources throughout the world. It was decided to establish the Jacqueline du Pré Research Fund.

Since we began four years ago we have held a number of concerts in the United Kingdom, the USA, Canada, Denmark, France, Israel and elsewhere. More are planned. We gave a special benefit performance with many great dancers at Covent Garden; then there

was Pinky Zukerman and the English Chamber Orchestra in New York, with performances elsewhere by many, including Ashkenazy, Misha and Cipa Dichter, Zubin Mehta and by Daniel himself, many times.

All this has done two things: it has, of course, raised a considerable amount of money, but what is far more important is that it has made a worldwide public aware of MS.

By becoming more widely known, MS is now attracting scientists to study the all-important research issues. People are also becoming more aware that it is possible to face MS courageously and to lead a fulfilling life within the context of the world's disabled.

I think the way Jackie, a pre-eminent performer and still a pre-eminent musician, has been able to adjust her life has given tremendous help to others. Jackie, in some strange way, has exchanged the recognition she was accorded as a musical virtuoso for a similar acknowledgement in adversity. She has made the transition with great bravery and sensitivity, and with cost to her privacy and with strain on her physical condition. She is a symbol throughout the world and an inspiration to the thousands of MS persons who daily show their determination to lead normal lives within their physical limitation.

I cannot end this brief tribute to Jackie without mention of Daniel, whose patience, understanding and support have enabled her to manage her life so splendidly. His courage and insight in facing all the inherent problems have had a profound impact on everyone who knows him.

Jackie was born for greatness. First as a musician and now as a symbol and inspiration for MS persons has she become renowned. But it is Jackie as a human being, luminous, loving, full of insight and emotion that I feel privileged to know and to call her my friend – and my teacher.

Jackie and the Wolf
by
JANET SUZMAN

She's got this really dirty laugh, unexpected in one so blonde, a gurgling giggle and dazzling grin which makes you feel positively better than you did a moment before. So when the full force of all this disarming battery is turned on you, you tend to succumb. Even over the telephone it's pretty powerful stuff, and combined as it was with a suspiciously meek request to please come and help her with *Peter and the Wolf*, well, naturally, I succumbed. Off I went to teach my grandmother to suck eggs. This, by the way, was a few years ago when she first ventured onto the stage in this new capacity of raconteuse.

One thing was absolutely clear to me as I drove to her house: her muscles may be ravaged by this ghastly, unfair illness she has contracted, but her instinct remains as clear and pure and strong as ever it was. There was not going to be much I could teach her. We sat in the drawing-room, her score on her knees, while she read the story to me, every now and then whistling the music of it, which clearly was easier for her to read than the words. She read it with an almost childlike freshness which was so utterly right that I found I could say nothing of any helpfulness whatsoever, just as I expected I wouldn't. I've heard some Peter and the Wolfers adopt a slightly condescending tone as if to signal 'children's story'; this affectation eluded her, much to my delight. So apart from feebly pointing out that maybe she was inclined to lean a little too firmly on the odd past participle ('no sooner HAD Peter gone than . . .'), we left the work alone and had tea.

Listening to her, something struck me as charmingly paradoxical,

Jackie by Zsuzsi Roboz

which is that her most Gallic of names seems by osmosis to have crept unwittingly into her speech, for although her French is no more than passing good, she appears to have the slightest touch of it in her otherwise frightfully English English. The merest hint of something foreign slips in and out of her speech like a spy disguising his origins. I can't put my finger on exactly where it crops up, but it gives to her speaking a most particular ring.

Music is life, breath, food and inspiration to her; the element she swims in like a lovely trout. The rockier waters of the word-spouter are more strange to her. She forsakes her usual musical elegance and that fierce frown of concentration and becomes endearingly like a puppy splashing in a mud bath. She didn't have much schooling and so her literary education is astonishingly zero, but that's one of the many things that makes me love her. What a relief it is to a person whose daily business is words, words and more words, to talk to someone whose response to them is immediate and fresh and uncluttered by a boring old education. She has no prejudices of a literary kind, no half-formed ideas; she is exhilaratingly unread, a tabula positively rasa! She hasn't even heard of *Gone with the Wind*, for heaven's sake! It tends to make one think about things all over again.

Musicians seem to me to trust their talents as a baby does its mother; they believe in the miraculous nature of music as a mother does her baby. Actors are far more suspicious of their talents; they disbelieve their powers, tussle with meanings and styles; in short they mistrust themselves an awful lot of the time. But, still, there is at least one thing that performers have in common: timing. If you have it, you have it. No one can teach you that elusive and priceless sense of what is right. Jackie has that thing in abundance, plus the most finely tuned ear that ever sat in a head. So is it any wonder that when I went to see my famous 'protégée' do her stuff at the Purcell Room, I should have preened with vicarious pride? Not a trick was missed in Peter's adventures with the wolf and assorted other animals; the delicacy with which she lauded the excessive bravery of the duck quacking angrily at the cat 'from the *middle* of the pond'; the mournful reverberations of nasty duck fate contained in ' . . . and with one gulp *swallowed* her'; the infant braggadocio expressed in 'boys such as he were not afraid of *wolves*'; the cautious exactitude of self-preservation in ' . . . not *too* close to the cat'.

And who says she doesn't have an ear for the collective clout of

the compounded consonant? No one has reached such depths of disdain with 'what kind of bird are you if you can't sswimm and ddivved into the pond', or such green-eyed viciousness with those crazy foreign r's of hers growling 'grrabb' and 'grreeedy'. 'Imagine the tryumphant prrocession!' cried Jackie as this little jewel of musical story-telling trod brightly to its end, the laughs coming unerringly and sweetly, lovingly conducted by Daniel towards that equally tryumphant figure in her wheelchair. Is there no end to her talents, I ask myself? Endowed with a quite sublime musical talent, she now shows dangerous signs of becoming a first-rate comedienne.

Press Association

After receiving the OBE, February 1976

'I Was Lucky, You See'
by
JACQUELINE DU PRÉ

(Compiled from conversations with the Editor and from BBC
television and radio programmes)

The very first time I heard a cello was on the radio in a programme
for children to show them every instrument in the orchestra. I
remember telling my mother: 'I want one of those please.' I was
four. It was managed in a rather magical way. I woke up one
morning and there was a cello beside the bed. It was with very great
excitement that I took it up and tried it. My mother fostered my
enthusiasm for the instrument by writing pieces for me. To the
music she put words and drawings, she would tell me the rhyme or
the words, show me the drawings and by that time I loved it so much
that playing was the greatest delight. I remember being inspired
later by the idea of horse hair and cat gut (well actually sheep gut)
getting together to make that lovely sound. In fact I still remember
hearing somewhere, 'A noise rose from the orchestra as the leader
drew the tail of the noble horse across the intestines of the timid
cat.'

When I was three I ran away from home. I was missing from seven
in the morning until seven-thirty in the evening and the police were
alerted. I did it again when I was five – on my tricycle.

At school I was one of those children who was made a scapegoat.
It was never easy for me to join in. Being rather miserable and feeling
isolated, when I actually left school it was a welcome day. I loved
maths. I loved English; I think much education can be acquired
without necessarily having it in a formalized manner. The way one
does perhaps lose out is through not being with other people and
therefore not learning to adjust with them and learning about life
with them.

When my family lived in Portland Place my father had a stick insect – bless its heart. But I could find no way to love it . . . I hated it. She was named Amanda – Mandy for short – and lived in her own aquarium. When she died she was given a burial in nearby Regent's Park. A deeply religious service was conducted by my father, who still remembers the spot where Amanda lies.

My first real public appearance in 1961 at the Wigmore Hall was memorable in more ways than one. After beginning the first piece, which was the Handel G minor Sonata, the A string began to unwind itself. This meant the sound got lower and lower. To compensate for this I was obliged to go higher and higher up the keyboard until the string finally fell to the floor. It happened very slowly, so that the audience did not realize what was happening. When it finally dropped it was obvious that I could not go on playing. By the time I had changed the string and was back on stage, there had been a few moments for reflection and I went back actually feeling stronger than when I started.

I loved performing. An audience consists of a variety of people, so there is no particular person or persons one has to play to, but every audience has its own particular aura. Every concert feels entirely different, the audience reaction is both interesting and stimulating. And it is possible to speak most eloquently through music.

I was used to being alone on my travels. I would read or explore the city I was in, but what I didn't like was going down to a big restaurant in a hotel, sitting down at a table alone. So I would eat in my room.

The cello is a lonely instrument and it needs another instrument or an orchestra with a conductor. So that to achieve a complete fulfilment from what one is doing, it is necessary to have someone with whom one has a great bond musically. It happened very frequently for me with my husband.

My first meeting with my husband was most remarkable. The door was opened and in came this very dynamic person; he sat down and we played through something, and to my surprise there was nothing to say, it was as though we had known each other for a very long time. It was a wonderful feeling. Sometimes I might not chat with someone as easily as I would wish, but with a fellow musician and somebody I liked, I knew I would be able to talk very freely, through music.

When Daniel went to Israel in 1967, I was pretty frightened and wanted to be with him. There was no war for ten days and we spent

Rehearsing Haydn's Toy Symphony at the Royal Albert Hall, July 1979. Jackie, with toy drum, is talking to Rafael Kubelik

our time playing all over Israel. The audience would be basically women because their sons, husbands and brothers were fighting. There was a special atmosphere in the air and a feeling that it was extremely important to do anything one could through one's abilities as a musician.

I don't actually know why I've been linked so much with the Elgar, unless it's because of its English element. I loved playing it. There is a passage at the end of the concerto which has always meant a great deal to me. It's very inward, very intense, very passionate and flamboyant and at the same time very soft, all of which sounds like a contradiction in terms. It's difficult to play in the sense that one has to be well aware of the kind of sound one is making and know exactly how one wants to achieve this . . .

When I was in Australia I went to a doctor to complain of some symptoms from which I seemed to be suffering and I was told it was adolescent trauma. Not very helpful, although it is not unusual, I believe, for MS to remain undiagnosed in its early stages. I had the frustration and the guilt of thinking: what on earth is wrong? Why

am I reacting in this way and feeling lousy at the same time?

It was while I was on my own in America that I had a nightmare of an experience. Rehearsals had been very difficult; I didn't feel in command of the bow. Various areas of my body were numb and I couldn't feel the strings of the cello. I recall arriving at Philharmonic Hall in New York and finding I was unable to open the cello case. I walked onto the platform not knowing how I would find a key or what sounds I was going to produce. I remember then realizing that my only hope was to use my eyes to help my fingers as much as possible. It was not good playing, an indifferent performance. I decided to return home and not fulfil any further engagements. When I got back my illness was quickly diagnosed. Since then I have not given a concert.

When I was told absolutely bluntly that I had MS and that nobody could prophesy what was going to happen, I asked a thousand questions and got straightforward answers. It was perhaps likely that I would not get up from the wheelchair again. It was tough medicine actually, but I was quite grateful, because it meant that for me MS was not shrouded in a great aura of mystery. Since then I have tried to think and work out what I can do from a wheelchair and what I can do is quite a lot.

I was lucky because Daniel was able to stay home at times when he was less busy. Actually he put off many of his engagements so that he could be with me. It is such a big problem when one's movements become restricted before one can find a way of looking after oneself for essentials like food, washing and dressing. At that time, before we had the good fortune to find our very dear housekeeper, Olga, Daniel, who previously hadn't known how to make tea with a tea bag, became very busy in the kitchen studying the rudiments of curry making.

There were long periods of being encompassed by four walls, time to feel very lonely, time to analyse each symptom with great intensity and watch its progress as if under a microscope. Those times were horrible and I managed them very poorly. When things are hard and one is not well, one is very conscious of the effect this has on those who are close to one; of the enormous resources it calls for in them. There is not only the difficulty of trying to learn to face up to the way one must regard oneself, but also finding a way of dealing with the feeling of guilt which such a situation brings upon those who are very close. However willingly it is accepted, it is nevertheless unhappily a part of the whole syndrome.

Maybe I am speaking too soon, but I feel I have gone through the hardest times when it comes to fear and a futile sense of uselessness and hopelessness. I feel that I have experienced all that fully and I hope it is now well behind me. It is a horrid feeling to have to be dependent and it can make one feel absolutely furious at times.

I enjoy listening to music, talking with my friends, going to the park and to concerts. I'm really quite busy. Nothing very special. The norm can be a pleasant if not entirely happy day. There are obviously times when I allow myself to accept the fact that it's normal when one feels low, but it's not the general rule as it was, and I think I can honestly say that I do enjoy very much what I enjoy.

I am not so frightened any more because I know that what I can do and have done in quite bad times, I shall perhaps still be able to do if really bad times come again. I also know that I shall have round me people who are totally steadfast and caring, so that I shall not be left literally alone, as well as perhaps in my own head. I have very good friends. I am very fond of the doctors who look after me and I have a lovely family. Being so surrounded by warmth and affection, I am constantly aware that thousands of people are without these blessings and that the number of those with multiple sclerosis who suffer the additional sorrow of loneliness does not bear contemplation.

When I was preparing *Peter and the Wolf*, Janet Suzman advised me, 'Don't over-emotionalize the words, the music is there to illustrate them.' It occurred to me that this is exactly what I tried to convey to my pupils – that the expression is inbuilt in the music and in the shape of the piece as well. Too much expressive indulgence will distort the musical structure.

Playing my recordings sometimes does give me great pleasure, because it is so much second nature to me that listening to a recording is almost as if I was back there doing it again. Oh, yes, I do find myself wishing I could do it like that now, but it's a great source of comfort and refreshment. I was lucky, you see, because my talent was one which developed very early, so by the time the symptoms of MS developed severely enough to interfere with playing, I had done everything I could have wanted and had had so many marvellous experiences through the cello. So I can't reflect with any bitterness, neither do I have a terrible feeling of remorse. I look back with great pleasure at what I was able to do and the great joy I experienced in doing it.

I was converted to Judaism and Daniel and I wanted our children

Press Association

At the University of London Foundation Day dinner the Queen Mother conferred on Jackie the Honorary Degree of Doctor of Music, November 1979

brought up in the Jewish faith. But we have no children. I am sometimes asked if religion has helped me and I always reply – to be quite honest, not as much as music, because for me the Judaism is almost bound up in the music. I just cannot separate them or indicate their boundaries.

I know through all my troubles, I could never say that I am not a lucky person, because materially and emotionally I am very blessed. To have the things around which can be so cherished is enough to make one feel that this is a land full of milk and honey.

Extracts from Jacqueline du Pré's Notebooks

I was always a lover, since childhood, of the winter elements – of snow as it graced the earth gently with its snowflakes leaving that pristine white carpet. Oh, what a shame to spoil its velvet smoothness with a common footprint, but what a delicious excitement to create evidence of one's exploration into a virgin land! I remember the search for the single, magically designed snowflake, or of flinging myself into the snow loving its texture, the cold against one's skin and the fun of constructing hard snowballs to throw at random to watch their passage through the air and then their splintering rebound on the chosen target.

Wind and rain also thrilled me, as the first would dance wildly through my hair, buffeting my cheeks, exciting them to warmth, and also induce beauteous scents, and the second with its patter-patter which would invite the imagination to new worlds, would be the flowers into which I could explore the moisture with my face embedded in them, and the thrill with the luscious scents the rain would invite into my world.

(Written at 2 a.m. when my mind feels somewhat muddy and I have never been much of a mud lover!)

Elgar's photo now hangs on the wall – a document which tells so vividly of his unhappy life. A sick man who had through it a glowing heart in such a profusion of loveliness as expressed in so many of his works. How his face haunts me, and always will.

Never mind about present affliction – any moment may be the next!

I suppose all of us must learn to find independence in dependence.

If the sunshine beckons you, accept its invitation and love the gold quality of it.

A genius is one who, with an innate capacity, affects for good or evil, the life of others.

Don't let the sound of your own wheels drive you crazy.

A relationship is not what you would like it to be – or what you think it is. It defines *itself* by the actual quality of the interchange between the people involved.

Jacqueline du Pré's honours to date

Awarded the OBE 1976

Gained the Suggia Gift 1955

Gold Medal Guildhall School of Music
and Queen's Prize 1960

London début 1961

North American début 1965

Gave first performance of Goehr's Romanza
for Cello and Orchestra, which was written
for her 1968

City of London Midsummer Prize 1975

Fellow of the Guildhall School of Music 1975

Fellow of the Royal College of Music 1976

Incorporated Society of Musicians Medal 1981

Hon. RAM; Hon. Mus.D. London, Open,
Sheffield, Leeds, Salford, Durham

Discography

DVOŘÁK Concerto in B minor, op. 104; *Silent Woods*, op. 68 (Chicago Symphony Orchestra/Barenboim)

UK: ASD 2751 *US*: Ang. S–36046

ELGAR Concerto in E minor, op. 85 (London Symphony Orchestra/ Barbirolli); *Sea Pictures*, op. 37, 'Sea Slumber-Song'; 'In Haven' (Capri); 'Sabbath Morning at Sea'; 'Where Corals Lie'; 'The Swimmer' (Dame Janet Baker, London Symphony Orchestra/ Barbirolli)

UK: ASD 665 * *US*: Ang. S–36338

ELGAR Concerto in E minor, op. 85 (London Symphony Orchestra/ Barbirolli); DELIUS Cello Concerto (Royal Philharmonic Orchestra/Sargent) Recorded under the auspices of the Delius Trust

ASD 2764

ELGAR Concerto in E minor, op. 85 (Philadelphia Orchestra/ Barenboim)
A concert performance recording

UK: CBS 76529 * *US*: Col. M–34530

HAYDN Concerto in C major; BOCCHERINI Concerto in B flat major (English Chamber Orchestra/Barenboim)

UK: ASD 2331 *US*: Ang. S–36439

HAYDN Concerto in D major, op. 101; MONN Concerto in G minor (London Symphony Orchestra/Barbirolli)

UK: SXLP 30273 * *US*: Ang. S–36580

SCHUMANN Concerto in A minor, op. 129; SAINT-SAËNS Concerto No. 1 in A minor, op. 33 (New Philharmonia/Barenboim)
UK: ASD 2498 *US*: Ang. S–36642

Favourite Cello Concertos HAYDN Concerto in D major, op. 101; ELGAR Concerto in E minor, op. 85 (London Symphony Orchestra/ Barbirolli); HAYDN Concerto in C major (Hoboken VIIb: 1) (English Chamber Orchestra/Barenboim); SCHUMANN Concerto in A minor, op. 129 (New Philharmonia Orchestra/Barenboim); DVOŘÁK Concerto in B minor, op. 104; *Silent Woods*, op. 68 (Chicago Symphony Orchestra/Barenboim) 3LP set

SLS 895

BRAHMS Sonata No. 1 in E minor, op. 38; Sonata No. 2 in F major, op. 99. With Daniel Barenboim (piano)
UK: ASD 2436 *US*: Ang. S–36544

BEETHOVEN Sonatas No. 1 in F major, op. 5, No. 1; No. 2 in G minor, op. 5, No. 2; No. 3 in A major, op. 69; No. 4 in C major, op. 102, No. 1; No. 5 in C major, op. 102, No. 2; 7 Variations on 'Bei Männern' from Mozart's *Die Zauberflöte*; 12 Variations on 'Ein Mädchen oder Weibchen' from *Die Zauberflöte*, op. 66; 12 Variations on 'See the Conquering Hero Comes' from Handel's *Judas Maccabaeus*. With Daniel Barenboim (piano) 3LP set
UK: SLS 5042 *US*: 3-Ang. S–3823

BEETHOVEN Trio No. 4 in D, op. 70, no. 1 ('Ghost'). Trio No. 5 in E flat, op. 70, no. 2. With Daniel Barenboim (piano) and Pinchas Zukerman (violin).
US: Vox C. 9024

BEETHOVEN Trio No. 6 in B flat major, op. 97 ('Archduke'); Trio No. 7 in B flat major ('1812'). With Daniel Barenboim (piano) and Pinchas Zukerman (violin).
ASD 2572 *

BEETHOVEN Piano Trios No. 1–7, no. 14; Trio in E flat (1790/91); 10 Variations on Müller's song 'Ich bin der Schneider Kakadu', op. 121a; 14 Variations in E flat major, op. 44. With Daniel Barenboim (piano) and Pinchas Zukerman (violin); Clarinet Trio in B flat, op. 11. With Daniel Barenboim (piano) and Gervaise de Peyer (clarinet). 5LP set

SLS 789

A Jacqueline du Pré Recital VON PARADIS *Sicilienne*; SCHU-MANN Three Fantasy Pieces, op. 73; MENDELSSOHN Song Without Words in D, op. 109; FAURÉ Elégie in C minor, op. 24; J. S. BACH Toccata in C, BWV 564 – Adagio; SAINT-SAËNS *Carnival of the Animals* – Le Cygne; FALLA *Suite Populaire Espagnole* – Jota; BRUCH *Kol Nidrei*, op. 47. With Gerald Moore (piano), Roy Jesson (organ), Osian Ellis (harp) and John Williams (guitar)

HQS 1437

PROKOVIEV Peter and the Wolf, op. 67 (English Chamber Orchestra/Barenboim). Narrated by Jacqueline du Pré Recorded 14 October 1979

DG 2531275

* also available on cassette

The Jacqueline du Pré Research Fund for Multiple Sclerosis

Everyone who loves classical music knows of Jacqueline du Pré's astounding, radiant talent and her tragic disablement, caused by multiple sclerosis (MS).

Miss du Pré has lent her active support to The Multiple Sclerosis Society of Great Britain and Northern Ireland, her national society, and to the International Federation of Multiple Sclerosis Societies (IFMSS) and their ceaseless effort to find the cause, more effective treatments and a cure for MS. The Federation is composed of National Societies in 29 member nations, and a network of 169 neurologists and scientists in 39 countries.

Through the work of her husband, Daniel Barenboim, and of her friend, James D. Wolfensohn, who at the time of this writing is President of the IFMSS, the Jacqueline du Pré Research Fund was created under the chairmanship of Mr Wolfensohn. Many of the world's great artists have given benefit performances to raise money for the Fund, including, among others, Itzhak Perlman, Eugenia and Pinchas Zukerman, Misha and Cipa Dichter, Zubin Mehta, Yo Yo Ma, the English Chamber Orchestra, Dame Margot Fonteyn, Natalia Makarova, Anthony Dowell, Valentina Kozlova, Leonid Kozlov, Zizi Jeanmaire, Rudolph Nureyev, and Daniel Barenboim.

Multiple sclerosis is a chronic, generally progressive disease of the central nervous system. It commonly strikes women and men between the ages of 15 and 50, most frequently those who are in the prime of life. Because of the long-term nature of the disease, in most cases, and its unpredictable course, MS imposes a tremendously heavy socio-economic burden on the entire family and upon society as a whole.

MS is characterized by inflammation and disintegration of the myelin sheath, an insulating covering that wraps in layers around nerve fibers in the central nervous system: later, sclerotic tissue (scars) form in the many damaged places. Messages traveling to and from the brain can be distorted, misdirected or lost as they go by these damaged areas. Symptoms vary from

patient to patient and depend on the site of damage in the myelin sheath and the extent of damage. Millions of people worldwide are believed to have MS, although exact figures are unknown because of the large number of cases that go unreported or await final diagnosis. It is more common in colder climates.

There is, to date, no known cure for multiple sclerosis. Current research focuses on immunology, virology, epidemiology and clinical trials. More than 100 full time investigators based at university medical schools and hospitals are currently pursuing active investigations in both basic and clinical research.

In addition to massive research programs in the United States, Great Britain and Canada, many other Societies support research programs and all member Societies of the Federation provide patient services which include support to MS clinics, medical equipment loans, varied rehabilitative, counseling and recreational programs, and referral services to those who have MS and their families.

Since the inception of the first national Society in the United States, in 1946, more than $69 million has been allocated to research in that country alone. Immense progress has been made in the last decade in understanding the mechanism of the disease. New regimens are now being tested and reported which seem to alter its course.

There is no better way to honor the artistry of Jacqueline du Pré than to join in the battle against multiple sclerosis. If you would like to learn more about the activities and progress in combating multiple sclerosis, or contribute to the Jacqueline du Pré Research Fund, contributions and inquiries can be directed to the Multiple Sclerosis Society at the following address:

Jacqueline du Pré Research Fund
National Multiple Sclerosis Society
205 East 42 Street
New York, N.Y. 10017
Tel. (212) 986–3240 contact: Joan Davis Berger

All royalties from the sale of this book are being donated to the Jacqueline du Pré Research Fund.

George C. Boddiger
Chairman, International
Development Committee
International Federation of
Multiple Sclerosis Societies

BRAZIL

ABDO
Publishing Company

BRAZIL

by Christopher Forest

Content Consultant

Samuel Cohn
Professor, Department of Sociology, Texas A & M University

CREDITS

Published by ABDO Publishing Company, 8000 West 78th Street, Edina, Minnesota 55439. Copyright © 2012 by Abdo Consulting Group, Inc. International copyrights reserved in all countries. No part of this book may be reproduced in any form without written permission from the publisher. The Essential Library™ is a trademark and logo of ABDO Publishing Company.

Printed in the United States of America,
North Mankato, Minnesota
062011
092011

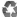
Editor: Melissa York
Copy Editor: Susan M. Freese
Series design and cover production: Emily Love
Interior production: Kazuko Collins

About the Author: Chris Forest is a fifth-grade teacher from Natick, Massachusetts. He has written for a variety of educational publishers during the last 16 years.

Library of Congress Cataloging-in-Publication Data
Forest, Christopher.
 Brazil / by Christopher Forest.
 p. cm. -- (Countries of the world)
 Includes bibliographical references and index.
 ISBN 978-1-61783-106-5
 1. Brazil--Juvenile literature. I. Title.
 F2508.5.F595 2011
 981--dc23
 2011020915

Cover: Sugar Loaf, Rio de Janeiro, Brazil

TABLE OF CONTENTS

CHAPTER 1	A Visit to Brazil	6
	Map: Political Boundaries of Brazil	9
	Snapshot	15
CHAPTER 2	Geography: Rain Forest and More	16
	Map: Geography of Brazil	19
	Map: Climate of Brazil	20
CHAPTER 3	Animals and Nature: Biodiversity under Threat	30
CHAPTER 4	History: Emperors, Dictators, Presidents	46
CHAPTER 5	People: A Unique Society	62
	Map: Population Density of Brazil	64
CHAPTER 6	Culture: Blending Three Heritages	74
CHAPTER 7	Politics: Under New Leadership	92
CHAPTER 8	Economics: South American Powerhouse	104
	Map: Resources of Brazil	107
CHAPTER 9	Brazil Today	118
TIMELINE		128
FACTS AT YOUR FINGERTIPS		130
GLOSSARY		134
ADDITIONAL RESOURCES		136
SOURCE NOTES		138
INDEX		142
PHOTO CREDITS		144

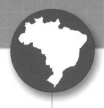

CHAPTER 1
A VISIT TO BRAZIL

Your plane comes in for a landing at the Brasília International Airport in Brasília, Brazil, and you glance out the window. Looking from above, you can see how the city's central district is laid out in the shape of a flying bird. You see the trees and savanna of Brasília National Park, the world's largest park inside an urban area. You know the clear skies and warm weather will make your stay a memorable one.

As you walk through the terminal to claim your baggage, your eyes wander to a display: Welcome to Brazil it reads. The display is filled with dozens of brochures. This is your first trip to Brazil, and you have come to visit the Amazon rain forest. As you survey the display, you realize that Brazil is so much more than the Amazon. It's a place to explore. As you read the pamphlets, you become even more fascinated with the country. You want to walk the sparkling white beaches of

Brazil is the largest Portuguese-speaking country in the world.

Brasília is known for unique architecture, including the city's Metropolitan Cathedral.

the Atlantic shore. You want to visit Rio de Janeiro during Carnival and see the extravagant costumes. And you can't wait to sample the country's hugely diverse cuisine.

BRAZIL'S VARIED HERITAGE

Similar to many South American countries, Brazil pays homage to its blended culture in a variety of ways. Despite the fact Brazil has been independent from its colonial ruler, Portugal, since 1822, the national language of the country is still Portuguese. A variety of indigenous and other European languages are spoken in the country as well.

Buildings left by the Portuguese settlers who ruled the country for three centuries are intermingled with the twentieth-century architecture of modern metropolises. Old churches and missions dot the landscape. Cities first founded by Portuguese pioneers remain to this

THE TREATY OF TORDESILLAS

In the 1490s, the age of exploration had just begun. Portugal and Spain were vying for supremacy over the oceans. The two countries, which often shared a tumultuous history, decided that compromise was better than all-out warfare in the New World. To prevent border wars, the two countries signed the Treaty of Tordesillas on June 7, 1494, under which they agreed to divide the new lands between them. An imaginary line was drawn through the New World. All lands to the east of this line belonged to Portugal, and all lands to the west of this line belonged to Spain. As a result of this treaty, Portugal gained access to the land that would become Brazil.

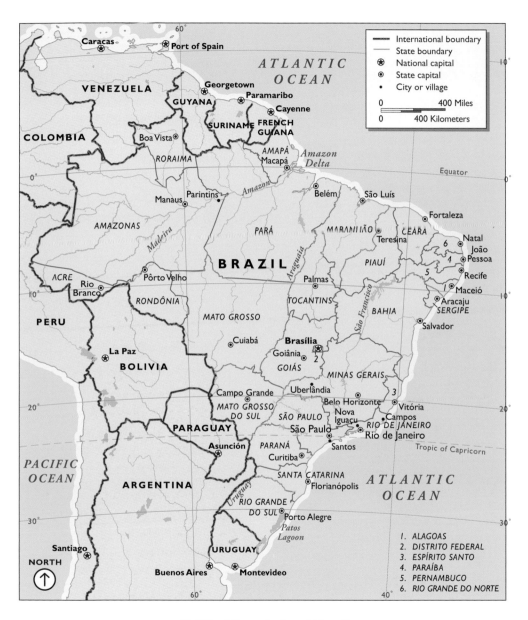

Political Boundaries of Brazil

1. ALAGOAS
2. DISTRITO FEDERAL
3. ESPÍRITO SANTO
4. PARAÍBA
5. PERNAMBUCO
6. RIO GRANDE DO NORTE

UNESCO WORLD HERITAGE SITES OF BRAZIL: CULTURAL IMPORTANCE

The United Nations Educational, Scientific, and Cultural Organization (UNESCO) designates World Heritage sites. The following are sites in Brazil designated as culturally important:

Brasília: Capital city of Brazil

Historic Center of Salvador de Bahia: Site of the first capital of Brazil (1549–1763)

Historic Center of São Luís: Seventeenth-century town featuring Portuguese colonial architecture

Historic Center of Diamantina: Eighteenth-century town built in the style of a medieval Portuguese village

Historic Center of Goiás: Eighteenth-century village

Historic Center of Olinda: Sixteenth-century city with many churches and chapels.

Historic Town of Ouro Preto: Eighteenth-century city that was at the center of Brazil's gold rush

Jesuit Missions of the Guaranis: Seventeenth- and eighteenth-century Jesuit missions

Sanctuary of Bom Jesus do Congonhas: Eighteenth-century church

São Francisco Square in São Cristóvão: Represents a unique merging of Portuguese and Spanish architecture from 1580 to 1640.

Serra da Capivara National Park: Location of cave paintings more than 25,000 years old

day, testimony to the age of European discovery. They serve as a reminder of the time when Portugal and Spain competed for control of the New World. In contrast, the capital city, Brasília, was planned and built entirely new in the mid-twentieth century and has become a model for harmonious urban planning.

Brazil is also known for its natural wonders. Perhaps no natural wonder quite captivates the imagination of Brazilian visitors more than the vast tropical rain forest of north-central Brazil, the largest rain forest in the world. There, the Amazon River, the second-longest river in the world, has shaped the remarkable

Amazon River boat tours are becoming more and more popular.

landscape. The Amazon teems with the greatest assortment of wildlife found in one region.

Brazil is an exciting place for sports enthusiasts. The nation is known for successful team sports, including its volleyball and basketball teams. But they pale in comparison to the king of all Brazilian sports: soccer. Brazil is a hotbed for soccer, and some of the world's most famous players—including the internationally renowned Ronaldo and Pelé—have come from the country. It's the only country to have won soccer's World Cup five times.

No visit to Brazil would be complete without visiting one of the many festivals that occur throughout the country. The celebrations, which can last up to a week, give the people of Brazil a chance to celebrate and share each other's company. Perhaps the most famous of these festivals is the Carnival of Rio de Janeiro. This four-day festival lights up the streets and the night during February or early March each year.

BRAZIL'S WORLD CUP WINS

1958: Defeated Sweden

1962: Defeated Czechoslovakia

1970: Defeated Italy

1994: Defeated Italy

2002: Defeated Germany

Carnival is known for colorful, extravagant costumes.

An advertisement for a nearby café praises its local Brazilian coffee beans. The country is well known for its coffee exports. Coffee plants were brought to Brazil in 1727, and in the eighteenth and nineteenth centuries, Brazil was nearly synonymous with coffee. Large coffee plantations were established throughout the nation, and Brazil continues to be the world's largest producer of the crop.[1] You look forward to sampling a steaming, fragrant cup.

You sit back a moment and ponder the possibilities. Just a few minutes ago, you came to Brazil to see the Amazon. Now you know the country has a lot more to offer, and you can't wait for your adventure to start.

The Amazon River basin encompasses nearly half of Brazil.

SNAPSHOT

Official name: Federative Republic of Brazil (Portuguese: República Federativa do Brasil)

Capital city: Brasília

Form of government: federal republic

Title of leader: president

Currency: real

Population (July 2011 est.): 203,429,773
World rank: 5

Size: 3,287,612 square miles (8,514,877 sq km)
World rank: 5

Language: Portuguese (official); other languages spoken include Spanish, German, Italian, Japanese, English, and many Amerindian languages

Official religion: none; Roman Catholicism, 73.6 percent; Protestantism, 15.4 percent; Spiritualism, 1.3 percent; Bantuism/Voodoo, 0.3 percent; other, 1.8 percent; unspecified, 0.2 percent; none, 7.4 percent

Per capita GDP (2010, US dollars): $10,900
World rank: 104

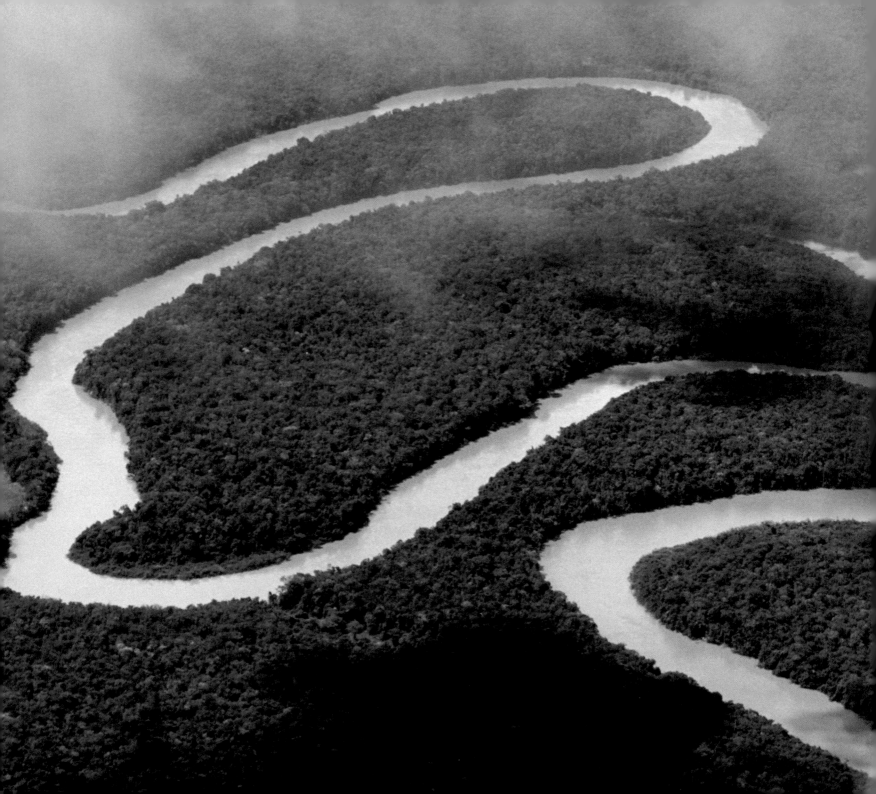

CHAPTER 2

GEOGRAPHY: RAIN FOREST AND MORE

Brazil is the fifth-largest country in the world. Consisting of approximately 3.3 million square miles (8.5 million sq km), it is slightly smaller than the United States.[1] Brazil makes up nearly 50 percent of the South American continent and comprises its eastern section.

The eastern border of Brazil is formed with the Atlantic Ocean, while the remainder of the country touches Uruguay, Argentina, Paraguay, Bolivia, Peru, Colombia, Venezuela, Guyana, Suriname, and French Guiana—every country in South America except Chile and Ecuador. Extending into four major time zones, the wedge-shaped country spans approximately 2,731 miles (4,395 km) from north to south and 2,684 miles (4,319 km) from east to west.[2]

The Amazon River is the second-longest river in the world.

BOUNDARY DISPUTES

Although most of Brazil's boundaries are clearly defined, three are disputed by neighboring countries. The first is the boundary formed with Paraguay near the Guaíra Falls. Both Brazil and Paraguay claim ownership of a region now covered by a reservoir.

The other two boundary disputes are between Brazil and Uruguay. The first dispute involves ownership of Brasileira, an island located where the Quaraí and Uruguay Rivers meet. The second dispute involves territory in the region of the Invernada River.

The dominant features of the Brazilian landscape include eight major river systems. One of those river systems, the Amazon River and its tributaries, winds through the largest tropical rain forest in the world. The Amazon River alone contains 20 percent of the world's freshwater.[3] The country also includes several island groups, including the Fernando de Noronha archipelago, located off the northeastern Atlantic coast.

The equator cuts through the northern section of Brazil. Although most of the region is tropical, a variety of biomes are found in the country. This makes for a diverse environment that is home to nearly 20 percent of the total life on Earth.[4] Brazil may be divided into five major geographic regions: northern, northeastern, southern, southeastern, and central-western.

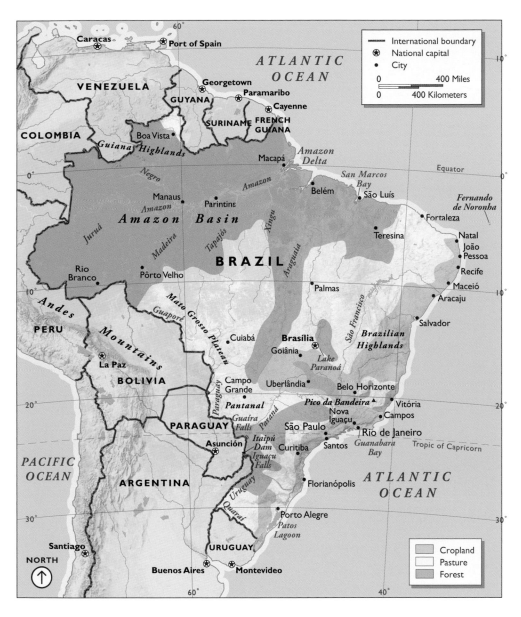

Geography of Brazil

NORTHERN BRAZIL

The northern region of Brazil consists of the states of Acre, Amazonas, Amapá, Pará, Rondônia, Roraima, and Tocantins. It is known internationally as the Amazon region, as it includes the major portion of the Brazilian rain forest. The region is known for its tropical climate and its rain forest habitat.

The Amazon region is the least densely populated portion of the country. Many of the people there live off the land, surviving through farming, ranching, or lumbering. The rain forest provides a wealth of products to the world—from nuts and rubber to innovative natural medicines developed from Amazonian plants.

BRAZIL'S LARGEST CITIES (2009 ESTIMATES)

São Paulo: 19.96 million

Rio de Janeiro: 11.836 million

Belo Horizonte: 5.736 million

Porto Alegre: 4.034 million

Brasília: 3.789 million[5]

NORTHEAST BRAZIL

The northeast region of Brazil, which includes the states of Alagoas, Bahia, Ceará, Maranhão, Paraíba, Pernambuco, Piauí, Rio Grande do Norte, and Sergipe, was the first portion of the country to be colonized

Cacti grow in the dry sertão region in northeastern Brazil.

by Portuguese settlers. This region is dry and hot, mostly composed
of semiarid landscape known as the *sertão*. The sertão is covered with
scrubby forest known as *caatinga*. It experiences a six-month dry period
followed by a short period of quick, powerful storms that provide much-
needed rainfall.

The coastline of the northeast region is humid and was once covered with a vast forest. During the colonial era, settlers began chopping down trees to make way for sugar plantations. Today, the Atlantic forest has nearly disappeared, replaced by cities and large farms. The coastline is known for beautiful sandy beaches, making it a popular tourist destination.

SOUTHEAST BRAZIL

The southeastern section of Brazil consists of the states of Espírito Santo, Minas Gerais, Rio de Janeiro, and São Paulo. Similar to the northeast region, it was once known for its lush Atlantic forests, large remnants of which have been protected by UNESCO as World Biosphere Reserves. These rain forests had long been separated from the Amazon by plains, and they once held unique species. But over time, these forests were cut to make way for farms and cities. Portions of the remaining forest are protected by parks.

The Paraná is the second-longest river in South America.

Today, the cities in this region have the highest population density of any part of Brazil. It contains the business hub of the country, centered in São Paulo, and it produces coffee and iron ore. It is also known for the popular tourist resorts that dot the landscape and boasts some of the country's most popular attractions.

Visitors to Sugar Loaf outside Rio de Janeiro can ride in a cable car to catch a bird's-eye view of Guanabara Bay.

AVERAGE TEMPERATURE AND RAINFALL

Region (City)	Average January Temperature Minimum/ Maximum	Average July Temperature Minimum/Maximum	Average Rainfall January/July
Amazon Basin (Manaus)	75/88°F (24/31°C)	75/90°F (24/32°C)	9.8/2.3 inches (24.9/5.8 cm)
Nontropical Southern Brazil (Porto Alegre)	66/88°F (19/31°C)	48/66°F (9/19°C)	3.5/4.5 inches (8.9/11.4 cm)
Tropical East Coast (Rio de Janeiro)	73/84°F (23/29°C)	63/75°F (17/24°C)	4.9/1.6 inches (12.5/4.1 cm)
Brazilian Plateau (Goiânia)	63/86°F (17/30°C)	55/90°F (13/32°C)	12.5/0 inches (31.7/0 cm)
Coastal Lowlands (Recife)	77/86°F (25/30°C)	72/81°F (22/27°C)	2.1/10 inches (5.3/25.4 cm)[6]

the flat grassland known as pampas, which is common to South American countries. This grassland is home to many cattle farms. Most people, however, live in the cities near the coast.

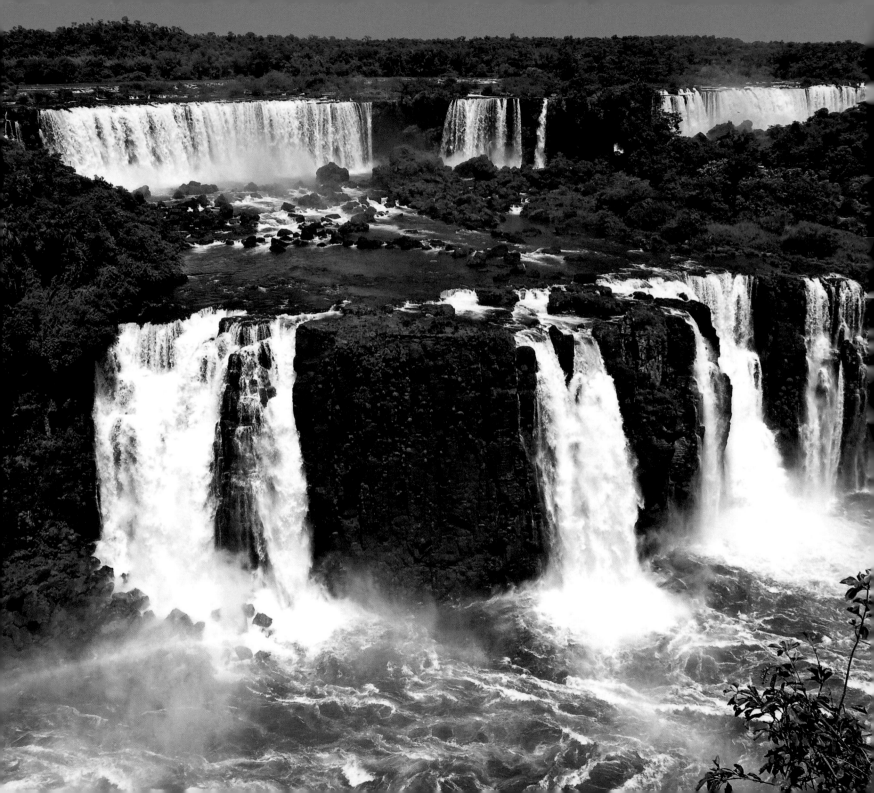

The Paraná River is also found in this portion of Brazil. This majestic river cuts through the portion of the country and gives way to an area known as Iguaçu Falls, a set of 275 waterfalls that spans almost 1.7 miles (2.7 km) across.[7] The falls culminate in a spot known as the Devil's Throat, where a large portion of the river disappears dramatically into a deep gorge. Near this spot is the Itaipú Dam, a human-made landmark on the border of Paraguay that boasts one of the largest hydroelectric plants in the world.

CENTRAL-WESTERN BRAZIL

The central-western section of Brazil is comprised of the states of Goiás, Mato Grosso, and Mato Grosso do Sul. It includes a diverse array of habitats, most of which occur on a giant plateau approximately 2,000 feet (600 m) above sea level.[8]

The main feature of this region is the *cerrado*, a flat grassland known for its unique squat shrubbery. This land once held cattle ranches but now features soybean farms. The southwestern expanse of this region gives way to the Pantanal, a tropical forest and freshwater wetland known for aquatic birds, caimans, piranhas, and alligators.

Brazil is larger than the lower 48 US states combined.

Iguaçu Falls lies on the border of Brazil and Argentina.

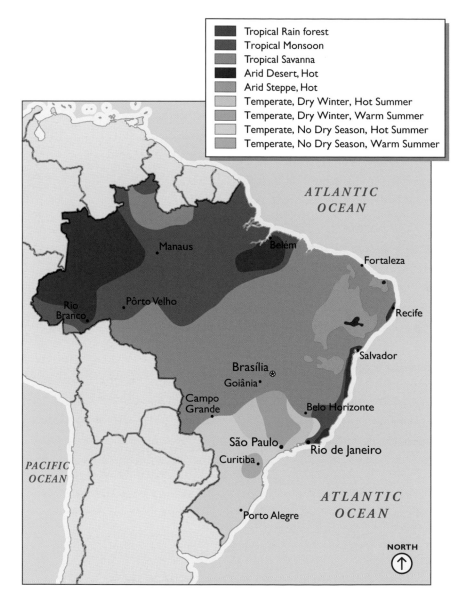

■	Tropical Rain forest
■	Tropical Monsoon
■	Tropical Savanna
■	Arid Desert, Hot
■	Arid Steppe, Hot
■	Temperate, Dry Winter, Hot Summer
■	Temperate, Dry Winter, Warm Summer
■	Temperate, No Dry Season, Hot Summer
■	Temperate, No Dry Season, Warm Summer

ATLANTIC OCEAN

Manaus

Belém

Fortaleza

Pôrto Velho

Rio Branco

Recife

Salvador

Brasília

Goiânia

Campo Grande

Belo Horizonte

São Paulo

Rio de Janeiro

Curitiba

PACIFIC OCEAN

ATLANTIC OCEAN

Porto Alegre

NORTH

Climate of Brazil

CLIMATE

Brazil is often considered a tropical country because of its proximity to the equator and its vast regions of rain forest. Indeed, 90 percent of the country falls within the tropical zone. However, Brazil has five climatic regions: equatorial, semitropical, highland tropical, subtropical, and semi-arid. Much of the country receives an average annual rainfall of 40 to 70 inches (100 to 180 cm).[9]

The northern regions of Brazil, where the equator intersects the country, are mostly tropical. This region includes most of the Amazon River, with its vast rain forests. Rain falls in this region for much of the year, accumulating at least 60 inches (150 cm) and in many places more than 80 inches (200 cm) per year.[10] There is little variation in temperature in this section of the country and no real dry season.

The semiarid zones of Brazil are located in central and northeast Brazil. In these zones, rain may not fall for six months of the year, from May to November. When the rain falls, it comes in quick bursts. A year's worth of rain can fall in one day. The average yearly rainfall is as low as 30 inches (75 cm) in some areas.[11]

The southern parts of the country, particularly south of the Tropic of Capricorn, enjoy a more temperate climate. Frost is not uncommon during the winter, which runs from June through August, and snow can be found in the region's mountains.

ANIMALS AND NATURE: BIODIVERSITY UNDER THREAT

Brazil is home to an amazingly diverse plant and animal population. Because the nation features the world's largest rain forest and second-longest river, it provides an ideal habitat for vast numbers of exotic and unique species. This large country also includes temperate forests, deserts, highlands, and savannas, and each habitat is home to its own species.

LAND ANIMALS OF BRAZIL

According to scientists, Brazil is home to the most diverse animal population in the world. Scientists predict there may be as many as

The blue morpho is one of the many colorful butterflies found in the Amazon.

104,000 animal species in the country, including insects; however, only 7,300 have been scientifically categorized. On average, 700 new animal species are catalogued each year.[1]

The Amazon rain forest is home to a proliferation of life. Insects, spiders, and other small life forms are abundant and can grow quite large—stick insects can grow more than 12 inches (30 cm) long, and the goliath bird-eating spider is the size of a small pizza, boasting a 12-inch (30-cm) diameter including its legs. The region is also know for its many species of large, beautiful butterflies.

The spider monkey roams the Amazon's trees. It subsists on fruits, nuts, seeds, leaves, and flowers in addition to bird and spider eggs. When separated from its group, the monkey makes a call similar to a horse's neigh, which has been known to startle unsuspecting humans. The tapir roams the forest floors. This hoofed mammal has a short trunk and is unrelated to other living species. The Amazon basin

CRITICALLY ENDANGERED MONKEYS

Monkeys in Brazil are endangered due to loss of habitat and capture for sale as pets. The following monkeys are listed as critically endangered by the International Union for Conservation of Nature (IUCN):

Black-faced lion tamarin

Blonde, Ka'apor, and Yellow-Breasted Capuchin monkeys

Blond Titi monkey

Northern Muriqui

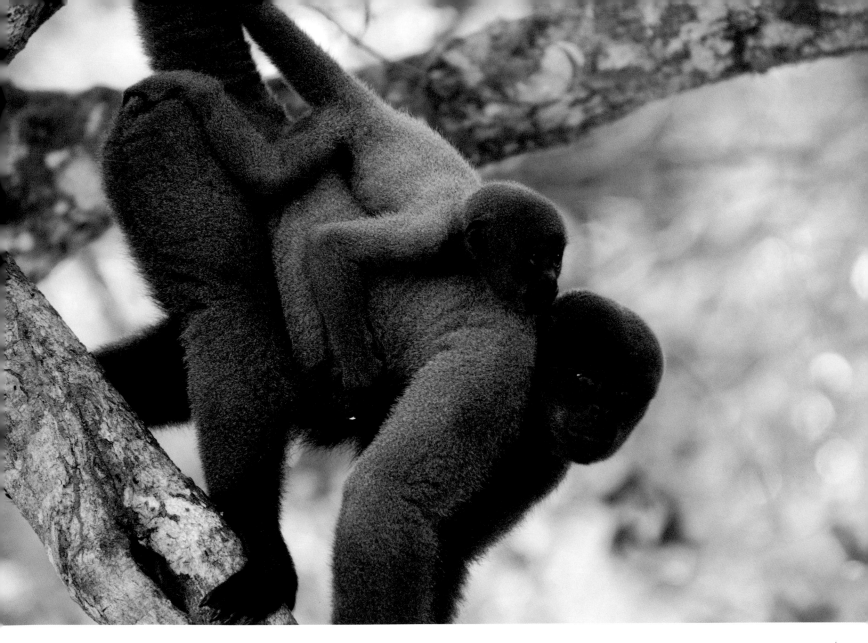

The common woolly monkey is one type of primate that lives in Brazil.

is also home to the largest species of anteater in the world. Known as the giant anteater, this creature may grow six feet (1.8 m) or longer. Its tongue can stretch to nearly two feet (0.6 m) to reach the ants the animal feeds upon. The largest rodent, the capybara, lives on Amazonian riverbanks and throughout South America.

Equally as diverse as the Amazon is the Pantanal region of Brazil. This large wetland ecosystem contains one of the largest concentrations of animals in one place in the world. Species in this region include the caiman, jaguar, maned wolf, and anaconda. The Pantanal is a popular spot for animal documentary filmmakers.

CREATURES OF THE SKY

Many bird and mammal species soar the Brazilian skies. The white-lined bat is named for the white stripe that runs from its ears to its tail. Only two to four inches (5 to 10 cm) long, this bat is about the size of an adult human's palm. It roosts in trees under leaves and eats fruit.

More Amazon life is found in the tree canopy than on the ground.

In 2002, the president signed an order making the sabiá-laranjeira, or rufous-bellied thrush, Brazil's national bird. The small songbird is light brown with a red breast.

One of the most colorful birds in the region is the Toco toucan. Known for its large, brilliant orange beak, the bird is found in the rain forests of Brazil. The Toco is

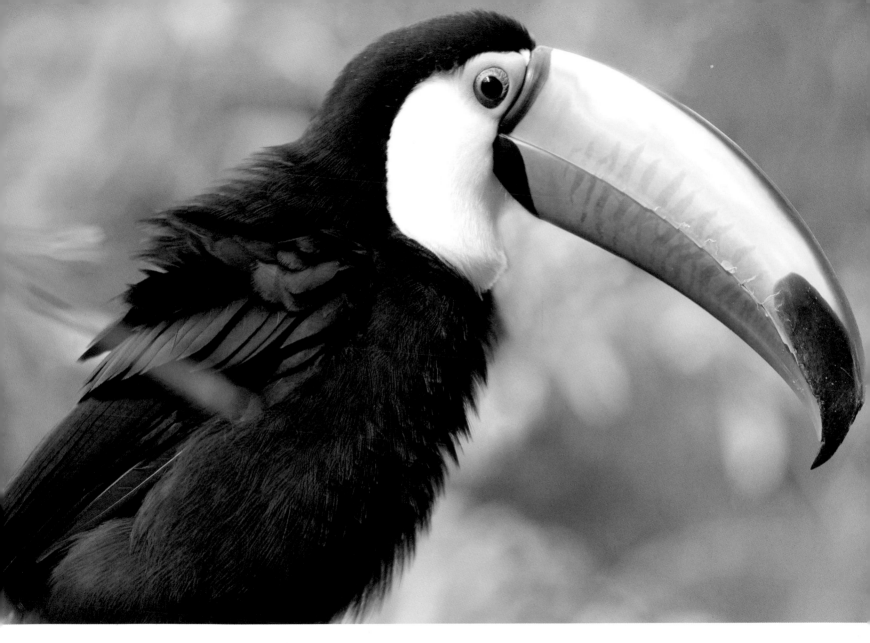

Toco toucan

the largest of the 37 toucan species found in South America, growing to nearly two feet (0.6 m) tall. The Toco's diet is primarily fruit, but it also eats insects, young birds, small lizards, and eggs. The Toco is a target for animal hunters and poachers, who illegally capture the birds and sell them to pet stores.

PIRANHA ATTACKS

In recent years, damming of rivers has caused an increase in piranha attacks—dams slow river waters, creating ideal conditions for the fish to reproduce. Forced to compete for resources, the increasing piranha population begins to seek marginal food sources.

Piranhas can rip off chunks of skin on human bathers, leaving large wounds, but they do not often cause major damage. Although piranha attacks have led to at least one amputation of a human toe, the claims of attacks leading to human deaths are unfounded. Scientists studying reports of piranha attacks in the past decade did learn of three instances in which piranhas ate humans—but the victims died of other causes such as drowning.[2]

WATER ANIMALS OF BRAZIL

Piranhas are found in many of the rivers and waterways in Brazil. These sharp-toothed fish lay their larvae among the grasses of slow-moving rivers. Usually, piranhas eat plants, insects, and other fish, but occasionally they will form groups and go into a feeding frenzy to attack a large animal. The pirarcu, a long and narrow fish with a wide tail, is one of the largest freshwater fishes in the world. Water reptiles such as caimans also lurk in the

Piranhas have sharp teeth and strong jaws to rip apart their prey.

tropical waterways of Brazil. In recent years, the caimans of the Amazon have been disappearing at an alarming rate as industry and gold mining have damaged their habitat.

The Amazon is also home to one of the rarest manatees in the world. Known as the Amazonian manatee, it has the same gray color and rough skin as other species of manatee. However, unlike many manatees found in oceans, the Amazonian species cannot survive in a saltwater environment. Instead, it lives in freshwater and eats surface plants. Its greatest threats are poaching and habitat loss caused by humans.

PLANT LIFE OF BRAZIL

Most of Brazil's huge variety of plant species are found in the rain forests that comprise nearly 40 percent of Brazil.[3] There may be as many as 5 million plant species in the country; approximately 30,000 plants have been scientifically categorized.[4] On average, a new plant species is recorded every two days.[5]

NATIONAL PLANT

The national plant of Brazil is the ipê-amarelo. It is a flowering tree that bursts into large golden blossoms for one week a year. Its scientific name is *Tecoma chrysostricha*, and it is a member of the large family of tropical begonias, which includes hundreds of species. Many similar tree species are also known as ipê.

WELL-KNOWN MEDICINAL PLANTS OF BRAZIL

Common Name	Medicinal Purpose	Location in Brazil
Aroeira	Anti-inflammatory; treats ulcers	Cerrado
Ginseng brasileiro	Fights tumors	Paraná River region
Ipecac	Treats stomach issues	Amazon and Atlantic forest
Pata de Vaca	Treats diabetes	Atlantic forest
Sucupira	Painkiller	Cerrado

Orange, mango, and guava are just three of the tropical plants that have become valuable crops in international and domestic trade. Brazil is also home to numerous plants that are cultivated for their medicinal value. The Amazon River basin alone is believed to contain hundreds of medicinal plants. These plants include trees and herbs that have been used for centuries for a variety of health benefits, including anti-inflammatory aids, antacids, and even cancer-fighting treatments.

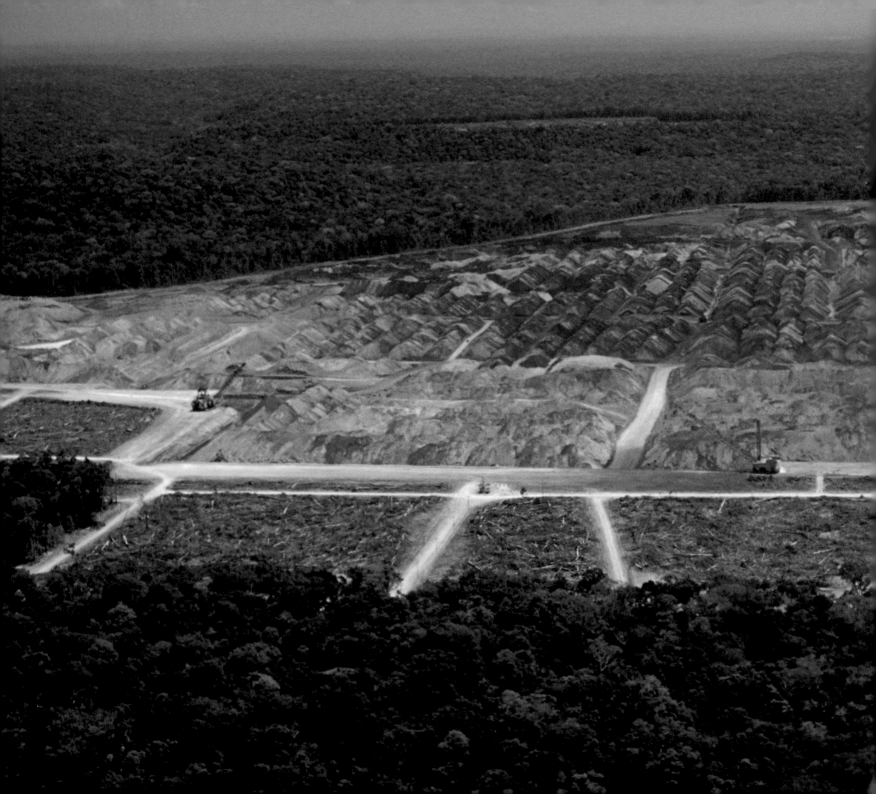

Other regions of Brazil also provide a variety of unique plant species. The central-western region of the country contains the Pantanal, one of the world's largest freshwater wetlands. The habitats of the Pantanal include large forests and grasslands that become flooded seasonally. The eastern coastline of the country is known for the last remaining Atlantic forests of Brazil. These include many species of shrubs and hardwood trees.

ENVIRONMENTAL THREATS

Brazil faces a variety of environmental threats, but the one that has attracted the most attention internationally is the rapid deforestation of the Amazon rain forest. The rise of industrialization and the need for commercial land brought about the destruction of large amounts of rain forest during the 1970s and 1980s, and more rain forest continues to disappear every day.

Deforestation worries scientists and environmentalists. It threatens to permanently eradicate a variety of plant and animal life. Many species have not been scientifically described, including potentially valuable medicinal plants. In addition, the burning of the forests sends carbon into the air, contributing to climate change.

Deforestation is a huge problem in the Amazon region.

A second major threat to the Brazilian environment is the poaching and illegal trafficking of wild animals. Monkeys, tropical birds, and other forms of wildlife are a valuable commodity on the black market. Customers in Europe and the United States are willing to pay high prices for illegally obtained pets. The hyacinth macaw, for example, has been known to sell for as much as $25,000. Between 2000 and 2005, the number of animals rescued by police in the rain forests of the country tripled.[6] This increase may be the result of stepped-up enforcement, a rise in illegal activity, or a combination of both.

CONSERVATION EFFORTS

Centuries ago, the Portuguese colonists of Brazil realized the county's environment had to be protected. In 1797, the king issued a law that forbade the burning or destruction of forests. The first national parks were created in the late 1930s, and today, Brazil has 64 national parks that preserve and protect the country's diverse wildlife and plant species.[7]

An average acre of Amazon rain forest can contain 250 species of trees.

Itatiaia National Park, established in 1937, was the country's first national park. It provides views of Agulhas Negras, the seventh-tallest mountain in Brazil, as well as some of Brazil's endangered Atlantic forests. Tijuca National Park in Rio de Janeiro provides views of the protected sections of the region. It is one of the smallest but most visited parks in the country.

While efforts to preserve the land continue, attendance at Brazil's national parks is low because of the lack of roads and other infrastructure in and out of the parks. Indeed, 34 parks have no management plan and are not open to the public.[8] Only 3.8 million visitors entered the parks in 2009,[9] compared to the 275 million people who visit the US national parks.[10]

During the past decade, the Brazilian government and conservation groups have worked to stop environmental damage in the country. A variety of wildlife protection groups have organized efforts to help preserve and protect the Amazon rain forest.

ENDANGERED SPECIES IN BRAZIL

According to the International Union for Conservation of Nature (IUCN), Brazil is home to the following numbers of species that are categorized by the organization as Critically Endangered, Endangered, or Vulnerable. Because the list does not include species that have an unknown status, the number of species threatened with extinction in Brazil is likely higher:

Mammals	80
Birds	123
Reptiles	28
Amphibians	30
Fishes	80
Mollusks	21
Other Invertebrates	24
Plants	387
Total	773[11]

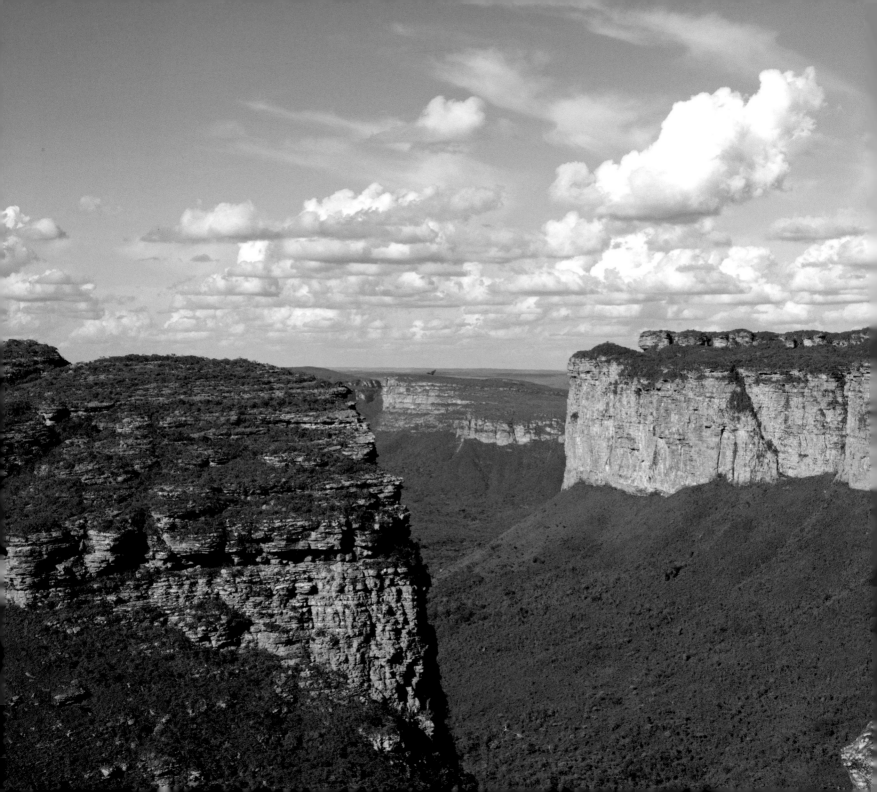

In 2002, the Brazilian government launched the ten-year-long Amazon Region Protected Areas (ARPA) program with help from various conservation groups, including the World Wildlife Fund (WWF). The program strives to protect nearly 123 million acres (50 million ha) of land in the Amazon region.[12]

Recent laws have been passed to help prevent overdevelopment of the grasslands area of the cerrado. The government and conservation organizations have also established programs to help protect the Atlantic forests region. The rapidly reducing forests are one of the most endangered sections of forest in the world, as only 7 percent of the original rain forest remains.[13]

Scientists use radar to measure deforestation in the Amazon.

Chapada Diamantina National Park in northeastern Brazil contains steep cliffs, caverns, and spectacular rock formations.

CHAPTER 4

HISTORY: EMPERORS, DICTATORS, PRESIDENTS

Brazil was originally settled by tribes of people who arrived in the area more than 11,000 years ago. Some of these people included the Guarani and the Tupinamba, who built permanent or semipermanent villages. These early residents grew cassava, guavas, and sweet potatoes. They also hunted and fished in the heavily forested regions of the country. These early tribes were polytheistic, worshipping a variety of gods. They were known for their ability to work with their hands and make pottery.

Today, there are almost 5 million Guarani in South America.

Pre-Columbian pottery found in Brazil

EUROPEAN EXPLORERS AND SETTLEMENT

The arrival of European explorers in South America changed the future of Brazil forever. Hoping to prevent an all-out war in the New World, Spain and Portugal signed an agreement to divide the Americas between them in 1494. Portugal claimed the land now known as Brazil. In January 1500, Spanish sailor Vicente Yáñez Pinzón visited the region but he was not allowed to stake a claim.

WAS CABRAL LOST?

Did Portuguese explorer Pedro Álvares Cabral, who is credited with discovering Brazil on April 22, 1500, find the land by accident or on purpose? For centuries, Admiral Cabral was said to have stumbled upon the coast of Brazil when he and his fleet of 13 ships veered off course on their way to trade in India. However, some historians now believe the admiral may have been specially instructed by the king of Portugal to locate land believed to be in the vicinity. Whether he intended to or not, Cabral became a hero when he found the land he named Vera Cruz, or "True Cross," and claimed it for Portugal.

On April 22, 1500, Pedro Álvares Cabral, a Portuguese admiral, arrived on the shores of Brazil. He claimed the land for his home country and helped establish a strong bond between Brazil and Portugal that still exists to this day.

A number of explorers visited the land after Cabral. Many of them noticed that the forests contained a rather unusual wood that was bright red like the embers of a fire. They called this wood *pau-brasil*,

or literally "ember wood"—in English, it came to be called "brazilwood." Soon, the land became identified with these trees, and the name of Portugal's colony became Brazil.

THE COLONIAL PERIOD

Portuguese sailors explored the region for three decades before the first colonial government was established in 1533. Important settlements, including Recife and Salvador, appeared in the northeast. There, the Portuguese settlers established large sugarcane plantations. In addition to sugarcane, they began growing tobacco and cotton for export. Where the settlers went, members of a Christian order known as Jesuits followed. Their mission was to convert the indigenous people to Catholicism.

The success of the Portuguese settlements came with a heavy price for the indigenous population. Portuguese settlers captured and enslaved members of local tribes to work on the plantations. Those who did not submit to slavery became embroiled in harsh battles with the Portuguese settlers. Others died of unfamiliar diseases brought by the Europeans.

Many indigenous groups fled to the middle of the country. There, Jesuits tried to Christianize many of them. The Jesuits had some success until groups of Portuguese settlers tried to recapture the native peoples and force them into slavery. This pushed many of the tribes deeper into central Brazil and, in turn, led the settlers to look elsewhere for slaves. Soon, the settlers brought enslaved people from Africa to work on the plantations.

SLAVERY IN BRAZIL

The first slaves in Brazil were indigenous people captured by the Portuguese settlers. Beginning in the mid-1500s, the settlers began importing slaves from the African coast. The practice went on until slavery was outlawed in 1888. Over this 350-year period, an estimated 3 to 4 million Africans were sold into slavery in Brazil.[1] Slaves often worked on sugar plantations, farms, and mines, performing a variety of duties. Living and work conditions were harsh and ruled by strict laws. Slaves were savagely punished for not performing duties adequately. Often, enslaved people who escaped banded together and set up their own villages to protect themselves from owners searching for them. In 1694, hundreds of runaway slaves were massacred by colonists in the town of Quilombo de Palmares.

Although slavery has been outlawed for more than 120 years, some people in Brazil today are subjected to forced labor. In the Amazon, farmers who fall into debt have been forced to work on large plantations to repay what they owe, living in terrible conditions. Some estimates put the number of illegally held workers at 25,000 to 40,000 people.[2] This practice is illegal, and the government launches periodic raids on the plantations to free the workers.

As the Portuguese colony evolved, competition developed over land ownership. In the mid-sixteenth century, French settlers began arriving. At first, the Portuguese who had settled in the area were indifferent. When the French seized control of the harbor that would become Rio de Janeiro in 1555, the Portuguese reacted with force. A series of battles occurred between the two groups. The Portuguese founded Rio de Janeiro in 1565 to defend the area. The French were defeated in 1567. A new threat occurred in 1624 and 1625, when the Dutch seized the settlement of Salvador. In 1630, more explorers from the Netherlands arrived in Brazil and established

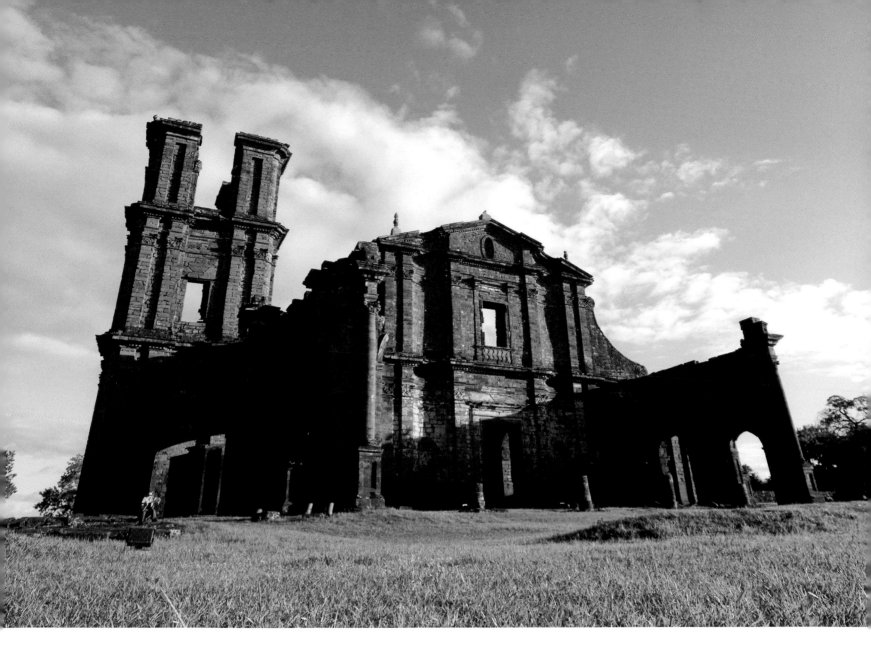

São Miguel das Missões, an eighteenth-century Jesuit mission,
is part of a **UNESCO** World Heritage site.

settlements in the northern regions of the country. Periodic battles occurred between the two European groups until 1654, when the Portuguese forced the Dutch out of the country.

For the next two centuries, Brazil remained a Portuguese colony. The first major rebellion against Portuguese rule occurred shortly after the American Revolution, in 1789. The uprising was quickly put down, and the leader, Joaquim José da Silva Xavier, was tried and executed. The spirit of independence remained, however, and Silva Xavier became a martyr to the cause and a national hero.

BRAZILIAN INDEPENDENCE

In 1807, life in Brazil changed dramatically. The European countries were embroiled in a war with France. As a result, the French emperor, Napoléon I, conquered Portugal. The reigning monarch of Portugal, John VI, fled to Brazil with his family. When he arrived in 1808, he was welcomed by Portuguese settlers and encouraged to lead the country as part of Portugal. King John instituted widespread changes in the government and opened Brazilian ports to other countries. He founded banks, encouraged publishers to start newspapers, and created new trade opportunities.

In 1821, six years after Napoléon's attempt to take over Europe was thwarted, a new government was established in Portugal. King John was recalled to Europe to help set up the new government. He left his son Pedro I—generally known as Dom Pedro—in charge of Brazil.

On September 7, 1822, Dom Pedro declared Brazil a country free from Portuguese rule and named himself emperor. The Brazilian Empire existed from 1822 to 1889.

Dom Pedro proved to be an ineffective ruler and led the country into a war with Argentina. He gave up the throne on April 7, 1831, handing the crown to his five-year-old son, Pedro II. Several regents struggled to govern until 1841, when Pedro II took command of the empire at age 14. He established a more democratic government, promoted friendship with the United States and Europe, and helped overthrow the dictator of Argentina in 1852. He also facilitated the abolition of slavery in 1888. Under his 49-year rule, the country prospered, building infrastructure that included railroads and a telegraph system.

Pedro II was emperor of Brazil from 1841 to 1889.

Pedro II was a successful ruler, but he made enemies. Former slave owners, military leaders, and citizens who did not like Pedro's heirs all combined to cause problems. On November 15, 1889, some members of the army led a revolt against Pedro's government. The army took control of the government, declaring Brazil a constitutional republic.

THE OLD REPUBLIC AND THE VARGAS ERA

Following the coup of 1889, the government remained in flux for the next 40 years as 13 presidents took office—some through elections and some through coups. In the 1920s, conflict developed over poor living conditions, the overproduction of coffee, and growing tension between Argentina and Brazil.

In 1930, liberal presidential candidate Getúlio Vargas lost the election, then led a coup and took control of Brazil on October 24. He helped revolutionize Brazil's status in the world, ushering in an age of industrialism and ending the country's dependence on an agricultural economy. Initially, Vargas's government was threatened by revolutionaries who hoped to establish their own government, but the Brazilian Army was able to subdue their efforts. Fear of revolts, such as the one in Spain that led to the Spanish Civil War of the early twentieth century, convinced Brazilians to support Vargas's idea of a strong military.

Vargas's leadership brought about an era of growth in Brazil. He instituted political and military initiatives that strengthened the country. He also encouraged pride in Brazilian nationalism and helped promote

As president, Getúlio Vargas helped modernize Brazil.

BRAZIL'S CONTRIBUTIONS TO WORLD WAR II

During World War II, Brazil sided with the Allies, including the United States and the United Kingdom, against the Axis powers of Germany, Italy, and Japan. Brazil's leader, Getúlio Vargas, wanted to establish Brazil's prominence in world affairs, and Brazil's contributions proved particularly important to the war effort. The country allowed US planes to use the airbase at Natal, in northern Brazil, so they could refuel during long trips across the Atlantic Ocean. Having access to this airbase made it possible to attack Axis forces in Africa, the Middle East, and China. Brazil also sent 25,000 soldiers to Italy in 1944.[3] These soldiers played a role in liberating Europe from the Nazis and other Axis powers.

the restoration of historic sites throughout the country. Vargas further capitalized on this nationalism by offering support to the Allies during World War II (1939–1945).

In 1934, during Vargas's presidency, Brazil established a new constitution that made him the legal president. Citizens hoped this constitution might spark an era of long-term democracy with regular presidential elections. However, this was not the case. When Vargas's term was due to end in 1937, he led a coup that kept him in power and created a new government called the Estado Nôvo, or "New State."

Vargas refused to step down again in 1943, when his tenure as president was due to end, citing the ongoing World War II as a reason. After the war, a range of political and military leaders feared that Vargas

would attempt to remain in power. They pressured the president to relinquish control, and he stepped down in 1945.

Although he was officially known as a president, in some ways his administration was more like a dictatorship. Nonetheless, he is still beloved by many in Brazil. Unlike many dictators, however, he gained popularity among his citizens when he instituted laws that were helpful to workers. Vargas also strengthened the army, developed the economy, and improved the living conditions of the middle class. Yet Vargas also angered many citizens by arbitrarily changing laws and canceling elections.

THE SECOND REPUBLIC AND RETURN TO MILITARY RULE

Later in 1945, General Eurico Gaspar Dutra was elected president of Brazil. The country officially became a republic again, and it adopted a new constitution in 1946. Dutra began loosening laws and giving rights back to citizens. In the election of 1950, however, Vargas won back the presidency. In August 1954, the military again demanded that he resign. He took his own life on August 24, 1954.

After the Vargas era ended, Brazil underwent a series of transformations. The government began encouraging the growth of the interior, locating the new capital in Brasília in 1960. In 1964, after the government failed to deal with social problems and inflation, a military coup overthrew the democratic government. A coalition of generals created a "national security regime" that aimed to promote economic

A CITY THAT TOOK 133 YEARS TO BUILD

What do Brasília, Washington DC, and Canberra, Australia, have in common? They are the only three planned national capitals in the world. Similar to the other two cities, Brasília was a well-organized development. First discussed in 1823 by leader José Bonifácio de Andrada as a way to help stimulate the economy in the country's interior, the capital city was just a dream for many years. The constitution of 1891 designated the general area in the state of Goiás where the capital should be built.

Then, in 1956, President Juscelino Kubitschek made the capital city a reality. He proposed setting aside a specific portion of the land in Goiás to be the new capital, replacing Rio de Janeiro. Urban planner Lucio Costa and noted architect Oscar Niemeyer laid out the city in perfect symmetry. This innovation in capital city design included natural spaces, wide-lane streets, and stunning architecture, in particular the Planalto Palace (also known as the Hall of Government), the Congress, and the Supreme Court, situated around the Plaza of Three Powers. Because of its exemplary design, Brasília was named a UNESCO World Heritage site.

growth while at the same time repressing those who opposed the military state.[4]

By the end of the 1960s, the coalition government had established a variety of laws that helped maintain military power. Some of these laws dissolved existing political parties and created new ones, including the Brazilian Democratic Movement, which made Brazil a two-party country. From 1969 to 1975, military power was further maintained through censorship of the press and an increase in the power of the executive office, including the power to create taxes and to encourage bills to be passed. In addition, many basic human rights were ignored, including due

process, and the military took over management of the country's colleges. Despite the human rights abuses, military dictatorships in Brazil and elsewhere in South America during this period enjoyed the support of the US government.

THE NEW REPUBLIC

By the late 1970s, the Brazilian people had grown weary of military rule. Although the country's economy had become stronger and the middle class had grown more prosperous, the oil crisis of the mid-1970s put an end to the nation's economic gains. Inflation soared, and the value of the Brazilian money decreased. Also, many citizens began viewing the military's power as a stranglehold. At the same time, Brazil faced major problems as its debt soared and workers began striking over wages. In 1983, millions of Brazilians picketed in the streets, lobbying for a return to the democratic government.

Brazil experimented with a parliamentary system of government from 1961 to 1963.

By 1984, the public demand for democracy had reached a fever pitch. The military regime had brought the country to the edge of bankruptcy, and many citizens wanted a new form of government. By 1985, the military government had collapsed, and the country had begun holding elections again. Most of the political leaders became involved in developing a new constitution, which was established in 1988.

Fernando Cardoso was the president of Brazil during a time of economic growth in the country.

Since that time, the country has been known as the Federative Republic of Brazil. It is governed as a republic, led by elected presidents and not military dictators. The new government has had its share of trouble, however. Fernando Collor de Mello, the first president under the new constitution, saw his tenure shaken by scandal when his brother accused him of offering favors in exchange for money. An investigation proved these allegations true, and Collor del Mello was impeached and replaced by his vice president, Itamar Franco. In 1995, Fernando Cardoso took office. Cardoso had previously served as finance minister. Working with economic advisers, Cardoso established a new currency, the real, and helped lower inflation during the mid-1990s.

Cardoso won reelection in 1998 and remained in office until 2003. As president, he helped usher in a period of economic growth and political stability that had not been seen in years. Political corruption remained a problem, however. During the recent presidency of Luiz Inácio Lula da Silva (2003–2011), several key cabinet members resigned as a result of scandal.

Recently, the country has seen prosperous times. As of 2010, the country had the seventh-largest economy of any country in the world when measured by gross domestic product (GDP).[5] Oil reserves discovered off the nation's coast promised a bright future. Combined with successful investments in soybeans, beef, and ethanol, Brazil was positioned to become one of the world's top four economies by 2050, as predicted by investment firm Goldman Sachs.

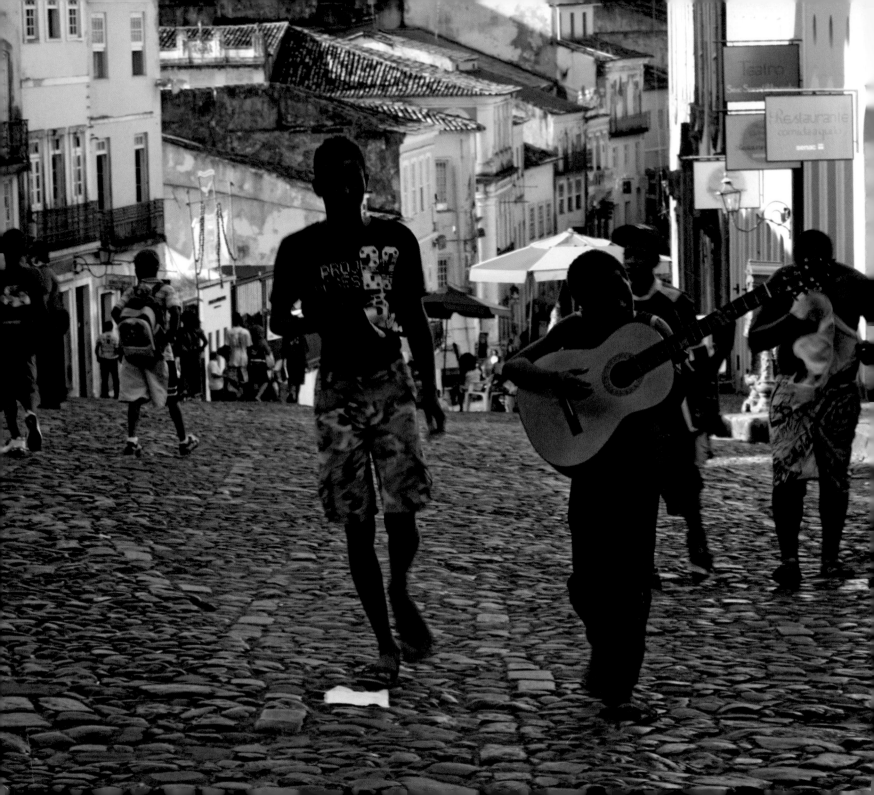

CHAPTER 5

PEOPLE: A UNIQUE SOCIETY

Brazil has the largest population of any country in South America and the fifth-largest population in the world, with an estimated 203,429,773 people.[1] The country represents a true diversity of cultures that have come together to create a unique society.

DISTRIBUTION AND COMPOSITION

Brazil may be one of the largest countries in the world, but the distribution of its people makes it one of the least dense. It has a density of approximately 61.5 people per square mile (23.8 people per sq km).[2] However, the population is not evenly distributed. Few Brazilians live in the Amazon and in the country's interior, and most Brazilians live near the coasts.

Most Brazilians live in urban areas.

Population

Per Square Mile	Per Square Km
Over 2,500	Over 1,000
650 to 2,500	250 to 1,000
65 to 650	25 to 250
13 to 65	5 to 25
0 to 13	0 to 5

ATLANTIC OCEAN

Boa Vista

Macapá

Negro

Amazon

Manaus

Belém

São Luís

Amazon

Parintins

Fortaleza

Teresina

Natal

Araguaia

João Pessoa

Recife

Rio Branco

Pôrto Velho

Madeira

Palmas

São Francisco

Maceió

Aracaju

Cuiabá

Brasília

Salvador

Goiânia

Paraguay

Campo Grande

Uberlândia

Belo Horizonte

Vitória

Paraná

Nova Iguaçu

Campos

São Paulo

Rio de Janeiro

Curitiba

Santos

Florianópolis

Uruguay

PACIFIC OCEAN

Porto Alegre

ATLANTIC OCEAN

NORTH ↑

Population Density of Brazil

Although Brazil was considered a rural country for much of its history, its population has become more urbanized in the last 50 years. This trend has been particularly noticeable in the last decade, as more than 1.1 percent of Brazilians make their way to the cities each year. Approximately 87 percent of the people now live in urban centers of the country.[3] This includes the 19.9 million people who call São Paolo home, making it one of the largest cities in the world.[4]

A majority of Brazilians—53.7 percent—consider themselves white or Caucasian.[5] Much of these people have descended from Portuguese settlers and immigrants. Italian and German immigrants and their descendents also comprise a significant portion of the white population. Between 1875 and 1960, approximately 5 million European immigrants settled in the southern regions of Brazil.[6]

BRAZIL, LAND OF THE YOUNG

0–14 years old: 26.2%

15–64 years old: 67%

65+ years old: 6.7%

Median age: 29.3 years old[7]

Brazil's birth rate is 17.79 births per 1,000 people, lower than the world average.

A DIVERSE POPULATION

In Brazil, different ethnicities and cultures commonly mix. Much of this acceptance is due to the history of Brazil, during which six major groups were involved in settlement:

1. Indigenous groups from the Guarani and Tupi cultures

2. Portuguese settlers who colonized the region in the sixteenth century

3. Africans who originally were brought over as slaves

4. European settlers, particularly those from the Netherlands and France, who arrived following the Portuguese exploration, and German, Italian, Russian, Polish, and Spanish immigrants who began arriving in the nineteenth and twentieth centuries

5. Middle Eastern and North African immigrants who began arriving in the mid-nineteenth century

6. Asian immigrants who began arriving in the mid-nineteenth century (including a large population of Japanese immigrants)

The blending of these cultures has been evident since colonial times. Interracial marriage between European settlers, slaves, and members of indigenous groups was common and laid the foundation for the multicultural heritage seen in Brazil to this day.

speaking 170 different languages.[11] The largest tribes, such as the Guarani and Yanomami, have tens of thousands of members, while the smallest have only dozens.[12]

Racial mixing and blending is important to the culture of Brazil. Brazilians often view their idea of race relations in the context of the country's diversity. While people of each ethnicity are proud of their own heritage and background, interracial friendships and relationships are common. For centuries, Brazilians have intermarried across racial lines. The blend of races is reflected in the various cultural events and religions that incorporate many heritages.

Racial inclusion is a source of pride for many Brazilians, who point to the fact that the country has never had to enact any civil rights legislation or antisegregation policies as evidence that race is unimportant in Brazil and racial discrimination is not prevalent. However, some sociologists studying race in Brazil have noted that there is discrimination in education and business, with people of European heritage often gaining privileges. Sociologists also point to the lack of civil rights policies as further evidence the country in fact has race issues that have never been dealt with.

THE LANGUAGE

While neighboring countries mainly speak Spanish, the primary language of Brazil is Portuguese. This is a result of the long colonial relationship between Brazil and Portugal.

Early immigrants to Brazil were predominately Portuguese. When Brazil declared its independence in 1822, however, other Europeans began immigrating to Brazil. When slavery was abolished in 1888, huge numbers of immigrants from Italy, Spain, Portugal, Germany, Russia, Poland, Syria, Lebanon, and Japan—among other countries—entered Brazil. Many of these immigrants settled in and around the state of São Paulo to work in the coffee fields. Today, Italian is still commonly spoken in that region. Germans settled in the southern regions of Brazil to work on farms, so the German language is still heard today in that area, particularly in the states of Rio Grande do Sul, Espírito Santo, and Santa Catarina. Spanish is commonly spoken in the border regions of the country, while English is a

YOU SAY IT!

English	Portuguese
Hello	Olá (OH-lah)
Good night	Boa noite (BOW-ah NOY-chay)
Good-bye	Adeus (uh-DEOOSH)
Please	Por favor (pohr-fah-VOHR)
Thank you	Obrigado (male) (ohb-ree-GAH-doo) Obrigada (female) (ohb-ree-GAH-dah)
You're welcome	De nada (jeh NAH-dah)
Yes	Sim (SEEN)
No	Não (NOWNG)

popular second language. In addition, indigenous languages are still spoken in some parts of Brazil.

RELIGION

Because of the long-standing Portuguese influence, Roman Catholicism has been the dominant religion of Brazil throughout its history. Catholicism was the official state religion until 1883, and approximately 73 percent of Brazilians still identify themselves as Roman Catholic.[13]

During the last half-century, however, other religions have maintained their following or gained a foothold among Brazilians. People who practice Protestant faiths comprise

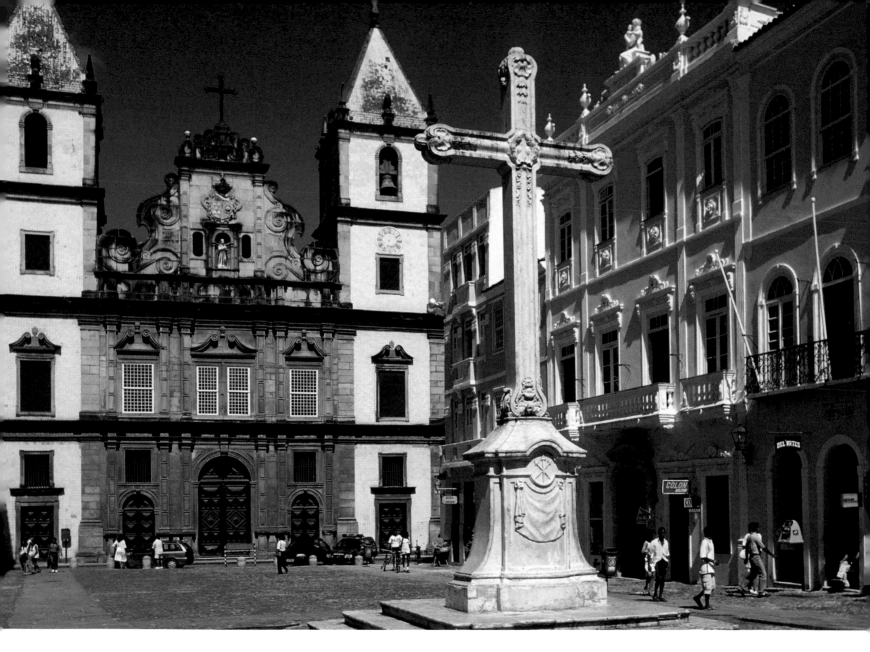

Roman Catholicism dominates the country's religious landscape.

KARDECISM

Emerging in Brazil in the 1930s, Kardecism is a form of spiritualism based on the teachings of nineteenth-century French medium Allan Kardec. As practiced in Brazil, it incorporates a blend of African, European, and indigenous beliefs and focuses on communicating with spirits. Typically, Kardecists meet in small groups of five to ten in a member's home, though they sometimes meet in temples as larger groups. There, a medium tries to communicate with the spirit world to obtain advice, help in solving problems, or even religious healing. Often the medium begins by reading from a Bible passage and offering up a Christian prayer before attempting to connect with the spirit world. As the session continues, the medium falls into a trance, allowing the spirit to speak through him or her. Kardecist mediums believe they conjure Amerindian spirits of nature, African gods, the spirits of deceased relatives and slaves, and even the spirits of famous medical doctors.

more than 15 percent of the population.[14] In recent decades, Christian evangelical churches have gained popularity, particularly in poorer regions of Brazil.

A small segment of the population, just over 1 percent, considers itself spiritualist.[15] Spiritualists practice religions that incorporate ancient African, European, and indigenous beliefs in worshipping multiple gods and seeing spiritual qualities in nature.

For example, members of the Candomblé faith worship multiple spirits associated with the natural world. This religion originated with African slaves in Brazil, who brought their polytheistic religions

to their new land. The religion, which has evolved over time, often finds participants worshiping 14 to 16 main gods derived from African deities and often identified with Catholic saints. On New Year's Eve in Rio de Janeiro, Candomblé believers gather on the beach to cast items such as fruit, flowers, or jewelry into the ocean as an offering to the goddess known as Yemanjá, or Mother Water. This ceremony can also be seen in the state of Salvador on February 2. Candomblé stores are quite popular in Brazil. They sell a variety of items associated with the religion, including candles, amulets, and incense intended to bring stronger health, wisdom, or fortune. Kardecism, a religion based in spiritualism and contacting the dead, has also gained popularity in the last century.

Practitioners of Islam, Shinto, Buddhism, and Eastern Orthodoxy are growing in number in Brazil.

CHAPTER 6
CULTURE: BLENDING THREE HERITAGES

The culture of Brazil is a blend of its three major heritages. The Portuguese influence on the country is dominant, as its language, customs, and core religious beliefs are overwhelmingly Portuguese. However, pieces of indigenous heritage remain, including the music and language. In fact, a variety of plants and animals found in Brazil are named using words from

TUPI LANGUAGE

The Tupi, one of Brazil's early indigenous groups, first settled in what is now known as the Amazon rain forest. Approximately 2,900 years ago, they began moving southward and toward the Brazilian coast. Several Tupi words have found their way into the English language, including jaguar (from *jaguara*), manioc (from *manioka*), piranha (from *piraya*), and tapioca (from *tipioca*).

African influences are seen in Brazilian traditions, including dress and holidays.

the Tupi dialect. Finally, African foods and religious traditions are still found in coastal Brazil, evidence of the time when Africans were brought in slave ships to Brazilian shores.

HOLIDAYS AND FESTIVALS

One of the most popular holidays in Brazil is the Festa de São João (Saint John's Eve). Celebrated on June 24, this predominantly Catholic holiday honors Saint John the Baptist. It is a time of traditional family gatherings, fireworks, and bonfires. Brazilians also celebrate many of the religious holidays associated with the Christian calendar, including Easter and Christmas.

Independence Day is celebrated every September 7. It recognizes the day Brazil declared its independence from Portugal. Tiradentes Day is celebrated April 21 to commemorate Joaquim José da Silva Xavier's attempt to overthrow the government in 1789. The patriot's nickname was Tiradentes, "Tooth-Puller," because he was a dentist.

Perhaps the most famous festival is Carnival, which occurs every year right before the Christian observance of Lent, the six-and-a half-week period before Easter Sunday. Historically, Christians fasted during the Lenten season, so many Roman Catholics celebrated the last days or hours before Lent with feasting and other festive events. The Portuguese colonists brought this festival to Brazil, where it has become a huge spectacle each year. Carnival festivities take place over several days and end on Fat Tuesday, the day before Ash Wednesday, which marks the

Dancers in a samba school perform during Carnival.

beginning of Lent. The festival combines three important pastimes—music, dance, and food—in one giant party.

The most famous Carnival is held each year in Rio de Janeiro, where large parades feature costumed, dancing revelers. The parades last for days as Carnival goers enjoy the music of local bands. Carnival draws locals and tourists alike, making for one wild, fun party.

MUSIC

Perhaps more so than any other facet of society, Brazil's music blends its three dominant cultures. The music of Brazil often combines the traditional reed flutes of indigenous music, the upbeat tempos of African music, and the singing and string playing of Portuguese music.

Brazilian music has long been characterized by this fusion of cultures. In the sixteenth century, Jesuit priests discovered that the Tupi tribes enjoyed music and dance. The missionaries borrowed the Tupi melodies and made them their own, replacing the Tupi words with religious chants.

Over time, a variety of music forms became popular in the country. Quick and happy samba music and dance emerged at the end of the nineteenth century. During Carnival in Rio de Janeiro, elaborately costumed people dance the samba in parades. Different styles of samba in the parade are known as samba schools, and many are associated with particular neighborhoods or groups. The samba schools have a long and

competitive history, each school striving to be judged the best in each year's Carnival.

Brazilian composer Heitor Villa-Lobos helped popularize Western classical music in the first half of the twentieth century. His choral, instrumental, and orchestral pieces, which combined elements of indigenous Brazilian music with European-style compositions, are still popular today. In the late 1950s, bossa nova music became widespread. Developed in Rio de Janeiro, this form of pop music combines elements of samba and jazz. Its lyrics, often carrying a message of social protest, are sometimes sung off-key. The *forró*, a style of folk music using the accordion, is popular in the northeast and resembles country music. The faster-paced *lambada* music developed along the coast and become popular internationally in the late 1980s and early 1990s.

SAMBA TIME!

No other music pulses to the beat of the night quite like the samba. Samba is a style of music that originated among the slaves of Brazil and derived from West African rhythms. Samba comes in many forms, from simple drum beats to elaborate songs, and it is the music of Carnival and many other festivals throughout Brazil.

Current trends in Brazilian music include the emergence of Música Popular Brasileira, or MPB music. While not a genre, this trend in music, which first appeared in the 1960s, takes other musical styles, such as bossa nova, and updates them with original songwriting. Another favorite

form is *choro* music. Although the word *choro* means "weeping," the music is generally upbeat. It originated in Rio de Janeiro in the nineteenth century and is played with flutes and guitars, including the *cavaquinho*, a small Portuguese guitar. Choro lost popularity in the 1960s as samba and bossa nova overtook it, but reemerged in the 1970s and is now popular again. Perhaps the most modern style to develop in Brazil is *axé* music. This genre, which developed in the Bahia region of Brazil, combines a variety of Afro-Caribbean musical forms, including calypso, forró, and reggae. It emerged in the mid-1980s and gets its name from the Candomblé term meaning "soul."

SOUNDS OF BRAZIL

Popular Brazilian musical instruments reflect the diversity of the country's culture:

Cavaquinho: A small Portuguese guitar

Maraca: An indigenous rattle instrument that is made from a hollowed gourd filled with dried seeds or beans.

Rabeca: A Portuguese fiddle

Reco-Reco: A percussion instrument made from a gourd that is played by rubbing a wooden stick along notches to make a scraping sound. It was common among ancient cultures around the world.

Tamborim: A percussion instrument of African and Portuguese origin. Not to be confused with a tambourine, this is a small drum played with a wooden drumstick.

ART AND LITERATURE

Two of Brazil's most famous artists are sculptor and architect Aleijadinho (born Antônio Francisco Lisboa) and Cândido Portinari. Aleijadinho was known for the elaborate soapstone

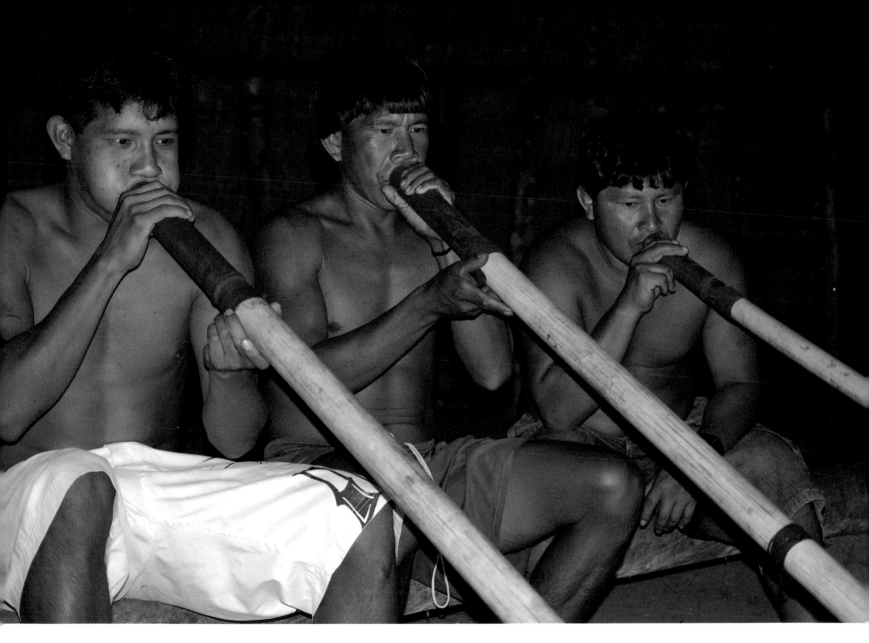

Brazilian music often includes tribal flutes.

carvings he created for Brazilian churches in the eighteenth century. His most famous sculptures, of 12 biblical prophets, may be seen in the Sanctuary of Bom Jesus in the town of Congonhas, Minas Gerais. Portinari is a twentieth-century artist known for painting Brazilian scenes.

Feiras, or painter markets, draw a variety of artists and collectors. The works offered for sale range from religious carvings to good luck charms to artistic clothing.

Brazilian authors have made significant contributions to the field of literature. In the late-nineteenth century, poet, novelist, and short-story writer Joaquim Maria Machado de Assis gained fame for writing poetic novels. In the mid-twentieth century, Jorge Amado drew acclaim for his stories set in historic Brazil. Rachel de Queiroz was a famous female novelist who, similar to Amado, wrote regional fiction in the mid-twentieth century. Vinícius de Moraes was a renowned poet of the twentieth century. His poetry helped to inspire and popularize two other art forms as the century progressed: the bossa nova style of singing and samba dance music. His most famous song is "A Garota de Ipanema" ("The Girl from Ipanema") which became a worldwide hit in the 1960s.

SPORTS

With thousands of teams spread throughout the country, sports are definitely a unifying force among Brazilians. Fans are remarkably loyal, and nowhere is this better illustrated than in the sport of soccer. Known by the Portuguese word *futebol,* or "football," this sport draws millions

of fans each year. Brazil's stars, including Pelé, have gained international acclaim. Members of the national team are treated like heroes, and fields throughout the country are filled with people young and old playing the sport. The biggest soccer rivalry today involves two São Paulo clubs, the Corinthians and the Palmeiras. This match-up, called "the Derby," is considered one of the best soccer competitions in the world.

The country's sports base has grown by the year. Brazilian basketball and volleyball teams have become powerful on the international stage. Basketball star Anderson Varejão played for the gold medal–winning Brazilian team at the 2003 Pan American Games. Today, he plays for the Cleveland Cavaliers in the US National

THE GREATEST SOCCER PLAYER IN THE WORLD

Edson Arantes do Nascimento—known better by his professional name, Pelé—is a legend in Brazil. Indeed, his name is synonymous with soccer throughout the world. Pelé learned to play as a boy by kicking around a handmade soccer ball. At age 16, he made Brazil's national team and soon became a star.

During his career, Pelé scored more than 1,200 goals in national and international competitions. In 1958, he scored two goals in the finals to help Brazil earn its first World Cup, and just four years later, he contributed to Brazil's second World Cup win.[1] Pelé retired from Brazilian soccer in 1974, but he played for the New York Cosmos from 1974 to 1977 to help increase interest in the sport among Americans. Many sports historians believe he is the greatest soccer player ever.

Fans cheer during a soccer match between Brazilian teams Botafogo and Flamengo in Rio de Janeiro.

Basketball Association (NBA). Fellow Brazilian Leandro Barbosa also plays in the NBA for the Toronto Raptors. In the first decade of the twenty-first century, Brazil's men's volleyball team was among the best in the world, winning three consecutive world titles in 2002, 2006, and 2010. In addition, the women's volleyball and beach volleyball teams consistently win medals in international competitions.

Capoeira is Brazil's homegrown martial art. This acrobatic self-defense technique was developed by African slaves, who disguised their protective fighting moves as a dance. Capoeira is performed to drumming and singing. Participants perform high kicks and somersaults, controlled movements that barely miss striking their partners. Highly skilled artists may demonstrate their moves with short blades strapped to their ankles or held between their toes.

The Maracanã stadium in Rio de Janeiro can hold 155,000 fans.

TELEVISION AND FILM

The most popular television shows in Brazil are known as telenovelas, and they resemble US soap operas. Hits throughout the country, these shows make instant stars out of actors and actresses. Local slang, customs, and fashions all make their way into pop culture through the telenovelas.

Brazil represents South America's largest media market, and its entertainment industry is dominated by TV Globo, a successful multimedia company. Founded in 1965, TV Globo not only provides a

variety of regular television programs to more than 100 million viewers throughout the country, but it also operates newspapers, radio stations, and pay-per-view programming. The company is best known for developing Brazil's popular telenovelas, but it has also developed children's shows and programs intended for other countries.

In 2009, Brazil had nearly 76 million Internet users, the fourth most in the world.

The first movies were produced in Brazil in the early 1900s. By the 1930s, popular Brazilian movies were known for their slapstick comedy. This era also saw the emergence of Carmen Miranda, a talented singer and actress. She eventually left Brazilian cinema for Hollywood, where she became known for her versatile singing style and trademark tropical headpieces. By the 1950s, many Brazilian movies were being recognized in the European market, including *Cangaceiro* (*The Bandit*), a Western film that won the Best Adventure Film category at the 1953 Cannes Film Festival.

By the end of the 1960s, however, the government had begun censoring films, and moviemakers had to work around restrictions. Government restrictions had loosened by the 1980s, but by then, the popularity of television and telenovelas had taken away from the popularity of movies. During the past two decades, the Brazilian movie industry has seen new growth.

FOOD

The daily eating patterns of Brazilians tend to follow a standard routine. The main meal of the day is *almoço*, or lunch, served anytime between 11:00 a.m. and 3:30 p.m. This meal may consist of a variety of foods, and it serves both social and practical purposes, as people meet and chat while they eat. Breakfast is usually the smallest meal of the day, and it may consist of bread and coffee (or for children, a mixture of coffee and milk). *Jantar*, or supper, is also a light meal. It is served between 7:00 and 11:00 p.m., with residents of large cities often dining at the late end of this time period.

Brazilians also enjoy brief snack breaks during the day. The *café* is typically a midmorning and midafternoon break, during which people enjoy coffee plus a small snack such as cookies. Another popular snack is the *empada,* a pastry filled with meat, shrimp, or cheese. Empadas are made at home or purchased from street vendors.

Brazil's cuisine blends the varied cultures of the land. The indigenous influence is seen in the frequent use of cassavas, sweet potatoes, and corn in recipes. People from the European cultures developed a love of fruits and pastries and incorporated these items into their meals. Perhaps the most dominant influence on Brazilian cuisine came from the African slaves, who brought their own sense of food to the region. Featuring peppers and coconut milk, the African influence has been seen in Brazilian cuisine from the seventeenth century until today.

HOLIDAY FOOD

Popular foods in Brazil are sometimes seasonal and are tied to holidays and festivals. During the June holidays that honor Roman Catholic Saints Anthony, John, and Peter, corn dishes are commonly served, including popcorn and corn cakes. During the Christmas season, it is common to see turkey basted with coffee and served with a stuffing made of sausage, celery, and farofa, or ground manioc.

Many inhabitants of the northern section of Brazil, including members of indigenous groups, collect food from the environment around them. Their traditional dishes feature fish, tropical fruits, and vegetables such as manioc. The food of Brazil's northeastern region reflects a mixture of African and indigenous flavors, and the southeastern region features some of the nation's most diverse cuisine. The west-central part of the country is known for dishes that contain fish, rice, corn, and manioc. The southern regions are known for meat dishes, which are popular with the cowboys of the region. Foods from Italian and German cultures are also prevalent. Bean and meat dishes are weekly staples in some parts of the country, and European and Middle Eastern dishes are also common. Meat, fish, rice, and corn are often main ingredients in prepared foods.

Desserts are also popular in Brazil. Many traditional cookies are made with *farofa*, toasted manioc flour. It was originally used by indigenous people and still serves as the basic flour of Brazil. Fruits and spices are common in most dessert recipes. Another favorite treat is churros, a pastry made of fried dough rolled in sugar.

ARCHITECTURE AND MONUMENTS

Portuguese architecture dominated Brazil until the mid-nineteenth century. The Portuguese influence, with its churches and monasteries, is best viewed in the Ouro Preto region, which is a UNESCO World Heritage site. A French influence became evident in the second half of the nineteenth century. By the beginning of the twentieth century, Brazil's modern period had started to develop, and Brazilian architects gained prominence. Some of the early twentieth-century architects include Affonso Reidy, who designed the Pedregulho apartments located just outside Rio de Janeiro, and the Roberto brothers Marcelo, Mauricio, and Milton, who planned the modernist-style passenger terminal at the Santos Dumont Airport.

One of the most famous landmarks in Brazil is the Cristo Redentor, or "Christ the Redeemer," statue, which rests on top of Mount Corcovado in Rio de Janeiro. The statue stands 98 feet (30 m) tall and features the arms of Jesus Christ stretching out over the city.[2] It was dedicated on October 12, 1931.

By the late 1950s, Brazil had developed its own sense of architectural style. And nowhere is that style more evident than in the heart of the country: Brasília. In the capital city, government buildings—many featuring shining glass facades designed by Brazilian architect Oscar Niemeyer—reflect the nation's modern style.

Each year, approximately 2 million people visit the Christ the Redeemer statue.

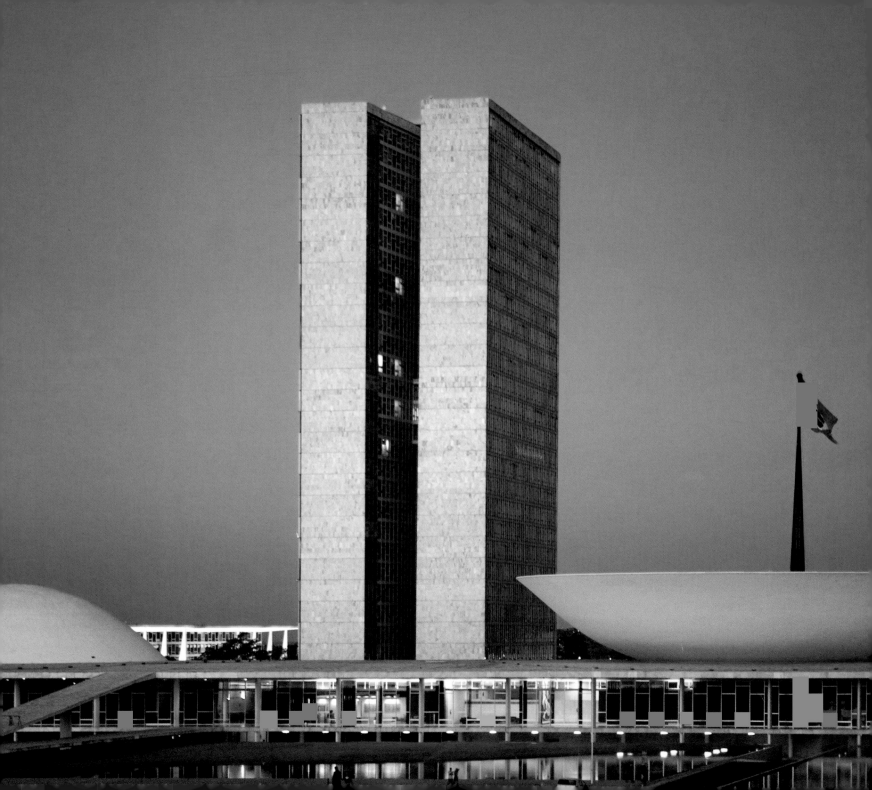

CHAPTER 7

POLITICS: UNDER NEW LEADERSHIP

The government of Brazil changed considerably during its first four centuries and was often in flux. During its history, Brazil has been a colony, an empire, a dictatorship, and a democracy.

Brazil declared its independence from Portugal and established itself as a country in 1822. According to the current constitution, which went into effect in 1988, Brazil is a federal republic. It consists of 26 states and a federal district. The country's laws, system of government, and rules are all established under its constitution.

Modeled closely after the constitutions of France and Portugal, Brazil's constitution is a lengthy document. It contains more than 200 articles that address topics such as education, social welfare, indigenous rights, and health care.

The Palace of the National Congress, designed by Oscar Niemeyer, houses the Federal Senate and the Chamber of Deputies.

Brazil's constitution has created a government that mirrors many republican models. The country has an executive, a legislative, and a judicial branch. Each branch has its own powers, and all the branches must work together to ensure the success of the government.

On April 21, 1993, a constitutional referendum was held in Brazil to determine whether the nation's form of government should change. That referendum was suggested by federal deputy Antônio Henrique Bittencourt da Cunha Bueno. Henrique Cunha Bueno, a member of the Social Democratic Party, argued that Brazil's greatest prosperity had occurred during the reign of Pedro II in the mid- to late-nineteenth century. Henrique Cunha Bueno believed that returning to a monarchy would bring about renewed prosperity in Brazil.

The referendum asked voters whether the government should keep its current republican form of government or take the form of a monarchy. It also asked if the country should be run by a presidential system (in which the executive branch exists

EIGHT CONSTITUTIONS

Since the first constitution was signed in 1824, Brazil has had eight different constitutions. The imperial government instituted the first constitution. The 1891 constitution was modeled after the US Constitution, which has checks and balances controlling the powers of the three branches of government. The constitutions of the 1930s, 1940s, and 1960s represented the country's fluctuating politics and were often reactions to changes in governments. In 1988, the current constitution was developed. It guarantees many social services for Brazilians.

separately from the legislative branch) or a parliamentary system
(in which the executive branch gets its power from the legislative branch).
A majority of Brazilians voted to maintain the presidential republic and
the constitution that was adopted in 1988.

THE EXECUTIVE BRANCH

The executive branch of Brazil's government is led by the president. The
president serves as both the chief of state and the head of government.
Presidents serve four-year terms and cannot serve more than two terms.
To become president, a candidate must be a native-born Brazilian at least
35 years old. The president can present bills to the legislature and veto
laws. He or she is also responsible for cabinet appointments.

STRUCTURE OF THE GOVERNMENT OF BRAZIL

Executive	Legislative	Judicial
President	Congresso Nacional (National Congress) Senado Federal (Federal Senate) Câmara dos Deputados (Chamber of Deputies)	Supremo Tribunal Federal (Federal Supreme Court) State courts City courts

President Dilma Rousseff on January 1, 2011, the day of her inauguration

Dilma Rousseff was elected president in 2010 and inaugurated on January 1, 2011. She is Brazil's first female president.

THE LEGISLATIVE BRANCH

The legislative branch, called the Congresso Nacional, or "National Congress," has many powers. It makes laws and votes on them, it controls the country's budget, and it can override a presidential veto. The congress is divided into two groups, or houses.

The first house is the Senado Federal, or "Federal Senate." It has 81 members, called senators. Each state elects three senators, as does the federal district. Senators have the power to approve major

BRAZIL'S NEW PRESIDENT, AT A GLANCE

On October 31, 2010, the people of Brazil elected Worker Party candidate Dilma Rousseff their first female president. She received 56 percent of the vote, defeating José Serra, the Social Democratic candidate.[1]

Born in 1947, Rousseff grew up in a middle-class family in Minas Gerais. Her father was a Bulgarian immigrant lawyer and businessman, and her mother, a native Brazilian, was a teacher. In the 1960s, Rousseff became involved in politics by joining the underground resistance against the military government. She was captured in 1970 by government officials, tortured, and imprisoned for three years.

Released in 1973, Rousseff went on to study economics and become a politician. She served as minister of mines and energy and as chief of staff under President Luiz Inácio Lula da Silva from 2003 until 2010, when she began preparing to run for president.

The flag of Brazil

appointments by the president, such as ambassadorships. Senators serve eight-year terms, and individuals must be at least 35 years old to run for office.

The second house of the congress is called the Câmara dos Deputados, or "Chamber of Deputies." This house has 513 members, called deputies. Deputies are elected from each state, and the number elected varies by state based on population. More populous states have more deputies. Each state has a minimum of eight seats, and the largest state (currently São Paulo) is allowed a maximum of 70 seats. Deputies serve four-year terms, and individuals must be at least 21 years old to run for office.

THE JUDICIAL BRANCH

Brazil's judicial branch is made up of the city, state, and federal court systems.

THE GREEN, YELLOW, AND BLUE

The green, yellow, and blue flag of Brazil owes much of its design to the flag flown by the former Brazilian Empire, which existed from 1822 to 1889. The current flag has a green background with a large, yellow diamond in the center. Over the diamond is a blue globe with 27 white, five-pointed stars—one for each state and the federal district. The motto "Ordem e Progresso," or "Order and Progress," is written in green on a white band that spans the globe.

The green represents the rich forests of Brazil, while the yellow symbolizes the nation's mineral resources, especially gold. The blue globe and stars represent the sky over Rio de Janeiro on the morning of November 15, 1889, the day Brazil was declared a republic.

The highest court in the land is the Supremo Tribunal Federal (STF), or "Federal Supreme Court." It is comprised of judges who have been appointed by the president and then approved by the Senate. The STF helps to interpret laws and determine if they are constitutional. It also helps settle disputes between the executive and legislative branches, between states, and between states and the federal government. In addition, the STF is in charge of trials of presidents and congressional and cabinet members.

The STF is an 11-member panel. Judges must be at least 35 years, and no one can be appointed after age 65. Judges are appointed for life and may remain on the court until age 70, when they must retire by law. The leader of the STF serves a two-year term, unlike in many countries, where one person can lead the highest court for many years.

POLITICAL PARTIES

The earliest political parties formed shortly after Brazil declared independence in 1822. Those early parties represented pro-Brazil and pro-Portuguese factions. In time, new parties evolved and took positions on many issues, although they were repressed during the dictatorship eras.

At least 27 political parties are represented in modern Brazilian politics, and they are involved in all levels of the government.[2] Many of the parties are regionalized, which means they have a large base of support in a certain portion of the country. The government of Brazil has never

adopted national political parties. To this day, it is common to see more than a dozen different parties represented in the Congresso Nacional.

The major parties in Brazil include the Partido do Trabalhadores (PT), or the "Workers' Party." This party was formed by union leaders and gained influence by commanding auto industry strikes. President Rousseff is a member of this party, which has been the most popular in the nation since 2000. The Partido do Movimento Democratico Brasileiro (PMDB), or "Party of the Brazilian Democratic Movement," is strongest in rural areas and among the poor. The Democratas Party (DEM), or "Democratic Party," was once known as the Liberal Front Party. As the party furthest to the political right, it supports free market initiatives, limited government involvement, and low taxes.

A man prepares to vote in the Brazilian presidential election in October 2010.

PARLIAMENTARY IMMUNITY

Members of Brazil's Congresso Nacional have one controversial right that extends to no other congressional members in any other country. In almost all circumstances, members of the Congresso Nacional have parliamentary immunity from criminal and civil charges. This means that members cannot be charged for crimes—even those that result in death—unless the house to which they belong decides to lift their right to immunity.

Brazilian congress members' rights are similar to the right to parliamentary immunity in the United Kingdom, where lawmakers are granted immunity from civil action for slander or libel. The situation in Brazil is also similar to that of France, where lawmakers may not be put on trial for actions accomplished within their duties as lawmakers. In both France and the United Kingdom, however, the immunity extends only to a lawmaker's role as a politician and not outside it—unlike in Brazil.

POLITICAL PROBLEMS

During the past two decades, several scandals have rocked the republic. In the 1990s, new laws gave legislators influence over decisions made about state-owned businesses. Those laws created opportunities for legislators to benefit in unintended ways— including financially—by passing decisions in favor of the state's businesses. Also in the 1990s, political corruption led to the impeachment of then-president Fernando Collor de Mello and members of the Parliamentary Budget Commission.

In 2005, a large political scandal drew media attention as charges were

In 2005, people marched in São Paulo to protest government corruption. The sign in front reads, "We are not clowns! We want the truth."

brought against 40 political figures for a scheme involving vote buying and irregular party financing. The scandal was connected to people at many levels of government, including cabinet members of then-president Luiz Inácio Lula da Silva. Lula da Silva was not implicated, however, and after the scandal he was reelected to another term.

CHAPTER 8

ECONOMICS: SOUTH AMERICAN POWERHOUSE

The economy of Brazil is the largest in South America. Based heavily on mining, agriculture, and manufacturing, Brazil's economy has grown during the past 40 years. In 2010, the per capita gross domestic product (GDP)—the total value of goods produced in the country divided by the population—was $10,900, ranking the country one hundred fourth in the world.[1]

AGRICULTURE AND INDUSTRY

Brazil's diverse landscape allows residents to grow a variety of crops, including citrus fruits, coffee, cocoa, corn, wheat, and rice. Revenue from

Brazilian farmers harvest sugarcane, which is used to produce ethanol.

BY THE NUMBERS

Brazil is the world's largest producer of coffee, frozen concentrated orange juice, sugarcane, and tropical fruits. It also has the most cattle of any country, with 170 million head in 2010.[3]

The US Department of Agriculture estimated that in 2008, the world produced 123 million bags of coffee, each weighing 132 pounds (60 kg). Of that total, Brazil produced approximately 38 million bags, or approximately one-third of the world's supply of coffee.[4] The country also crushed more than 660 million short tons (600 million metric tons) of sugarcane during the 2009–2010 growing season.[5]

sugarcane has increased in the last few decades. The crop is not only used for sugar but also as a source of ethanol—an important fuel alternative to gasoline. Brazil has also become one of the world's leading exporters of soybeans.

Livestock is another important industry in Brazil. From 1970 to 1991, the country's cattle herd nearly doubled, from 78.5 million to 152.1 million.[2] At the same time, poultry farms saw a similar increase as modernization improved the industry's capacity. Although Brazil has a large coastline, fishing remains an underdeveloped industry.

Mining is another important component of the country's economy. Even in colonial days, settlers dreamed about the mineral riches in the land's then-untapped interior. In 1695, miners in the São Paulo region found gold. Although these local miners attempted to keep the gold secret for fear of losing it to Portuguese authorities and to other settlers, word of the find eventually spread and a gold rush soon began. By 1709,

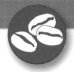

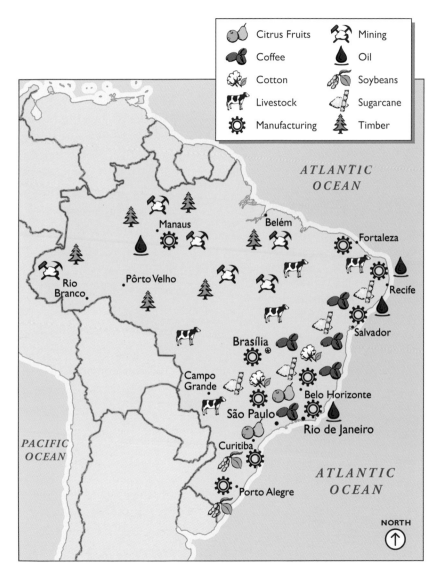

Resources of Brazil

THE BRAZILIAN REAL

The currency of Brazil is the real (pronounced "ree-AHL"), which is represented using the symbol R$. In the Brazilian system, 1 real equals 100 centavos. In May 2011, 1 real equaled 63 US cents.

Reais (plural of real) come in several denominations, ranging from R$1 to R$100. The R$1 is rare, however, as it was discontinued in 2006 and replaced by coins. The fronts of all bills show a woman wearing a crown of bay leaves, symbolic of the republic. A 10-real note featuring the image of Portuguese navigator Pedro Álvares Cabral, the first European to explore Brazil, is also in circulation. The back of each real shows a different animal native to Brazil:

R$1: Hummingbird

R$2: Hawksbill turtle

R$5: Great egret

R$10: Green-winged macaw

R$20: Golden lion tamarin

R$50: Jaguar

R$100: Dusky grouper

the rush, similar in scale to the California gold rush of 1849, had brought an influx of prospectors from the Northeast into the region.

The mining industry is also a prominent part of Brazil's present economy. Growth has been strong during the last three decades. In 2006, Brazil produced almost one-fifth of the world's iron.[6] The country also has significant reserves of many important minerals, ranking first in the world in niobium and in tantalite reserves, second in graphite and manganese, third in aluminum and vermiculite, fourth in magnesite, and fifth in iron.[7] In addition, experts suspect that Brazil has untapped gold reserves that have yet to be found.

One real is made up of 100 centavos.

Brazil is also rich in fossil fuels, including natural gas and oil. For 30 years, Brazil was committed to reducing its dependency on foreign oil. In 1980, the country imported 70 percent of the oil it needed; in 2011, Brazil meets all of its oil needs with biofuels, alternative energy sources, and domestic oil.[8] In 2006, the country ranked fourteenth in the world in oil, producing 629 million barrels.[9] The US State Department has noted that new oil discoveries put Brazil among the top ten countries in the world in oil reserves.[10]

FUELING THE FUTURE

Ethanol is often labeled as the future fuel of the world because it is renewable and cleaner to burn than gas. It is made from plant material that has been mashed into a powdery form. This powder is infused with water, then heated. An enzyme is later added to convert the mixture into sugars, and then yeast is added to ferment it into a liquid comprised of 10 percent alcohol. The alcohol is separated from the rest of the mixture and the remaining water is removed, leaving pure alcohol. The alcohol is mixed with a small amount of gasoline and can be used to power a vehicle.

Brazilian ethanol is made from sugarcane. Because sugarcane ethanol is so cheap to produce, especially in Brazil, it often results in lower gasoline costs for consumers.

Once considered a slow-growing industrial nation, Brazil has recently seen the development of many industries. Textiles, chemicals, and automobiles are all produced by the country's growing industries. The country has also become a growing power in the pharmaceutical industry—it is now the ninth-largest market in the world

and is home to four of the world's six largest pharmaceutical companies.[11] The steel industry has taken advantage of the country's rich iron deposits. In addition, Brazil is a global leader in biofuels research and the world's largest exporter of biofuels.[12] In recent years, the development of ethanol as a fuel additive has created both change and growth in the fuel and automotive industries. The country is also a global leader in deep-sea oil exploration and the production of hydroelectric power.

The tourism industry is a growing segment of the Brazilian economy, and more than 3 million people visit Brazil every year.[13] The Carnival of Rio de Janeiro,

Distribution of Brazilian Workers[14]

14%
20%
66%

Distribution of Brazilian GDP

6.1%
26.4%
67.5%[24]

■ Industry
■ Agriculture
■ Service

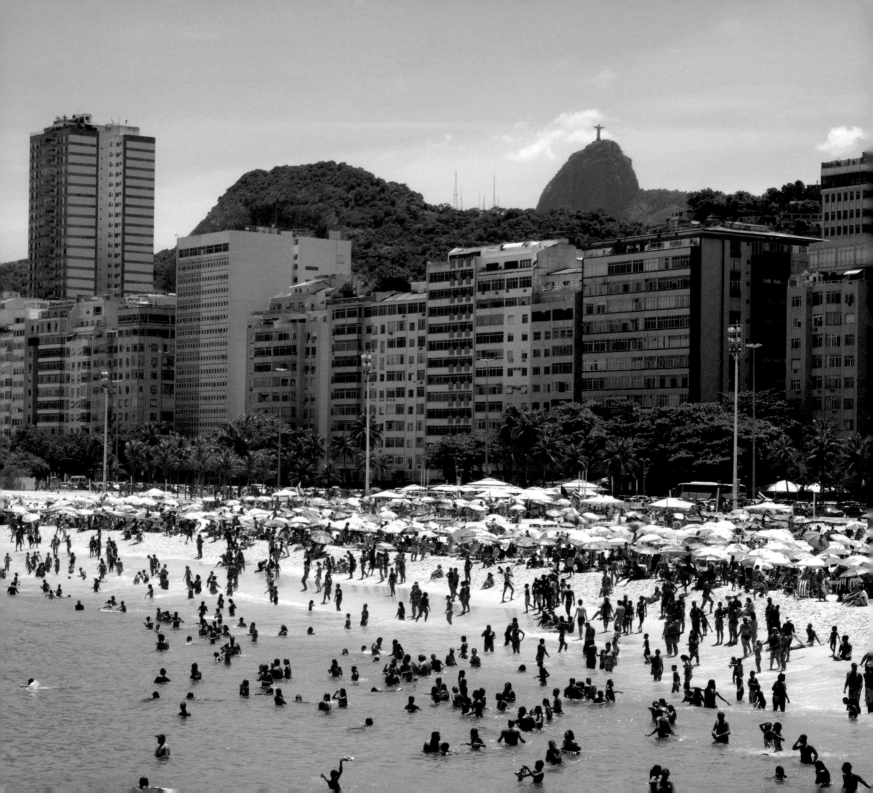

the beaches of the coastal cities, and the mysteries of the Amazon all attract tourists. According to the World Travel and Tourism Council, tourism accounted for 8.3 percent of all jobs in Brazil in 2011.[15]

INFRASTRUCTURE

In 2010, the *Global Competitiveness Report* released by the World Economic Forum—an independent committee designed to help bring about global change through business, politics, and education—examined the infrastructures of countries throughout the world. According to the report, Brazil's roads, railways, port infrastructure, and air transportation systems were mediocre or worse.[16]

This finding highlighted a deep-rooted problem with Brazil's infrastructure. Clearly, having adequate transportation systems is critical to helping the nation's global economy thrive. Recent presidential administrations have vowed to help correct the problem, but a lack of funding has continued to stall development of transportation systems in the country.

Brazil's commerce relies heavily on the nation's underdeveloped roads and waterways. When Brasília was built in the nation's interior in

In 2009, Brazil had almost 174 million cell phone users, the fifth most in the world.

Tourists come from all over to visit Brazil's beaches, including Copacabana, one of the most famous beaches in the world.

the 1960s, the government realized that its road system was inadequate. By the 1990s, Brazil had the third-longest system of roads in the world, although only 10 percent of the roads were paved.[17] The country has maintained these roads inconsistently, although the routes connecting the southern agricultural region with the north have been improved in the last two decades. Railways exist in the country but remain a less-used method of transportation.

Brazil's waterways remain particularly underdeveloped. Port cities along the nation's coast are often poorly prepared to deal with the large volume of ship traffic involved in transporting merchandise.

A final transportation issue is Brazil's underdeveloped airports. Officially, the country has 4,072 airports, ranking it second in the world. However, only 726 of these airports have paved runways, and the majority are tiny, private landing strips.[18] Many of the nation's airports are used to transport agricultural products to and from international trading partners.

Brazil's inflation rate was 4.9 percent in 2010, higher than the world average of 2.5 percent.

ECONOMIC OUTLOOK

From problems due to inflation in the late twentieth century to a devaluing of the national currency in the 1990s, Brazil has often seen tough economic times. However, the current outlook is good. Although Brazil was hard hit by the worldwide economic downturn in 2008, it was one of the first emerging markets to

begin recovery. Brazilian industries are becoming attractive to foreign investors, and in the past year the Brazilian currency has climbed in value. Unemployment has gone down from 8.1 percent in 2009 to 7 percent in 2010.[19] However, wages are still low for a large segment of the nation's workers. Approximately 26 percent of the population lives below the poverty level.[20]

One large concern is Brazil's GINI index. The GINI index looks at the gap between the richest and poorest citizens. It measures the distribution of family income in a country on a scale of 0 to 100, with 0 corresponding to perfectly equal income distribution and 100 to perfectly unequal. Brazil's most current GINI index, calculated in 2005, is 56.7. While that figure ranks as the tenth worst in the world, it is an improvement over the GINI index calculated in 1998, which was 60.7.[21]

The disparity between Brazil's rich and poor has decreased in recent years for a variety of reasons. In the mid-1990s, the gap was reduced by changes in tax laws and an end to hefty inflation. Brazil's government also invested more in its own economy than it had in decades past, helping to shrink the gap. In addition, the recent downturn in the global economy diminished the wealth of the richest class of citizens and helped lower the GINI. In fact, between 1999 and 2009, more than 27 million Brazilians rose from below the poverty level into the middle class.[22]

Brazil has several reasons to be optimistic. The country has the fifth-largest workforce in the world, at close to 104 million people.[23] It also continues to have an abundance of natural resources at its disposal. The development of ethanol as a source of clean energy has boosted Brazil's

economy. Oil deposits found off the Brazilian coast hold the promise of further economic growth.

Two important upcoming events should help Brazil gain even more economic, political, and international prominence. In 2014, the country will host soccer's World Cup, and in 2016, the Olympic Summer Games will come to Rio de Janeiro. These two events will not only bring jobs and tourism to the area, but they will also provide a reason to develop the country's inadequate infrastructure.

Investment analysts predict Brazil will be one of the world's four most promising economies in the next 40 years, along with Russia, India, and China. These four countries, referred to as BRIC by economists, contributed to one-third of the world's GDP growth during the past ten years.[24] Given this, experts predict Brazil will be an emerging economic market in the years ahead.

Hosting the Olympics in 2016 should bring an economic boost to Brazil.

CHAPTER 9
BRAZIL TODAY

Brazilians love to celebrate life, and their fun-loving spirit is often seen in Brazilian relationships. Friendships are cultivated at an early age and relationships within a family are important. People enjoy spending time with friends and family whenever possible. Carnivals and festivals provide regular opportunities for this. Holidays are often an important time for family and friends to gather. Soccer games, too, are times for celebration and enjoyment as Brazilians gather to cheer on their favorite teams.

The desire to celebrate also carries over into other aspects of life. Music and dance classes are held throughout Brazil, the most visible of which are the samba schools in Rio de Janeiro. Many adults and children take part in these classes and engage in friendly competitions. Brazilians' love of music and dance extends into Carnival and other festival celebrations.

Family and friendships are important in the daily lives of Brazilians.

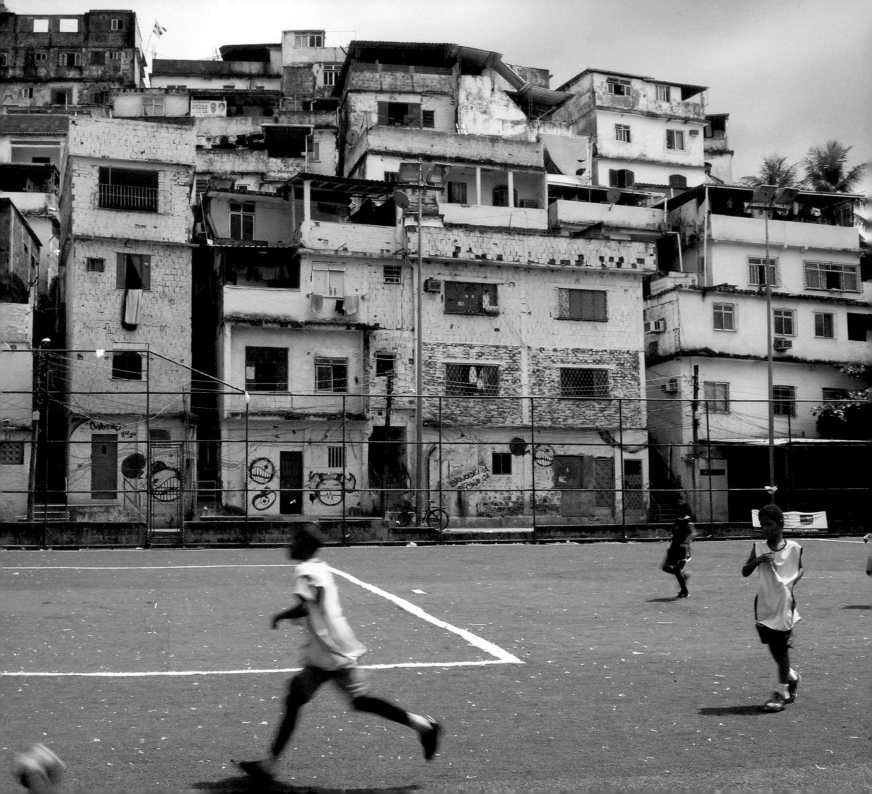

Despite the focus on celebration, life in Brazil is not without difficulty. The income disparity between the richest and poorest citizens ranks among the greatest in the world. Residents of favelas, slums and shanty towns outside Brazil's big cities, lead difficult lives. Many are unemployed and have difficulty finding basic necessities for themselves and their families. Crime is also a major problem in Brazil. While some crime rates, such as that for murder, have decreased since the 1990s, others have increased, such as the rate of illegal drug use among youths. Violent crime remains an issue in both large cities and around popular tourist destinations.

EDUCATION

In 1961, Brazil enacted the National Educational Bases and Guidelines Law, establishing a system of public schools and making basic education compulsory. A central theme of education has been the battle against illiteracy. A federal focus on improving reading among Brazilians began

Young people throughout the country play soccer.

in the 1960s and continues to this day. Initially, great strides were made in increasing literacy, but by the 1990s, some fundamental problems remained. First, the national funding of higher education at universities and colleges was prioritized over lower levels of education. Public education—in particular, the early grades—was not as well supported in the national budget. Along with this, the standard salary of the nation's teachers was often below minimum wage. The student dropout rate was a big concern as well. In 1999, a third of the high school–age population was not enrolled in school.[2]

To address these problems, Brazil raised educational standards, enforcing a minimum salary for teachers and increasing the amount of money spent per pupil. Since then, the nation's schools have seen a slow but definite improvement. More students are able to read and do basic math, and scores in reading, math, and science have risen slightly, although they lag behind many countries. In 2010, Brazil ranked 53 out of the 65 countries that took the PISA, an international test that compares countries' educational achievement.[3] Schools still struggle to maintain steady attendance. Students who do not pass a grade must repeat it, which means it is not uncommon to see someone 25 years old graduating from high school.

Approximately one-ninth of Brazilians age 18 to 24 attend universities.

Education is important in Brazil, but there are challenges in the educational system, including lack of funding and overcrowded schools.

Students are expected to attend at least eight years of elementary school and three years of high school, although they are only mandated to attend school for eight years. Schools in Brazil often operate in shifts because of overcrowding, and children of poorer families often drop out before reaching high school. Approximately 85 percent of girls and 78 percent of boys eligible for secondary schools attended in 2008, following steady improvement in the first decade of the twenty-first century.[4]

STUDENTS' EDUCATIONAL SUCCESS RATES (2004)

Students who repeat a primary grade: 20.1%

Students who repeat a secondary grade: 21.9%

Students who stay in school until grade 5: 72.7%

Students who stay in school until age 14: 80.5%

Number of years the typical student stays in school: 12.9[5]

Students hoping to continue their education into college must take an entrance exam called a *vestibular*. This exam, which involves a series of tests, is most often given between November and January and lasts several days. Students who pass are allowed to attend a Brazilian university or college. Student fees and tuitions are low, particularly at public colleges.

HEALTH CARE

Brazilians' general health status has improved steadily during the past two decades, as changes in the health-care system have been implemented. The government instituted a universal health-care program when it established the new constitution in 1988, resulting in a renewed focus on health. Brazilians have seen a steady improvement in their quality of life during the past 50 years. For example, the infant mortality rate decreased by nearly 40 percent between 1990 and 2009.[6] However, Brazil must improve its income disparity and poverty levels, as poor Brazilians may be malnourished or lack sanitation or clean water.

Brazil has a mix of public and private health-care facilities. Public hospitals and clinics are generally visited by the poor, and the facilities and speed and quality of care vary across the country. Generally, those who can afford it visit private health-care facilities.

CURRENT CHALLENGES

Environmental challenges pose an ongoing threat to Brazil's future success. The destruction of wildlife habitats, the poaching of animals, and the overuse of land for agriculture and mining all plague the country. The government has established plans to reduce deforestation throughout the country. Despite these efforts, drought in 2005 and again in 2010 resulted in the deaths of billions of trees. Some environmentalists fear

At the current rate of deforestation, the Amazon could disappear in 40 to 50 years.

government efforts might not be enough to stop the destruction of the Amazon. This is a huge concern, because the dense forests help eliminate about 25 percent of the world's carbon emissions.[7] Compounding the problem, when the forests are cleared by means of fire the resulting smoke contributes high levels of carbon to the atmosphere. On the bright side, estimates show that in 2010, deforestation in the Amazon was reduced by 70 percent, reaching the lowest level of tree loss in 20 years.[8]

Economic challenges also pose potential problems for Brazil. As the government deals with high levels of poverty and unemployment, creating jobs is crucial. Eliminating foreign debt is also key to the development of a strong economy, as is encouraging foreign development.

BRAZIL'S FUTURE

Despite the challenges Brazil must face, the future looks bright for several reasons. Laws have been put in place to help save endangered plant and animal species and to conserve land throughout the country. In addition, the economy is slowly recovering with the help of foreign investment. Brazil's vast assortment of natural resources, growing industries, and advances in renewable fuels make it well positioned to enjoy impressive economic strides in the future.

There is reason for both hope and optimism in Brazil. And there is reason to believe that this land of contrasts will continue to be one of the most varied, unique, and important countries in South America and the world.

Brazilians will continue to celebrate their unique culture and heritage.

TIMELINE

11,000 years ago	The first people settle in Brazil.
1494	On June 7, the Treaty of Tordesillas is signed, dividing the New World between Spain and Portugal.
1500	Portuguese admiral Pedro Álvares Cabral lands in and explores Brazil.
1533	The first colonial government is established.
mid-1500s	The first ships carrying African slaves arrive in Brazil.
1555	The French take control of the harbor that will later become Rio de Janeiro.
1565	Rio de Janeiro is founded.
1567	The Portuguese defeat and drive out French settlers in the region near Rio de Janeiro.
1624–1625	The Dutch take control of the Portuguese settlement of Salvador.
1654	The Dutch are permanently expelled from Brazil.
1695	Gold is found in São Paulo, leading to the Brazilian gold rush.
1727	The first coffee plants are brought to Brazil.

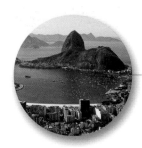

1789	Joaquim José da Silva Xavier launches an unsuccessful revolt in Brazil.
1808	John VI, sovereign of Portugal, arrives in Brazil.
1822	On September 7, Pedro I, son of John VI, declares Brazil's independence from Portugal.
1888	Slavery is abolished in Brazil.
1889	On November 15, a coup overthrows Pedro II, and military rule is established.
1930	On October 24, a military coup places Getúlio Vargas in power.
1931	On October 12, the statue of Cristo Redentor, or "Christ the Redeemer," is unveiled in Rio de Janeiro.
1946	Brazil creates a new constitution as the republic is restored.
1960	Brasília replaces Rio de Janeiro as the nation's capital.
1988	A new constitution is created and the federal republic is restored.
1993	On April 21, Brazilians approve a referendum to retain the presidential system.
2011	Dilma Rousseff is inaugurated as Brazil's first female president on January 1.

FACTS AT YOUR FINGERTIPS

GEOGRAPHY

Official name: Federative Republic of Brazil (in Portuguese, República Federativa do Brasil)

Area: 3,287,612 square miles (8,514,877 sq km)

Climate: Primarily tropical and subtropical, but temperate in the south.

Highest elevation: Pico da Neblina, 9,823 feet (2,994 m) above sea level

Lowest elevation: Atlantic Ocean, 0 feet (0 m) below sea level

Significant geographic features: Amazon River, Iguaçu Falls

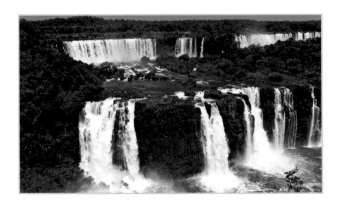

PEOPLE

Population (July 2011 est.): 203,429,773

Most populous city: São Paolo

Ethnic groups: white, 53.7 percent; mulatto (mixed white and black), 38.5 percent; black, 6.2 percent; other (including Japanese, Arab, Amerindian), 0.9 percent; unspecified, 0.7 percent

Percentage of residents living in urban areas: 87 percent

Life expectancy: 72.53 years at birth (world rank: 124)

Language(s): Portuguese (official); other languages spoken include Spanish, German, Italian, Japanese, English, and many Amerindian languages

Religion(s): Roman Catholicism, 73.6 percent; Protestantism, 15.4 percent; Spiritualism, 1.3 percent; Bantuism/Voodoo, 0.3 percent; other, 1.8 percent; unspecified, 0.2 percent; none, 7.4 percent

GOVERNMENT AND ECONOMY

Government: federal republic

Capital: Brasília

Date of adoption of current constitution: October 5, 1988

Head of state: president

Head of government: president

Legislature: National Congress, consists of the Federal Senate and the Chamber of Deputies

Currency: real

Industries and natural resources: textiles, shoes, chemicals, coffee, sugar, oranges, ethanol, iron ore

NATIONAL SYMBOLS

Holidays: Carnival is celebrated in Rio de Janeiro in February or March, just before Lent. Independence Day is celebrated on September 7. Tiradentes Day is celebrated April 21.

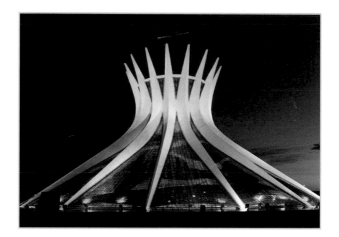

Flag: A green background with a yellow diamond in the center. Over the diamond is a blue circle with a constellation of stars and a white band that carries the national motto, "Ordem e Progresso" ("Order and Progress").

National anthem: "Hino Nacional Brasileiro" ("Brazilian National Anthem"); the music was adopted in 1890, but the lyrics were not officially recognized until 1922.

National bird: Golden parakeet

KEY PEOPLE

Carmen Miranda (1909–1955), samba singer, Broadway star, and Hollywood actress known as the "Brazilian Bombshell"

Oscar Niemeyer (b .1907), architect who popularized modern architecture in Latin America

Pelé (Edson Arantes do Nascimento, b. 1940), internationally known soccer star who led the Brazilian national team to World Cup championships in 1958, 1962, and 1970

Getúlio Vargas (1882–1954), twentieth-century Brazilian leader (president of Brazil from 1930–1945 and 1951–1954)

Dilma Rousseff (b. 1947), first female president of Brazil (took office in 2011)

STATES OF BRAZIL

State; Capital

Acre; Rio Branco

Alagoas; Maceió

Amapá; Macapá

Amazonas; Manaus

Bahia; Salvador

Ceará; Fortaleza

Espírito Santo; Vitória

Goiás; Goiânia

Maranhão; São Luís

Mato Grosso; Cuiabá

Mato Grosso do Sul; Campo Grande

Minas Gerais; Belo Horizonte

Pará; Belém

Paraíba; João Pessoa

Paraná; Curitiba

Pernambuco; Recife

Piauí; Teresina

Rio de Janeiro; Rio de Janeiro

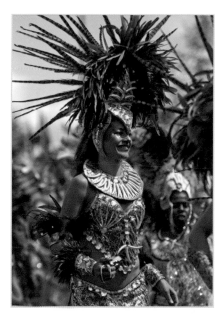

Rio Grande do Norte; Natal

Rio Grande do Sul; Porto Alegre

Rondônia; Pôrto Velho

Roraima; Boa Vista

Santa Catarina; Florianópolis

São Paulo; São Paulo

Sergipe; Aracaju

Tocantins; Palmas

GLOSSARY

biodiversity

The variety of plant and animal life in a particular habitat.

biome

A community of plants and animals.

facade

The face or front of a building.

indigenous

Originally or naturally belonging to an area.

inflation

An increase in prices or the amount of money needed to purchase goods or services.

regent

A person who leads a kingdom if the monarch is too young or otherwise unable to rule.

supremacy

Having ultimate power or control.

trafficking

The illegal selling and transporting of a product, such as drugs.

tributary

A stream or river that empties into a larger river.

Tropic of Capricorn

Line of latitude in the Southern Hemisphere that marks the edge of the tropics.

ADDITIONAL RESOURCES

SELECTED BIBLIOGRAPHY

Hudson, Rex A., ed. *Brazil: A Country Study*. Washington, DC: Government Printing Office, 1997. Print.

Meade, Teresa E. *A Brief History of Brazil*. New York: Facts on File, 2010. Print.

St. Louis, Regis, and Andrew Draffen. *Lonely Planet, Brazil*. Oakland, CA: Lonely Planet, 2005. Print.

FURTHER READINGS

Berkenkamp, Lauri. *Discover the Amazon: The World's Largest Rainforest*. Norwich, VT: Nomad, 2008.

Sheen, Barbara. *Foods of Brazil*. Detroit, MI: KidHaven, 2008. Print.

WEB LINKS

To learn more about Brazil, visit ABDO Publishing Company online at **www.abdopublishing.com**. Web sites about Brazil are featured on our Book Links page. These links are routinely monitored and updated to provide the most current information available.

PLACES TO VISIT

If you are ever in Brazil, consider checking out these important and interesting sites!

Amazon Rain Forest

Located in north-central Brazil, the Amazon is the largest rain forest on Earth and the most diverse environment in the world.

Copacabana and Ipanema

The two most famous beaches in the country are adjacent to one another in Rio de Janeiro.

Cristo Redentor (Christ the Redeemer) Statue

This famous landmark overlooks the city of Rio de Janeiro.

Iguaçu Falls

This huge waterfall, located in Iguaçu National Park, attracts thousands of tourists yearly and has a spectacular, mist-filled, view.

SOURCE NOTES

CHAPTER 1. A VISIT TO BRAZIL

1. "Background Note: Brazil." *US Department of State*. US Department of State, 8 Mar. 2011. Web. 9 Mar. 2011.

CHAPTER 2. GEOGRAPHY: RAIN FOREST AND MORE

1. "The World Factbook: Brazil." *Central Intelligence Agency*. Central Intelligence Agency, 1 Mar. 2011. Web. 9 Mar. 2011.

2. Rex A. Hudson, ed. *Brazil: A Country Study*. Washington, DC: Government Printing Office, 1997. Web. 9 Mar. 2011.

3. Ibid.

4. "Brazil, a Megadiverse Country." *Portal Brazil*. Brazil Government, 2010. Web. 9 Mar. 2011.

5. "The World Factbook: Brazil." *Central Intelligence Agency*. Central Intelligence Agency, 1 Mar. 2011. Web. 9 Mar. 2011.

6. "Country Guide: Brazil." *BBC: Weather*. BBC, n.d. Web. 9 Mar. 2011.

7. "Iguaçu Falls." *Encyclopædia Britannica*. Encyclopædia Britannica, 2011. Web. 14 Jan. 2011.

8. "Mato Grosso Plateau." *Encyclopædia Britannica*. Encyclopædia Britannica, 2011. Web. 14 Jan. 2011.

9. "Brazil." *Encyclopædia Britannica*. Encyclopædia Britannica, 2011. Web. 14 Jan. 2011.

10. "Country Guide: Brazil." *BBC: Weather*. BBC, n.d. Web. 9 Mar. 2011.

11. Ibid.

CHAPTER 3. ANIMALS AND NATURE: BIODIVERSITY UNDER THREAT

1. "Brazil, a Megadiverse Country." *Portal Brazil*. Brazil Government, 2010. Web. 9 Mar. 2011.

2. "Piranha Increase 'Due to Dams.'" *BBC NEWS*. BBC, 28 Dec. 2003. Web. 1 Dec. 2010.

3. "Amazon Rain Forest." *Encyclopædia Britannica*. Encyclopædia Britannica, 2011. Web. 14 Jan. 2011.

4. "Environment: Environmental Situation; Forests." *Portal Brazil*. Brazil Government, 2010. Web. 9 Mar. 2011.

5. "Brazil, a Megadiverse Country." *Portal Brazil*. Brazil Government, 2010. Web. 9 Mar. 2011.

6. "Growth in Wild Animal Trade Worries Brazil." *Reuters*. Reuters, 2 May 2007. Web. 30 Nov. 2010.

7. "WWF Conservation Projects in Brazil." *World Wildlife Fund*. World Wildlife Fund, 24 Nov. 2010. Web. 31 Dec. 2010.

8. Ariane Janér. "The National Parks of Brazil." *ecobrasil.org*. Brazilian Ecotourism Society, 20 Mar. 2010. Web. 31 Dec. 2010.

9. "WWF Conservation Projects in Brazil." *World Wildlife Fund*. World Wildlife Fund, 24 Nov. 2010. Web. 31 Dec. 2010.

10. "About Us." NPS.Org. *National Parks Service*, 8 Dec. 2009. Web. 22 Mar. 2011.

11. "Summary Statistics: Summaries by Country, Table 5, Threatened Species in Each Country."

IUCN Red List of Threatened Species. International Union for Conservation of Nature and Natural Resources, 2010. Web. 18 Jan. 2011.

12. "WWF Conservation Projects in Brazil." *World Wildlife Fund.* World Wildlife Fund, 24 Nov. 2010. Web. 31 Dec. 2010.

13. Ariane Janér. "The National Parks of Brazil." *ecobrasil.org.* Brazilian Ecotourism Society, 20 Mar. 2010. Web. 31 Dec. 2010.

CHAPTER 4. HISTORY: EMPERORS, DICTATORS, PRESIDENTS

1. Marshall C. Eakin. *Brazil: The Once and Future Country.* New York: St. Martin, 1996. Google Book Search. Web. 25 Apr. 2011.

2. "'Slave' Labourers Freed in Brazil." *BBC News.* BBC, 3 July 2007. Web. 25 Apr. 2011.

3. Frank D. McCann. "Brazil and World War II: The Forgotten Ally." *Estudios Interdisciplinarios de America Latina y el Caribe* 6.2 (1995): n. pag. Web. 9 Mar. 2011.

4. Teresa Meade. *A Brief History of Brazil.* New York: Facts on File, 2010. Print. 164.

5. "The World Factbook: Brazil." *Central Intelligence Agency.* Central Intelligence Agency, 1 Mar. 2011. Web. 9 Mar. 2011.

CHAPTER 5. PEOPLE: A UNIQUE SOCIETY

1. "The World Factbook: Brazil." *Central Intelligence Agency.* Central Intelligence Agency, 16 Mar. 2011. Web. 5 Apr. 2011.

2. Ibid.

3. Ibid.

4. Ibid.

5. Ibid.

6. "Background Note: Brazil." *US Department of State.* US Department of State, 8 Mar. 2011. Web. 9 Mar. 2011.

7. "The World Factbook: Brazil." *Central Intelligence Agency.* Central Intelligence Agency, 1 Mar. 2011. Web. 9 Mar. 2011.

8. Ibid.

9. Ibid.

10. "Brazil." *Encyclopædia Britannica.* Encyclopædia Britannica, 2011. Web. 14 Jan. 2011.

11. Geertje van der Pas. "On the Brink: Indigenous Peoples in Brazil." *Society for Threatened Peoples.* Society for Threatened Peoples, Feb. 2007. Web. 9 Mar. 2011.

12. "Brazilian Indians." *Survival International.* Survival International, n.d. Web. 9 Mar. 2011.

13. "The World Factbook: Brazil." *Central Intelligence Agency.* Central Intelligence Agency, 1 Mar. 2011. Web. 9 Mar. 2011.

SOURCE NOTES CONTINUED

14. Ibid.

15. Ibid.

CHAPTER 6. CULTURE: BLENDING THREE HERITAGES

1. "Pelé Biography." *Bio. True Story*. AE Television Network, 2010. Web. 29 Dec. 2010.

2. "Christ the Redeemer." *Encyclopædia Britannica*. Encyclopædia Britannica, 2011. Web. 14 Jan. 2011.

CHAPTER 7. POLITICS: UNDER NEW LEADERSHIP

1. "Dilma Rousseff." *Encyclopædia Britannica*. Encyclopædia Britannica, 2011. Web. 14 Jan. 2011.

2. "Partidos Políticos Registratado." *TSE*. Tribunal Superior Eleitoral, n.d. Web. 25 Mar. 2010.

CHAPTER 8. ECONOMICS: SOUTH AMERICAN POWERHOUSE

1. "The World Factbook: Brazil." *Central Intelligence Agency*. Central Intelligence Agency, 1 Mar. 2011. Web. 9 Mar. 2011.

2. Rex A. Hudson, ed. *Brazil: A Country Study*. Washington, DC: Government Printing Office, 1997.

3. "Background Note: Brazil." *US Department of State*. US Department of State, 8 Mar. 2011. Web. 9 Mar. 2011.

4. "Tropical Products: World Markets and Trade; December 2007 Circular." *FASOnline: Horticulture and Tropical Products Division*. US Department of Agriculture Foreign Agriculture Service, Dec. 2007. Web. 10 Mar. 2011.

5. "Published Global Agriculture Information Network Reports: Brazil; Sugar Annual, 2010." *US Department of Agriculture Foreign Agriculture Service GAIN Report*. US Department of Agriculture Foreign Agriculture Service, 12 Apr. 2010. Web. 10 Mar. 2011.

6. "Iron." *DNPM: National Department of Mineral Production*. Ministry of Mines and Energy [Brazil], 2007. Web. 10 Mar. 2011.

7. "Economic Environment." *DNPM: National Department of Mineral Production*. Ministry of Mines and Energy [Brazil], 2007. Web. 10 Mar. 2011.

8. "Background Note: Brazil." *US Department of State*. US Department of State, 8 Mar. 2011. Web. 9 Mar. 2011.

9. "Oil." *DNPM: National Department of Mineral Production*. Ministry of Mines and Energy [Brazil], 2007. Web. 10 Mar. 2011.

10. "Background Note: Brazil." *US Department of State*. US Department of State, 8 Mar. 2011. Web. 9 Mar. 2011.

11. "Health Technology." *Portal Brazil*. Brazil Government, 3 Feb. 2011. Web. 27 Mar. 2011.

12. "Background Note: Brazil." *US Department of State*. US Department of State, 8 Mar. 2011. Web. 9 Mar. 2011.

13. "Brazil." *Encyclopædia Britannica*. Encyclopædia Britannica, 2011. Web. 14 Jan. 2011.

14. "The World Factbook: Brazil." *Central Intelligence Agency*. Central Intelligence Agency, 1 Mar. 2011. Web. 9 Mar. 2011.

15. "Brazil: Key Facts at a Glance." *World Tourism and Travel Council*. World Travel and Tourism Council, 2007. Web. 10 Mar. 2011. 10. "Brazil's Infrastructure Challenge." *Latin Business Chronicle*. Latin Business Chronicle, 9 Sept. 2010. Web. 15 Mar. 2011.

16. Brazil's Infrastructure Challenge." *Latin Business Chronicle*. HACER. 9 Sep 2010. Web. 15 Mar 2011.

17. "Brazil." *Encyclopædia Britannica*. Encyclopædia Britannica, 2011. Web. 14 Jan. 2011.

18. "The World Factbook: Brazil." *Central Intelligence Agency*. Central Intelligence Agency, 1 Mar. 2011. Web. 9 Mar. 2011.

19. Ibid.

20. Ibid.

21. Ibid.

22. Mac Margolis. "A Crisis Fluke: Brazil's Shrinking Wealth Gap." *Newsweek*. Newsweek, 13 Aug. 2009. Web. 25 Mar. 2011.

23. "The World Factbook: Brazil." *Central Intelligence Agency*. Central Intelligence Agency, 1 Mar. 2011. Web. 9 Mar. 2011.

24. "Is This the 'Bric's Decade'?" *Goldman Sachs*. Goldman Sachs Global Investment Research, Mar. 2011. Web. 30 Mar. 2011.

CHAPTER 9. BRAZIL TODAY

1. "The World Factbook: Brazil." Central Intelligence *Agency*. Central Intelligence Agency, 1 Mar. 2011. Web. 9 Mar. 2011.

2. "Education in Brazil." *UNESCO Institute for Statistics in Brief 2008*. UNESCO, 31 Mar. 2011. Web. 31 Mar. 2011.

3. "No Longer Bottom of the Class." *Economist Online*. Economist, 9 Dec. 2010. Web. 12 Dec. 2010.

4. "Education in Brazil." *UNESCO Institute for Statistics in Brief 2008*. UNESCO, 31 Mar. 2011. Web. 31 Mar. 2011.

5. "Education Statistics: Brazil." *Childinfo*. UNICEF, May 2008. Web. 24 Mar. 2011.

6. "Millennium Development Goals Indicators: Brazil; Goal 4: Reduce Childhood Mortality." *United Nations Statistics Division*. United Nations, 23 June 2010. Web. 25 Apr. 2011.

7. Damian Carrington. "Mass Tree Deaths Prompt Fears of Amazon 'Climate Tipping Point.'" *Guardian.co.uk*. Guardian News and Media, 3 Feb. 2011. Web. 25 Apr. 2011.

8. "Background Note: Brazil." *US Department of State*. US Department of State, 8 Mar. 2011. Web. 9 Mar. 2011.

INDEX

agriculture, 105–106, 111, 125
Agulhas Negras, 42
Aleijadinho, 80–82
Amado, Jorge, 82
Amazon Region Protected
 Areas program, 45
Amazon River, 10, 14, 18, 22, 29,
 34, 38–39
Amazonian manatee, 38
animals, 31–38, 42, 75, 125
architecture, 8, 10, 58, 91
area, 15, 17
Argentina, 17, 53, 54
arts, 80–82
Atlantic forest, 22, 24, 39, 41,
 42, 45
Atlantic Ocean, 8, 17, 18, 56

Barbosa, Leandro, 85
basketball, 12, 83–85
Belo Horizonte, 20
Bonifácio de Andrada, José, 58
bordering countries, 17, 27
bossa nova, 79–80, 82
boundary disputes, 18
Brasília, 7, 10, 15, 20, 57, 58, 91,
 113–114
Brazilian Democratic
 Movement, 58, 101

Caatinga, 21
Cabral, Pedro Álvares, 48, 108
caimans, 27, 34, 36, 38
Candomblé, 72–73, 80
Cangaceiro, 86
capoeira, 85
capybara, 34

Cardoso, Fernando, 61
Carnival, 8, 12, 76–79, 111–113,
 119
cassava, 47, 87
censorship, 58, 86
central-western Brazil, 18, 27,
 41
cerrado, 24, 27, 39, 45
choro music, 80
climate, 20, 29, 41
climatic regions, 29
coffee, 14, 22, 54, 69, 87, 88,
 105, 106
Collor de Mello, Fernando, 61,
 102
Congress, 58, 95, 97–99, 101,
 102
conservation, 24, 32, 42–45
constitution, 56–61, 93–95, 125
constitutional referendum,
 94–95
Costa, Lucio, 58
Cristo Redentor statue, 91
currency, 15, 61, 108, 114–115

de Moraes, Vinícius, 82
de Queiroz, Rachel, 82
deforestation, 41, 45, 125–126
democracy, 56, 59, 93
Devil's Throat, 27
dictatorship, 57, 59, 93, 100
disease, 49, 66
diversity, 63, 68, 80
Dutra, Eurico Gaspar, 57

economic growth, 57–58, 59,
 61, 108, 116

economy, 54, 57, 59, 61,
 105–116
education, 69, 93, 113, 121–124
endangered species, 32, 43, 126
environmental threats, 41–42,
 125–126
equator, 18, 29
ethanol, 61, 106, 110, 111,
 115–116
ethnic groups, 65–69
explorers, 48–49, 50
exports, 14, 49, 106, 111

federal republic, 15, 61, 93, 99
feijoada completa, 89
Festa de São João, 76
flag, 99
food, 76, 78, 87–89
Franco, Itamar, 61

geographic regions, 17–27
giant anteater, 34
GINI index, 115
gold, 10, 38, 99, 106–108
government structure, 15,
 94–100
gross domestic product, 61,
 105
Guarani, 10, 47, 68

heath care, 93, 125
Henrique Cunha Bueno,
 Antônio, 94
holidays, 76–78, 88, 119
human rights, 58–59
hydroelectric plants, 27, 111

Iguaçu Falls, 24, 27
immigrants, 65–66, 68, 69–70
independence, 52–54, 69, 76,
 93, 100
Independence Day, 76
indigenous tribes, 49, 66–68, 76,
 78–79, 88
industry, 38, 105–113
infrastructure, 43, 53, 113–114,
 116
instruments, 80
Ipanema, 24, 82
ipê-amarelo, 38
iron, 22, 108, 111
Itatiaia National Park, 42

Jesuits, 10, 49, 78
John VI, 52

Kardec, Allan, 72
Kardecism, 72–73
Kubitschek, Juscelino, 58

language, 8, 15, 68, 69–70, 75
leaders, current, 101
literacy rate, 121–123
literature, 80–82
Lula da Silva, Luis Inácio, 61,
 97, 103

Machado de Assis, Joaquim
 Maria, 82
manufacturing, 105
massacre, 50
medicinal plants, 39, 41
military rule, 57–59
mining, 38, 105, 106–108, 125
Miranda, Carmen, 86

monkeys, 32, 42
music, 75, 78–82, 119

Napoléon I, 52
Natal, 56
national capital, 10, 15, 57, 58
national parks, 7, 10, 24, 42–43,
 66
national plant, 38
national security regime, 57–58
natural resources, 115, 126
Niemeyer, Oscar, 58, 91
northeast Brazil, 18, 20–22, 29,
 66, 79, 88
northern Brazil, 18, 20, 29, 52,
 56, 88

official name, 15
oil, 59, 61, 110–111, 116
Olympic Games, 116

Pantanal, 24, 27, 34, 41
Paraná River, 22, 27, 39
parliamentary immunity, 102
pau-brasil, 48–49
Pedro II, 53–54, 94
Pelé, 12, 83
piranhas, 27, 36, 75
pirarcu, 36–38
plantations, 14, 22, 49, 50
plants, 14, 20, 36, 38, 39–41,
 43, 75
poaching, 38, 42, 125
political parties, 58, 100–101
population, 15, 22, 49, 63–66,
 68, 72, 115, 121, 123
Portinari, Cândido, 80–82
Porto Alegre, 20, 25

Portugal, 8, 10, 48–49, 52, 69,
 76, 93
Portuguese, 8–10, 15, 21, 42,
 48–53, 65–66, 68, 75, 76, 78,
 80, 82, 83, 91, 100, 106, 108
poverty, 115, 125, 126

rain forest, 7, 10, 18, 20, 22, 24,
 29, 31, 32, 34, 38, 41–45, 75
real, 15, 61, 108
Recife, 25, 49
Reidy, Affonso, 91
religion, 15, 68, 70–73
revolts, 54
Rio de Janeiro, 8, 12, 20, 22, 24,
 25, 42, 50, 58, 73, 78–80, 91,
 99, 111, 116, 119
Roberto brothers, 91
Roman Catholicism, 15, 70,
 76, 88
Ronaldo, 12
Rousseff, Dilma, 97, 101

Sabiá-laranjeira, 34
Salvador, 10, 49, 50, 66, 73
samba, 78, 79, 80, 82, 119
São Paulo, 20, 22, 69, 83, 106
sertão, 21
settlement, 48–52, 68
Silva Xavier, Joaquim José da,
 52, 76
slavery, 49, 50, 53, 66, 69
soccer, 12, 82–83, 116, 119
southeast Brazil, 18, 22–24, 88
southern Brazil, 18, 24–27, 29,
 65, 69, 88, 114
Spain, 8, 10, 48, 54, 69
spider monkey, 32

INDEX CONTINUED

spiritualism, 15, 72, 73
sports, 12, 82–85
states, 20, 22, 24, 27, 69, 93, 99, 100
sugar, 22, 49, 50, 88, 106, 110
Sugar Loaf, 24
Supreme Court, 58, 95, 100
Supremo Tribunal Federal, 95, 100

tapir, 32
telenovelas, 85–86
Tijuca National Park, 42

Toco toucan, 34–36
Tordesillas, Treaty of, 8
tourism, 111–113, 116
trafficking, 42
Tupi, 68, 75–76, 78
Tupinamba, 47
TV Globo, 85–86

United National Educational, Scientific, and Cultural Organization, 10, 22, 24, 58, 91
Uruguay, 17, 18

Varejão, Anderson, 83
Vargas, Getúlio, 54–58
Vera Cruz, 48
Villa-Lobos, Heitor, 79
volleyball, 12, 83–85

World Cup, 12, 83, 116
World War II, 56–57

Yáñez Pinzón, Vicente, 48

PHOTO CREDITS